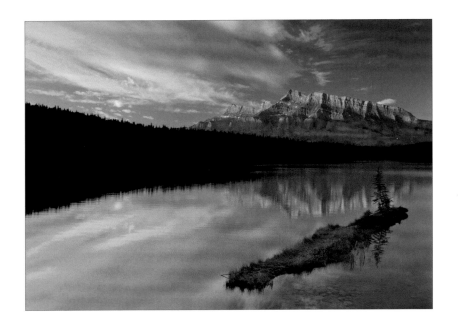

National Library of Canada Cataloguing in Publication
Wiggett, Darwin, 1961-

Dances with light: the Canadian Rockies / by Darwin Wiggett.

ISBN 1-55153-230-1

1. Rocky Mountains, Canadian (English)--Pictorial works. 2. Landscape photography--Rocky Mountains, Canadian (English) 3. Wiggett, Darwin R. (Darwin Reginald), 1961- I. Title.

FC219.W567 2005 779'.36711'092
C2005-900665-X

We acknowledge the financial support of the Government of Canada through the Book Publishing Industry Development Program (BPIDP) for our publishing activities.

Altitude Publishing Canada Ltd.
The Canadian Rockies / Victoria
Head office: 1500 Railway Ave.
Canmore, Alberta, T1W 1P6
1-800-957-6888
www.altitudepublishing.com

Layout & design: Scott Manktelow
Editor: Jennifer Groundwater

photo this page: Mount Rundle reflected in Two Jack Lake, Banff National Park

Printed in Canada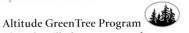
by Friesens Printers

Altitude GreenTree Program
Altitude will plant two trees for every tree used in the production of this book.

DANCES WITH LIGHT

The Canadian Rockies
by Darwin Wiggett

ALTITUDE PUBLISHING

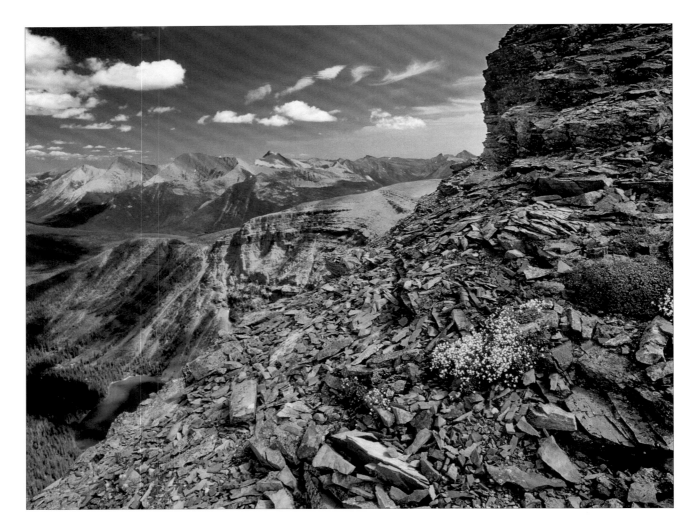

above
Akamina Ridge
Akamina-Kishinena Provincial Recreation Area

Introduction

The Canadian Rockies are a national treasure. For generations, visitors have come from all over the world to experience the astonishing scenery contained in the mountain national parks of Banff, Jasper, Kootenay, Yoho and Waterton. This gallery of photographs captures the essence of this magnificent wilderness in all its changeable moods: dramatic, exciting, colourful, wild, raw, inviting.

Most visitors fall in love with the Rocky Mountains the first time they see them. The reason is simple: being surrounded by these imposing giants reminds us that we are relatively insignificant, a small piece in a big puzzle. The mountains nurture us at a primitive level — reminding us that we are organic creatures, born of elemental sources — and they pull us back to a more ancestral place. We are of the earth, not separate from it.

Spending time in the Canadian Rockies leads us to look at the bigger picture: the grand scale of nature and the amazing forces of time, energy, and geological events required to make the vistas before our eyes. Wander just a short distance from the comforts of modern life and into the heart of the mountains, and you'll feel a shift in your senses. Suddenly, you'll see more clearly, your hearing will sharpen, and your nose will register pleasant, half-forgotten scents. Your heartbeat will quicken, you'll breathe more deeply, your body will tingle. You are part of nature, and you feel it to the core of your DNA.

There are wild and innate stirrings within each of us that the climate-controlled, glass, and steel environment we live in tends to destroy. The images in this book will serve to tug at those feelings long since dulled by modern urban living.

Dances with Light represents, as accurately as possible, scenes I have experienced during my time in this magical area. The images in this collection are merely a sampling of the seasonal, geographic, and ecological variety found in the Canadian Rockies. The interplay of light, atmospheric conditions and biotic changes over time makes the Rockies a dynamic and fluid place, continually transforming moment by moment. Many of the images reflect the look of the world waking up: the rising mist, the orange glow of dawn on the dew-covered vegetation, the lack of wind, and the absolute tranquility of mornings.

The majority of these photos were taken from well-marked roadside stops at viewpoints accessible to almost everyone. A few images were taken in the backcountry, but none of the scenes depicted here required any technical mountaineering skills to reach. Just put on some hiking boots and go for an early-morning stroll to experience these precious places. Nothing is more enjoyable than a walk on the well-marked and well-maintained trails of the Canadian Rockies. This is an experience to last a lifetime.

The many moods, places, and natural events that make up the Rockies are in this book, each captured in a mere fraction of a second. My hope is that the photos in this book will inspire you to experience the wilderness personally, for photos are not surrogates for actual experience. Dig deeper, wander farther, observe more closely, and begin your own journey into this exceptional landscape. Whether you visit popular Banff or Jasper National Park, or choose to go into a more isolated and wild destination like Mount Assiniboine Provincial Park, you are sure to find something here to stir your soul.

The mountains have thoroughly enriched my life, and I want to share my joy in these places with others. The result is the book you hold in your hands.

Darwin Wiggett

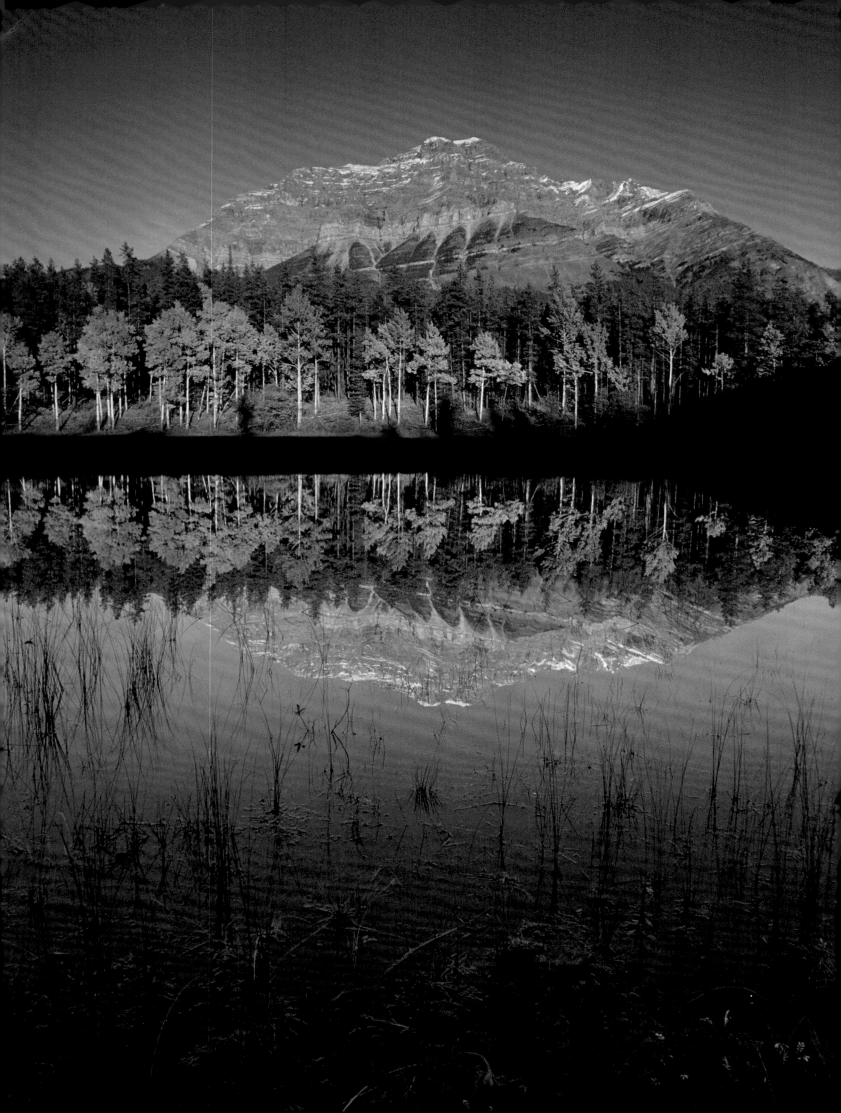

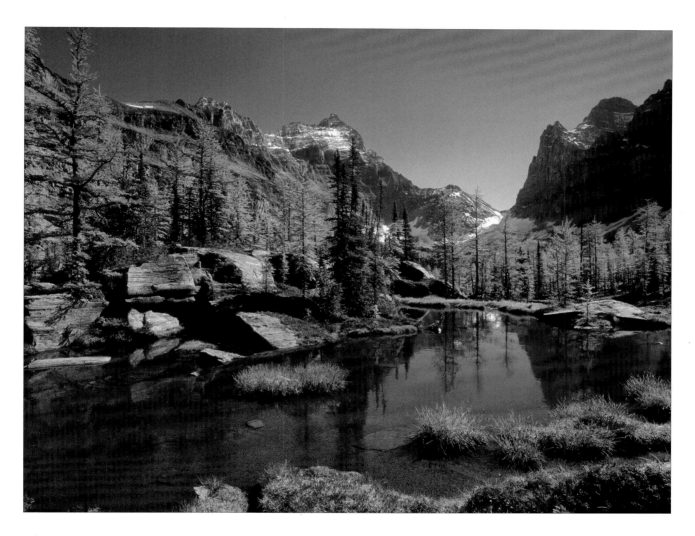

above
Opabin Terrace Pools and Mount Hungabee
Yoho National Park

opposite
Mount Kerkeslin
Jasper National Park

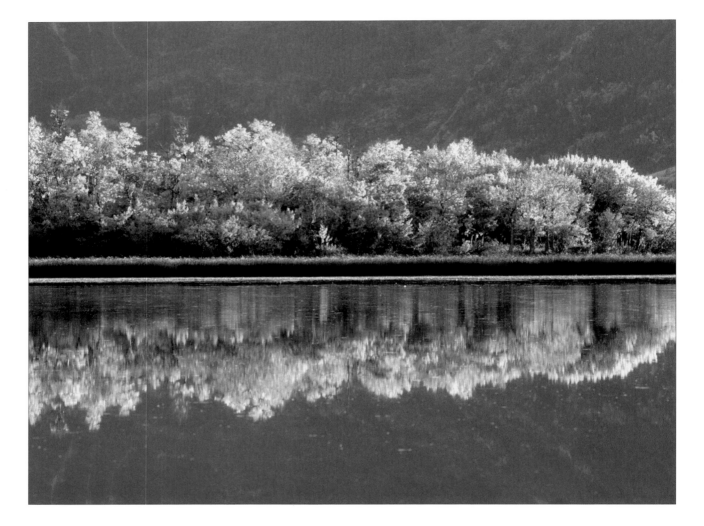

above
Maskinonge Lake
Waterton Lakes National Park

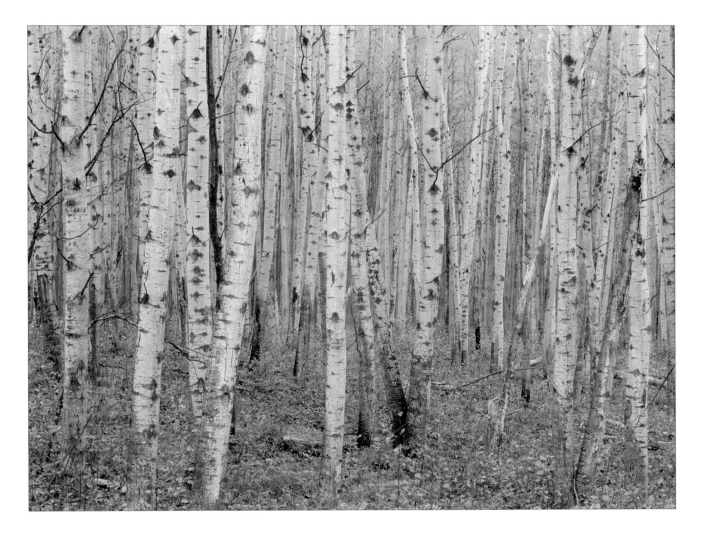

above
Aspen forest
Kananaskis Country

following pages
Peyto Lake
Banff National Park

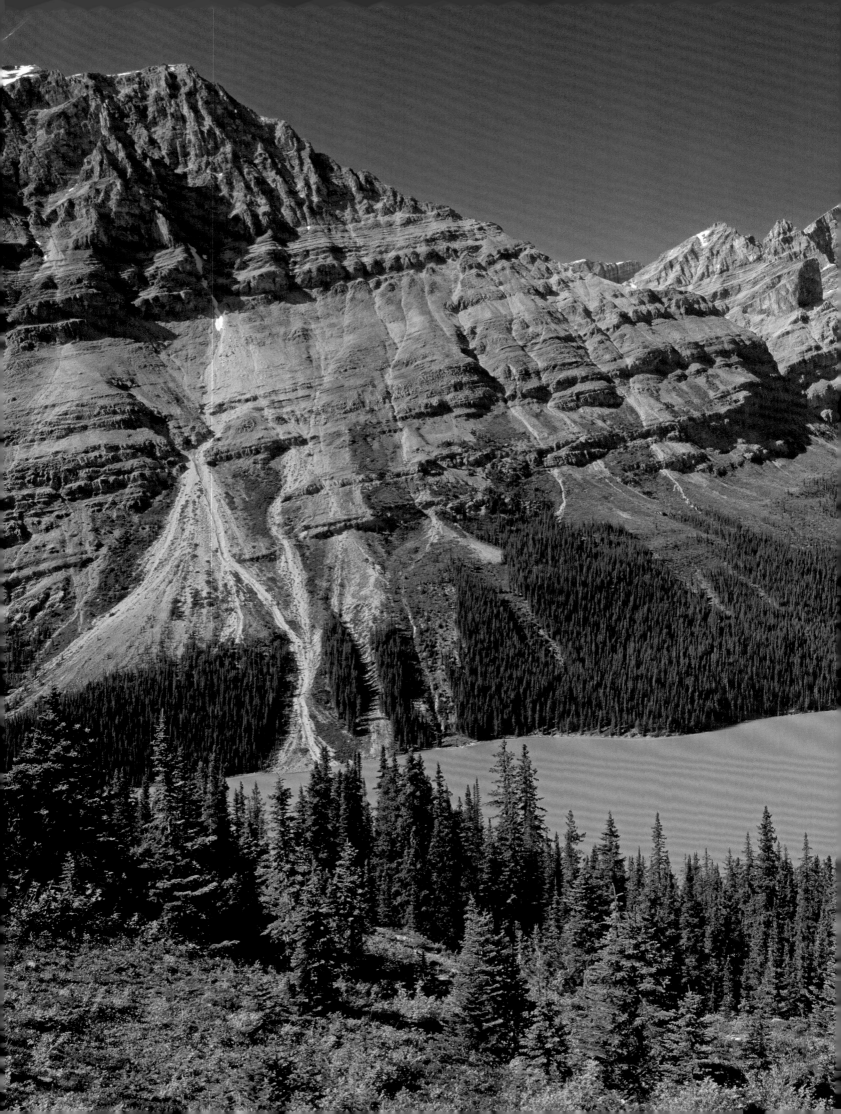

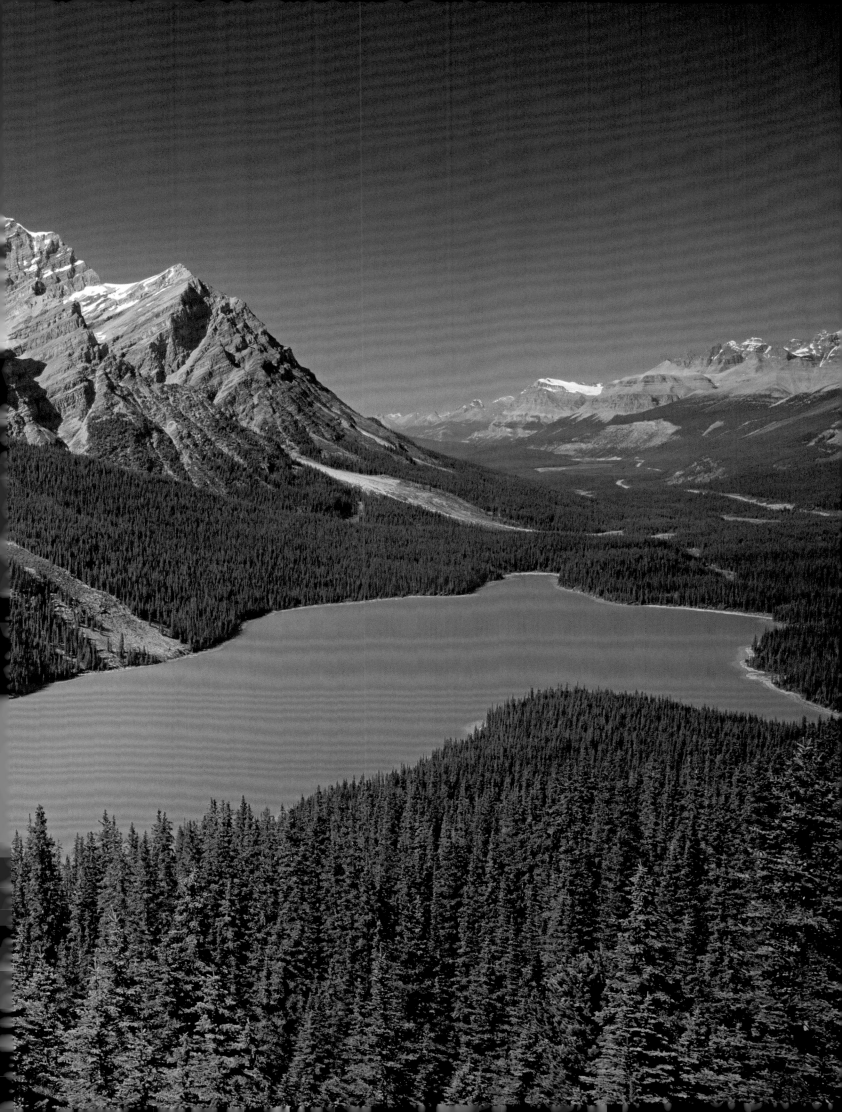

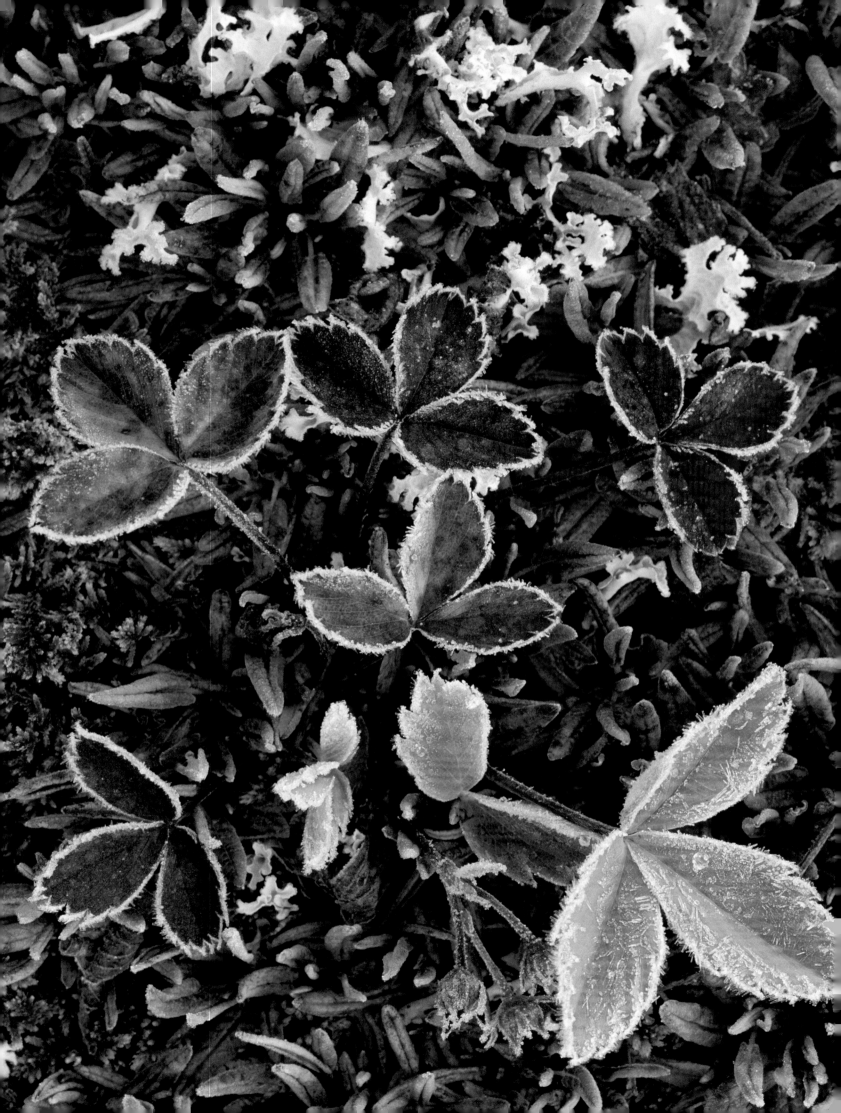

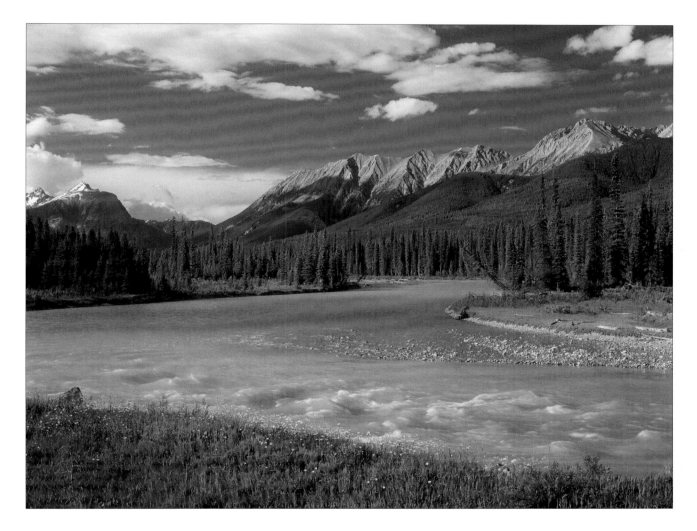

above
The Kootenay River and the Mitchell Range
Kootenay National Park

opposite
Wild strawberry leaves
Willmore Wilderness Park

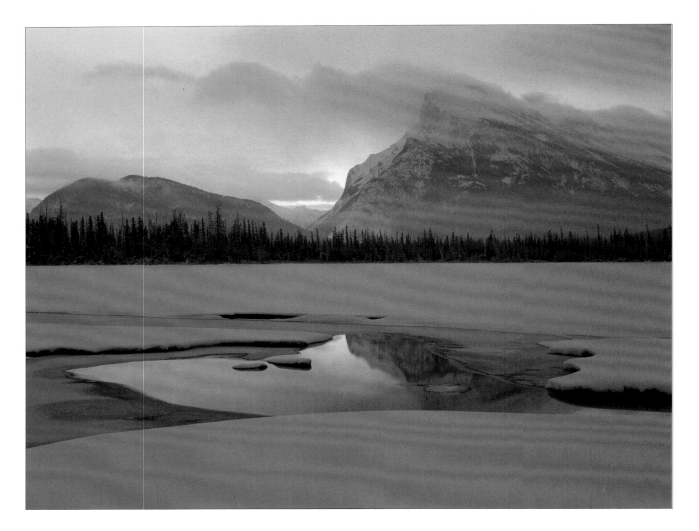

above
Mount Rundle over Vermilion Lakes
Banff National Park

opposite
Mount Crowfoot and fireweed
Banff National Park

following pages
Mount Rae over Highway 40
Kananaskis Country

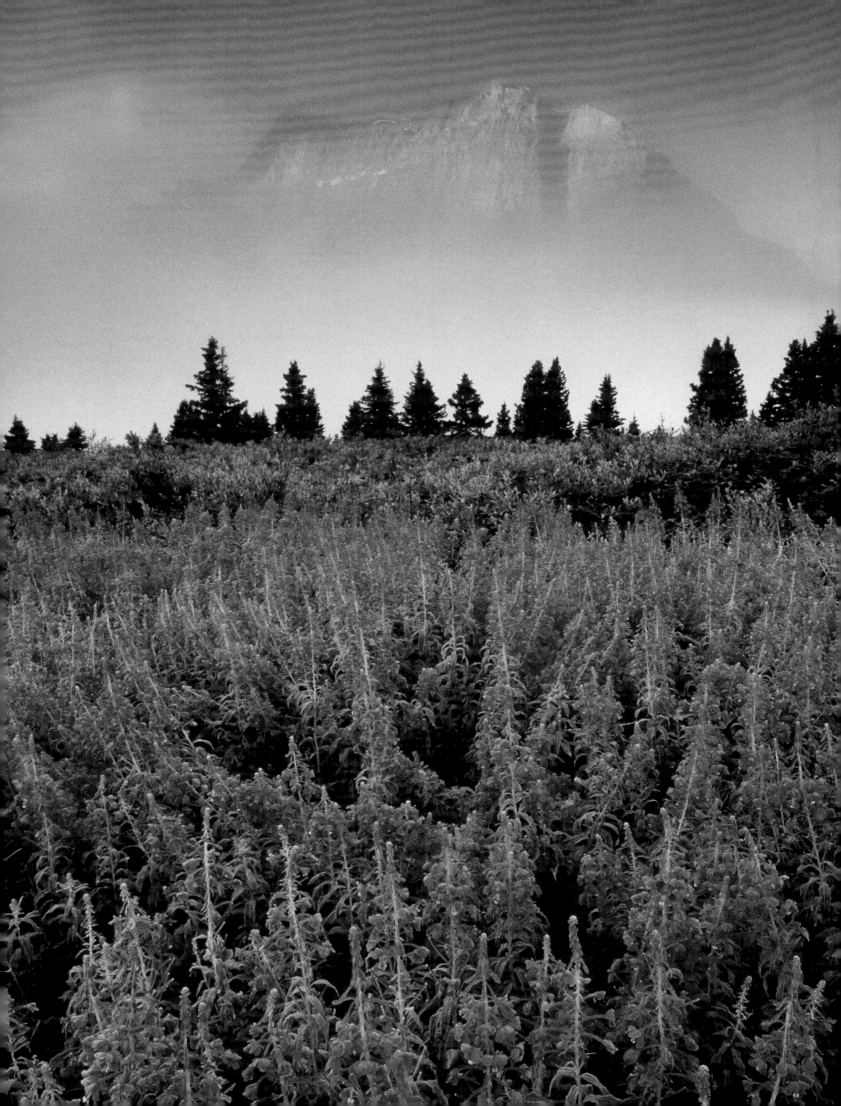

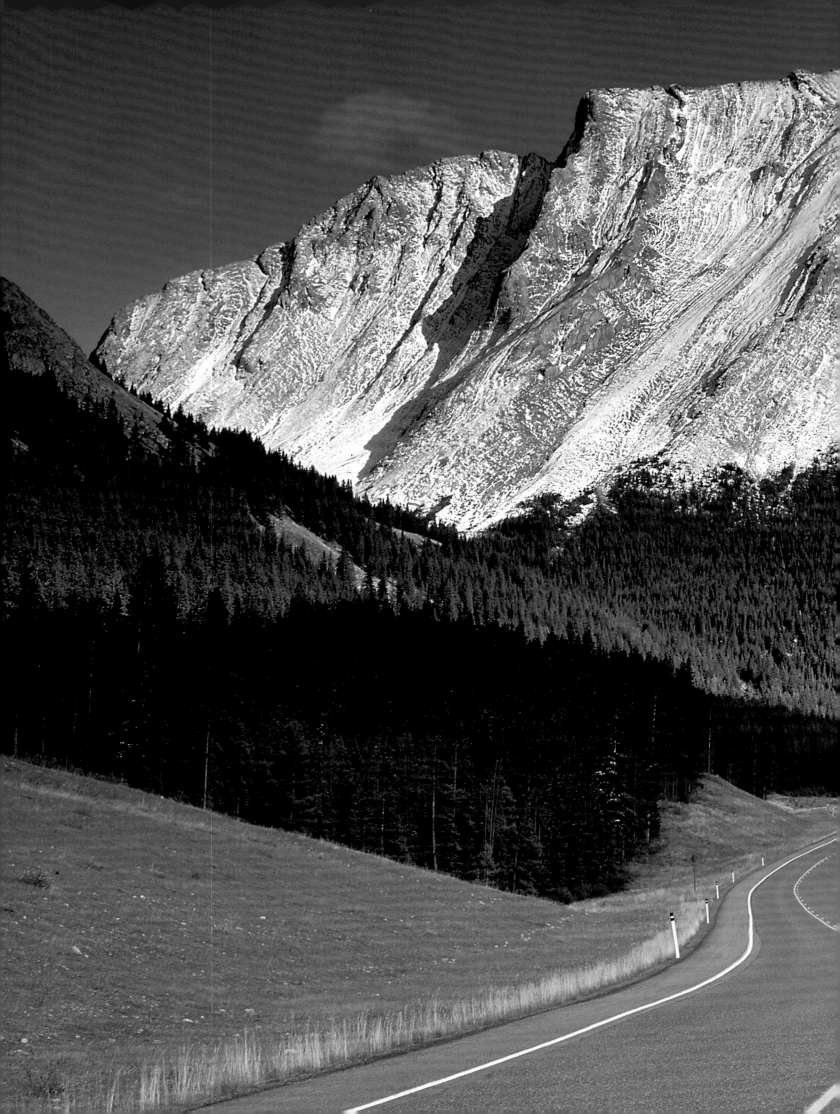

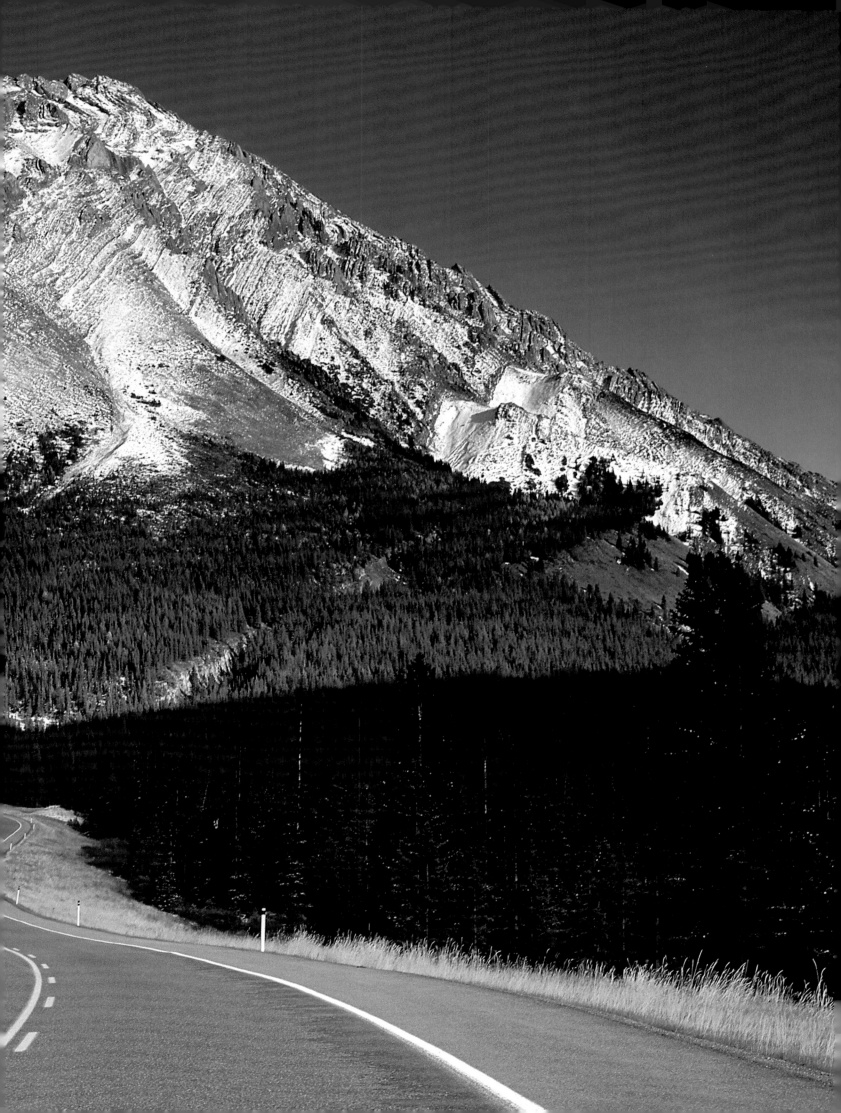

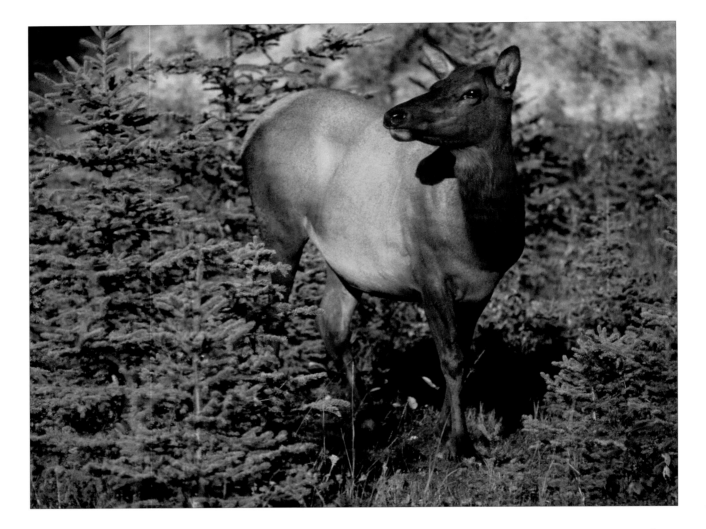

above
Cow elk
Jasper National Park

opposite
Sawback burn
Banff National Park

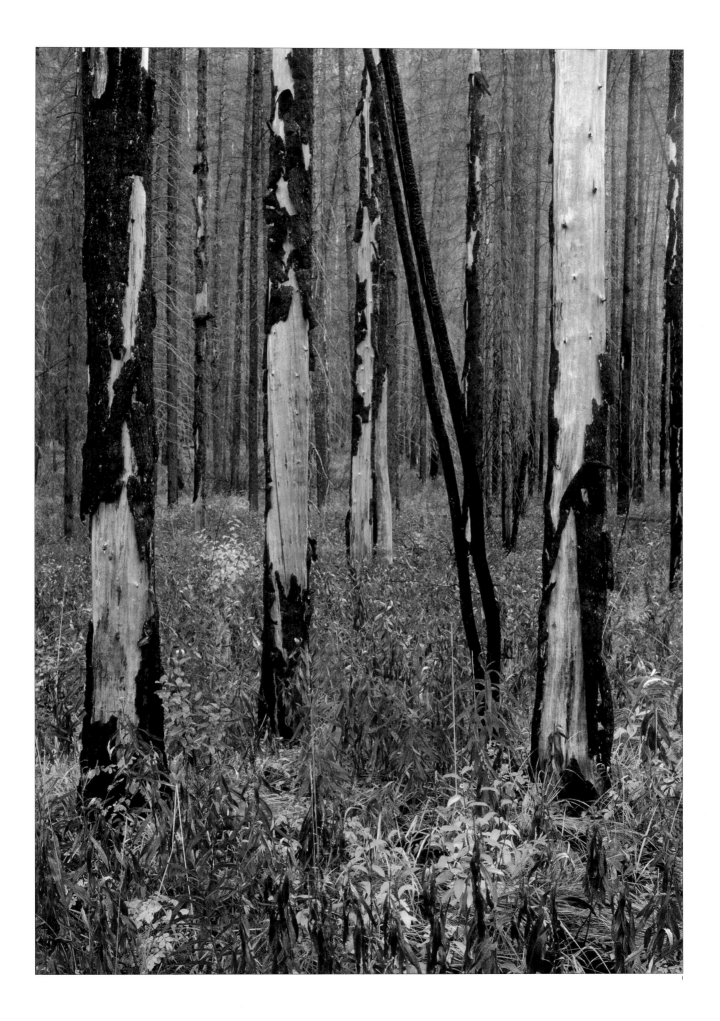

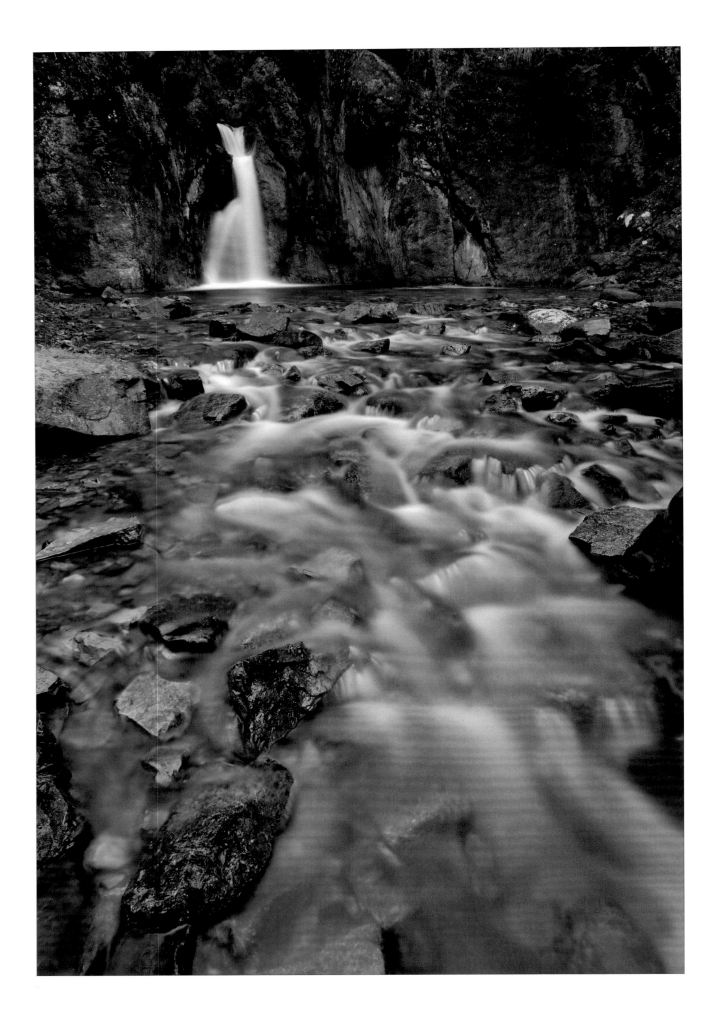

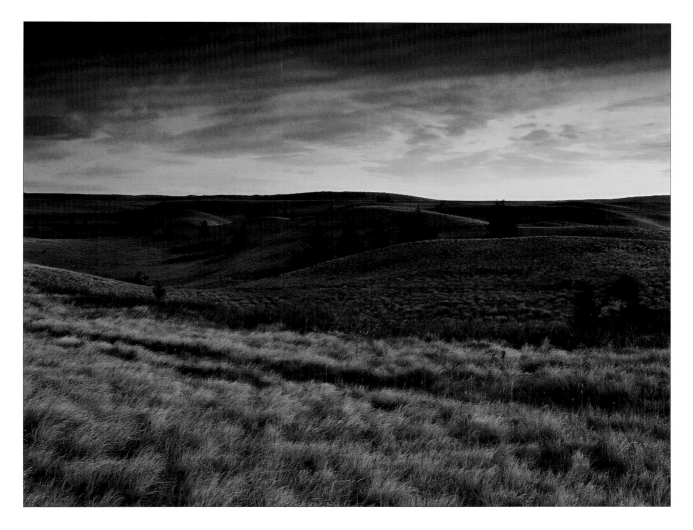

above
Meadow below Bellevue Hill
Waterton Lakes National Park

opposite
Cat Creek Falls
Kananaskis Country

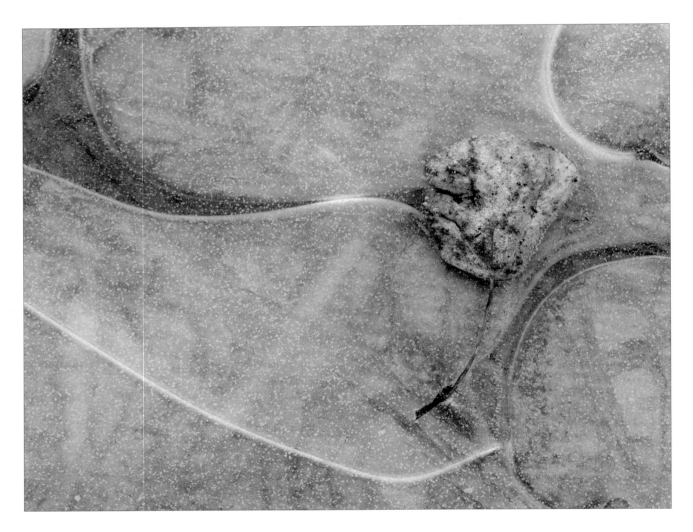

above
Aspen leaf
Kananaskis Country

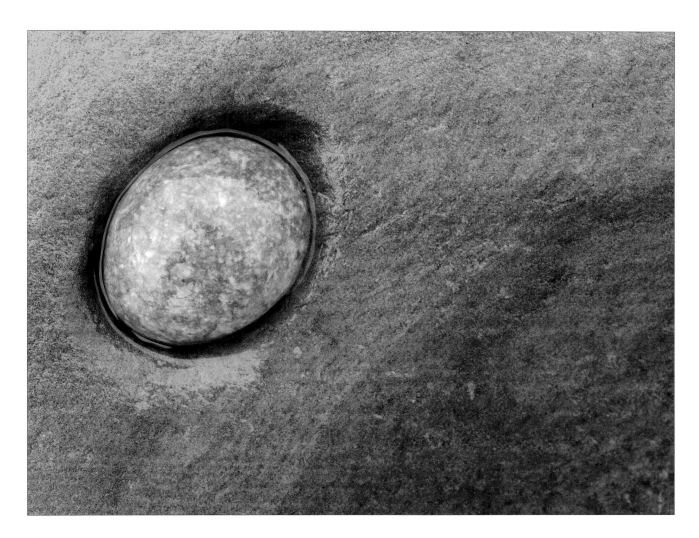

above
River stone
Kananaskis Country

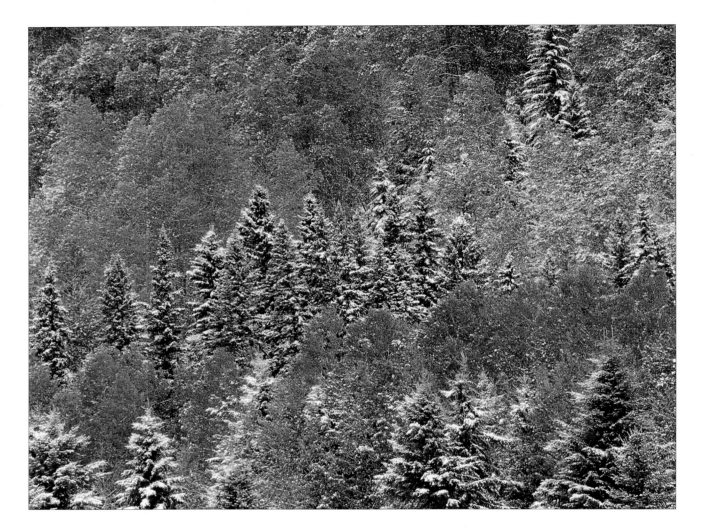

above
Spruce and aspen forest in Sheep River Valley
Kananaskis Country

opposite
Maligne River
Jasper National Park

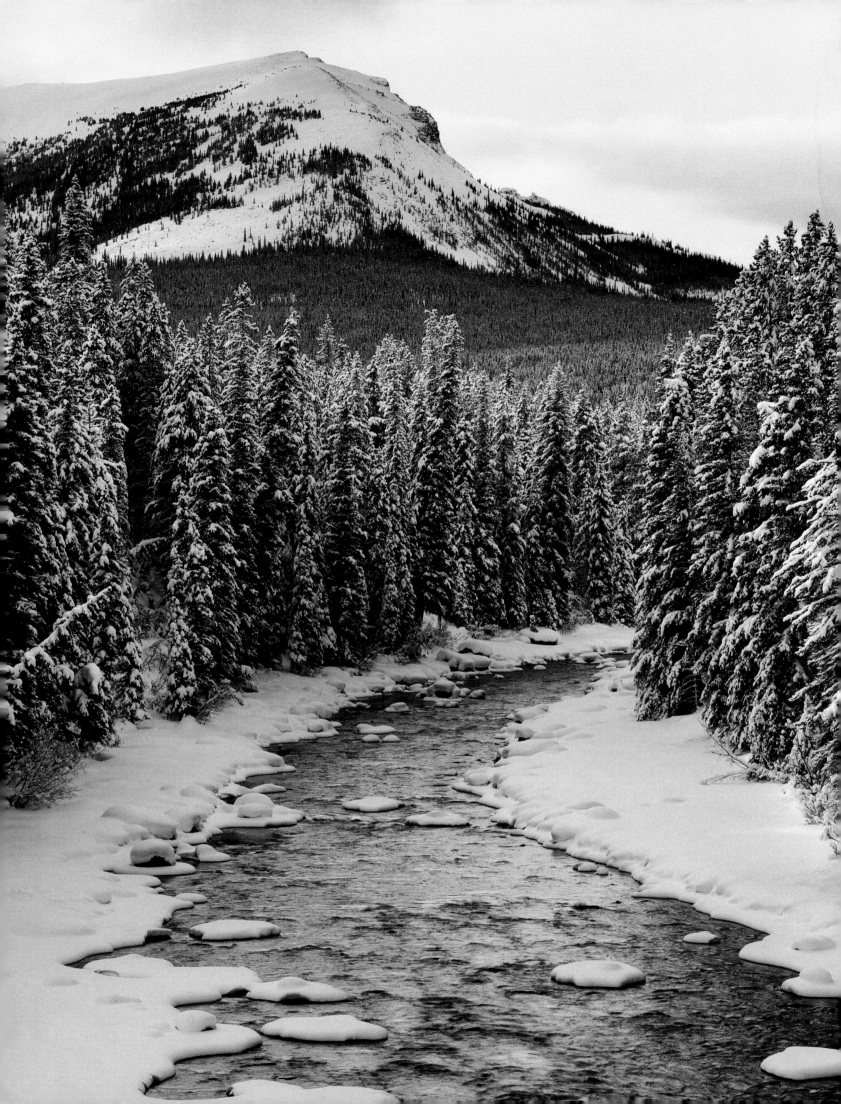

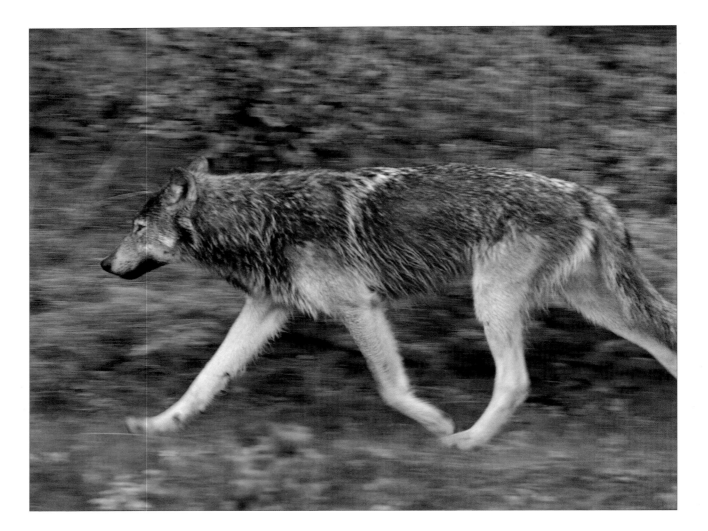

above
Timber wolf
Jasper National Park

opposite
Mount Birdwood
Kananaskis Country

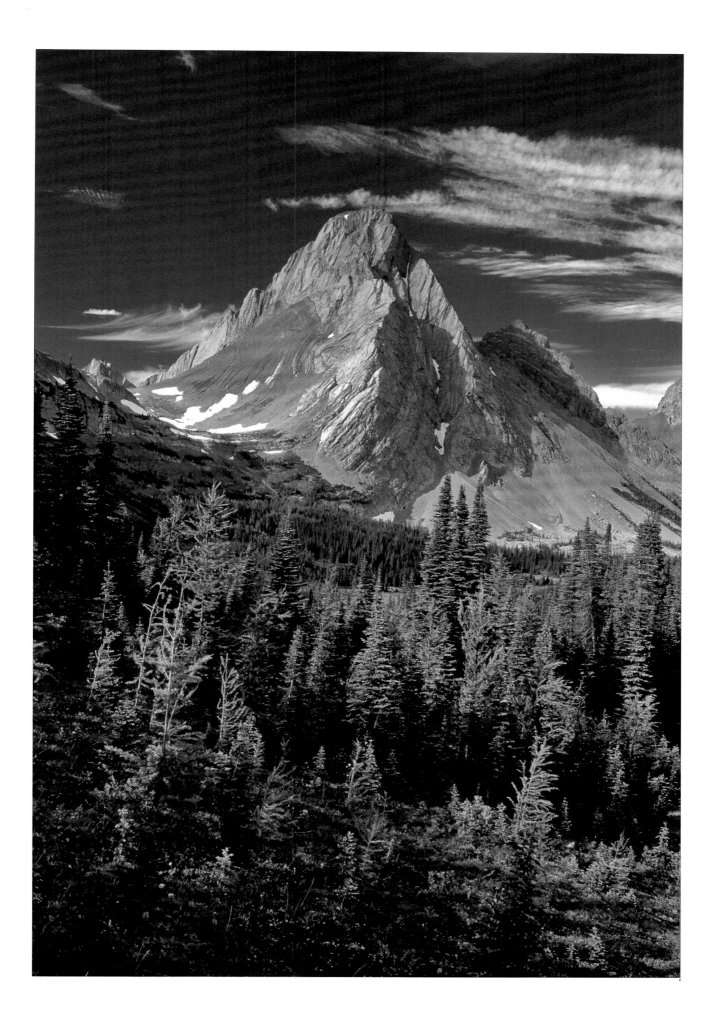

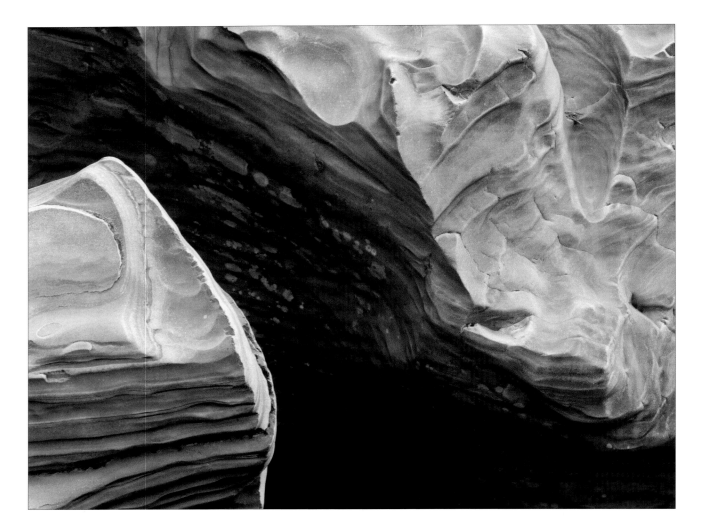

above
Rock bead below Natural Bridge
Yoho National Park

opposite
Spillway Lake and the Opal Range
Kananaskis Country

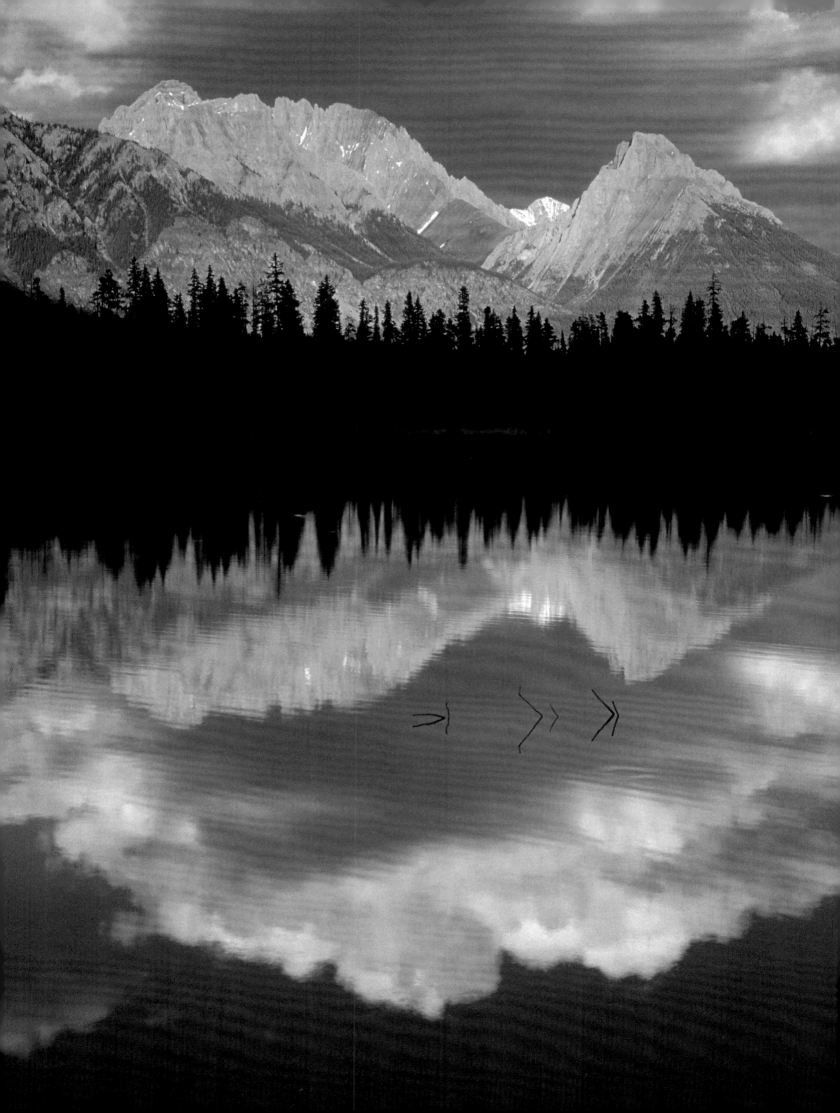

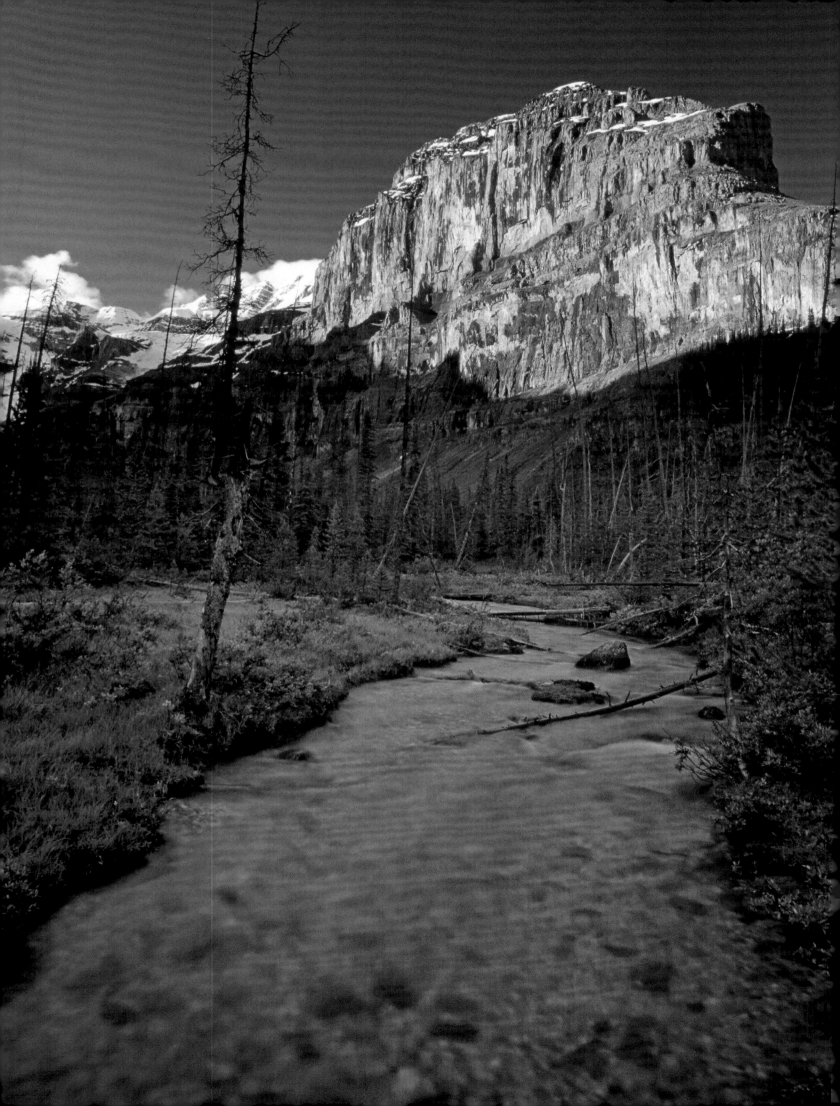

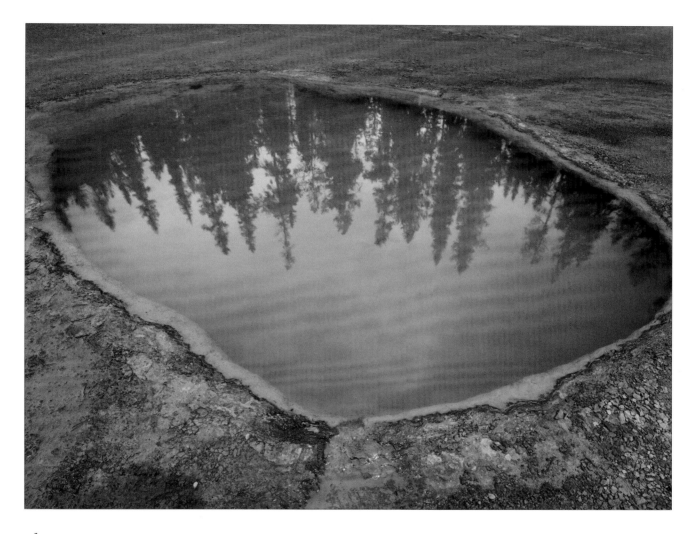

above
Paint Pots
Kootenay National Park

opposite
Stanley Peak and Stanley Creek
Kootenay National Park

following page, left
Forest floor
Jasper National Park

following page, right
Maligne Canyon
Jasper National Park

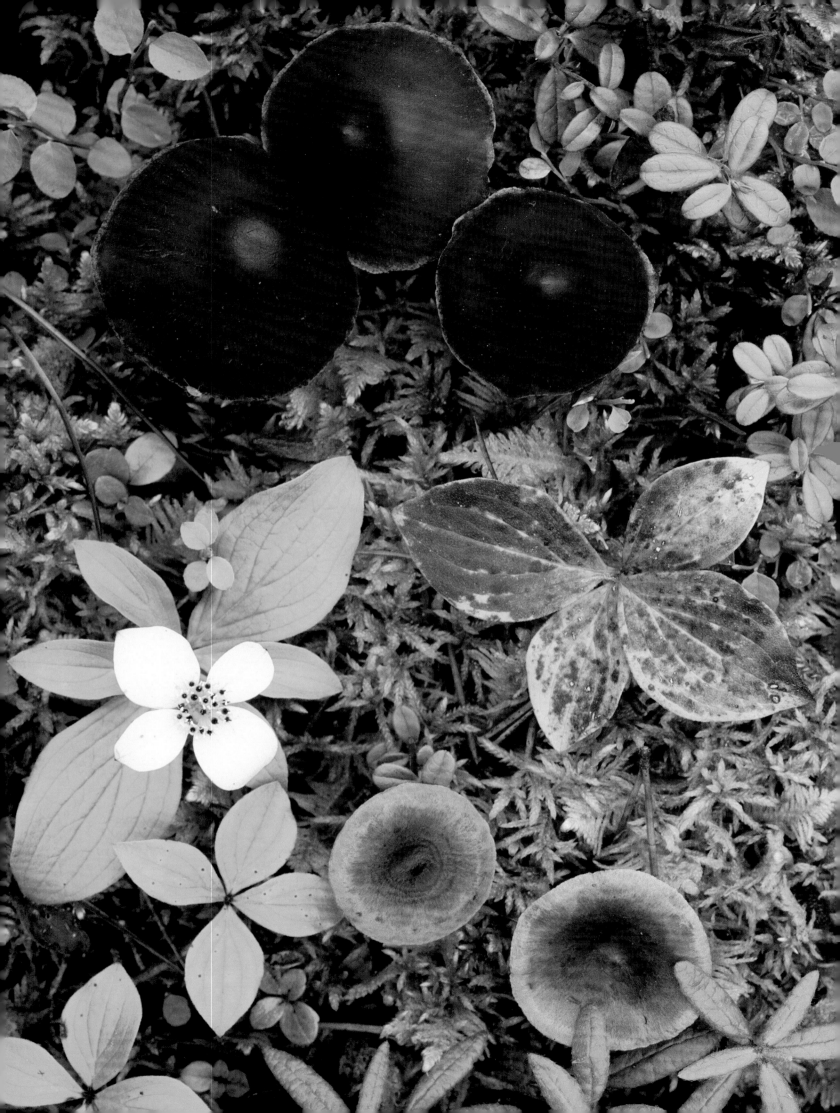

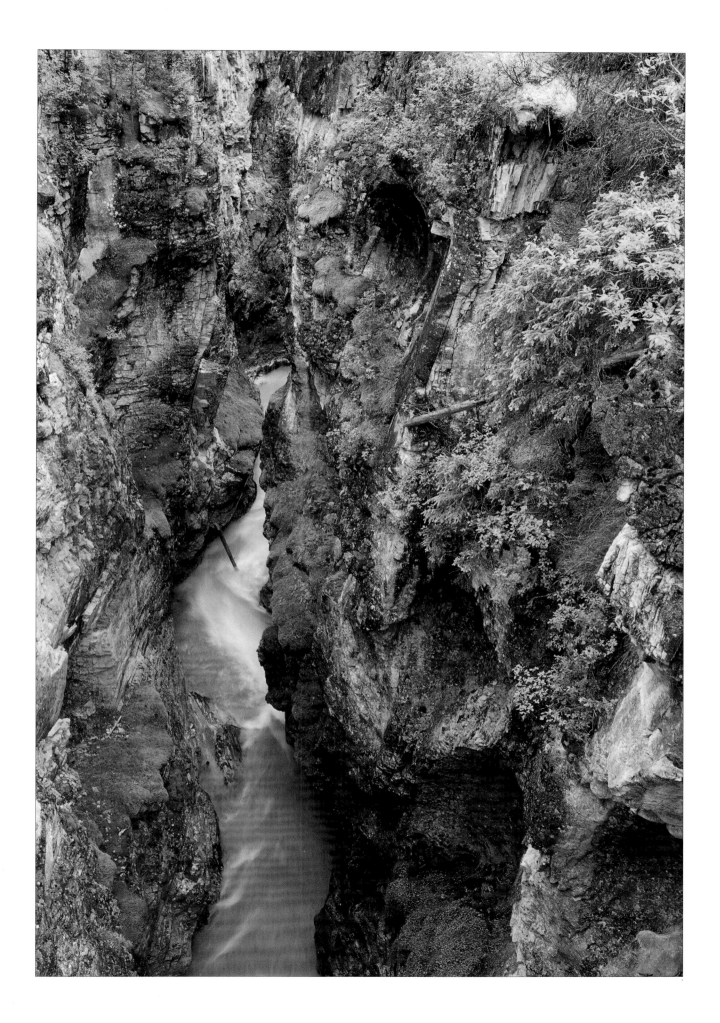

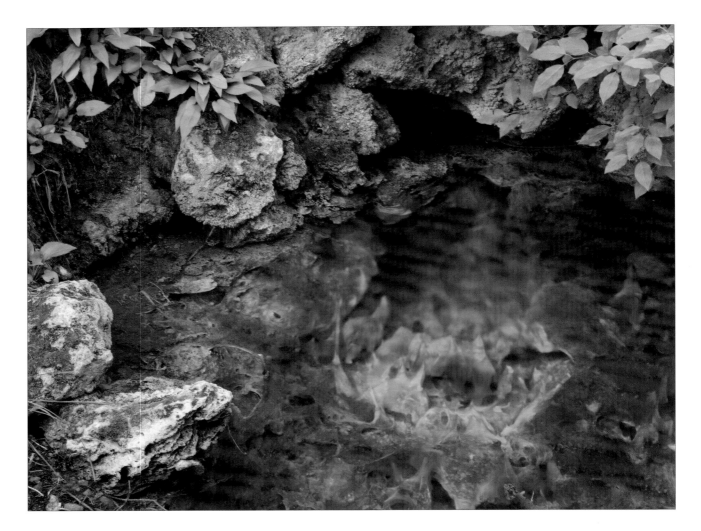

above
Hot Springs at the Cave and Basin
Banff National Park

opposite
Fairmont Banff Springs Hotel
Banff National Park

following pages, right and left
Moraine Lake and the Valley of the Ten Peaks
Banff National Park

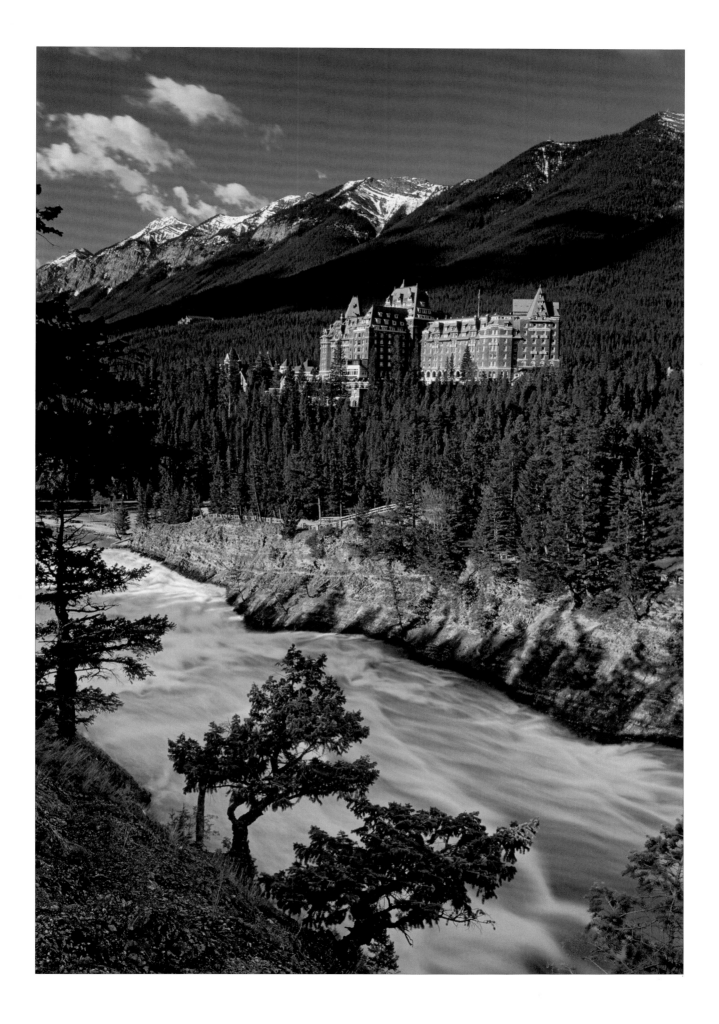

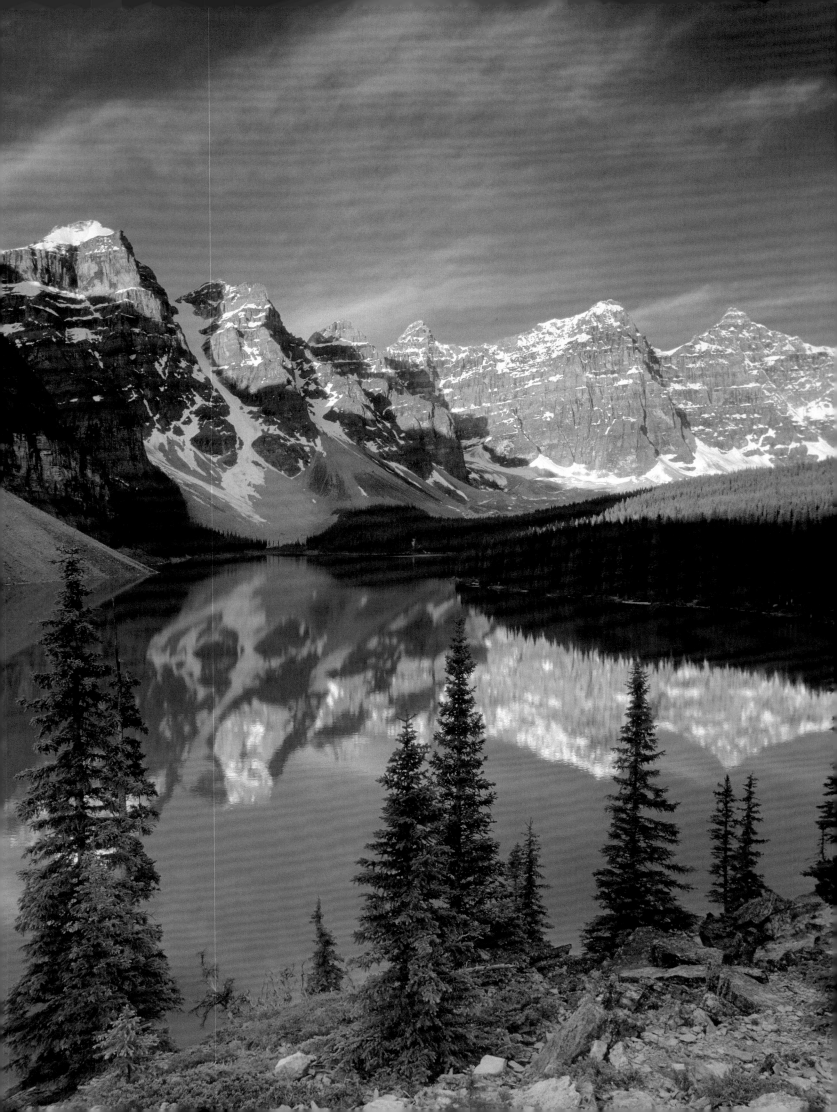

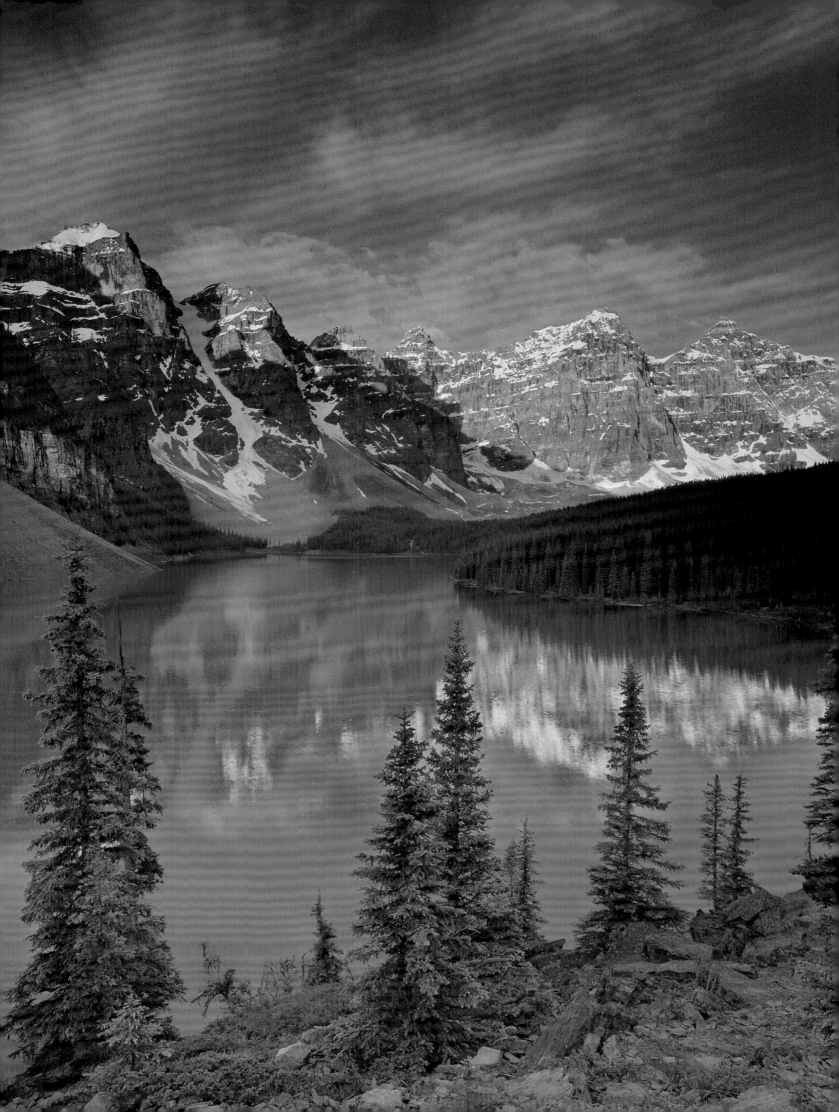

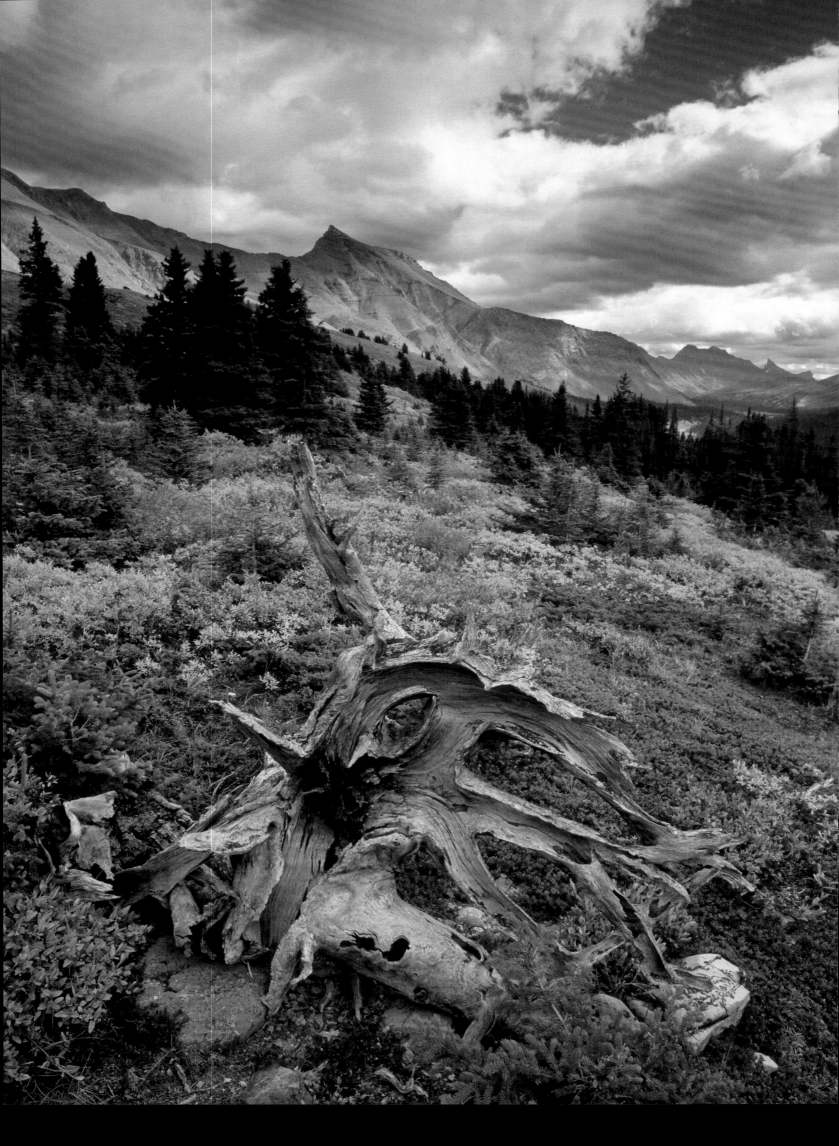

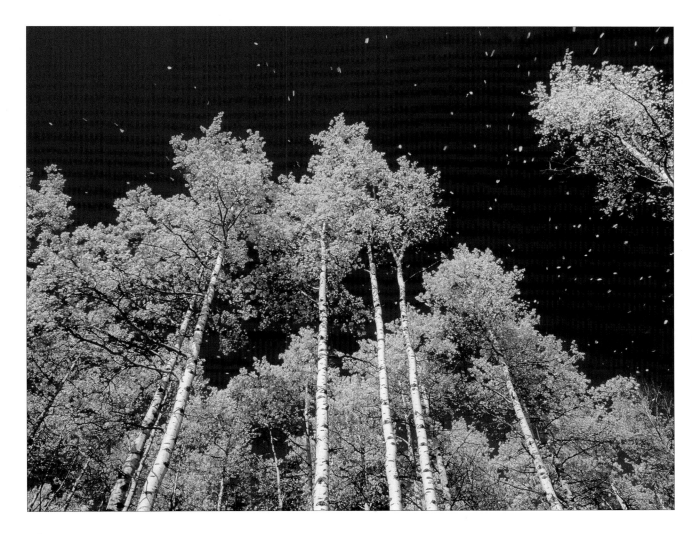

above
Aspen
Kananaskis Country

opposite
Wilcox Pass
Jasper National Park

following pages
Pocaterra Ridge
Kananaskis Country

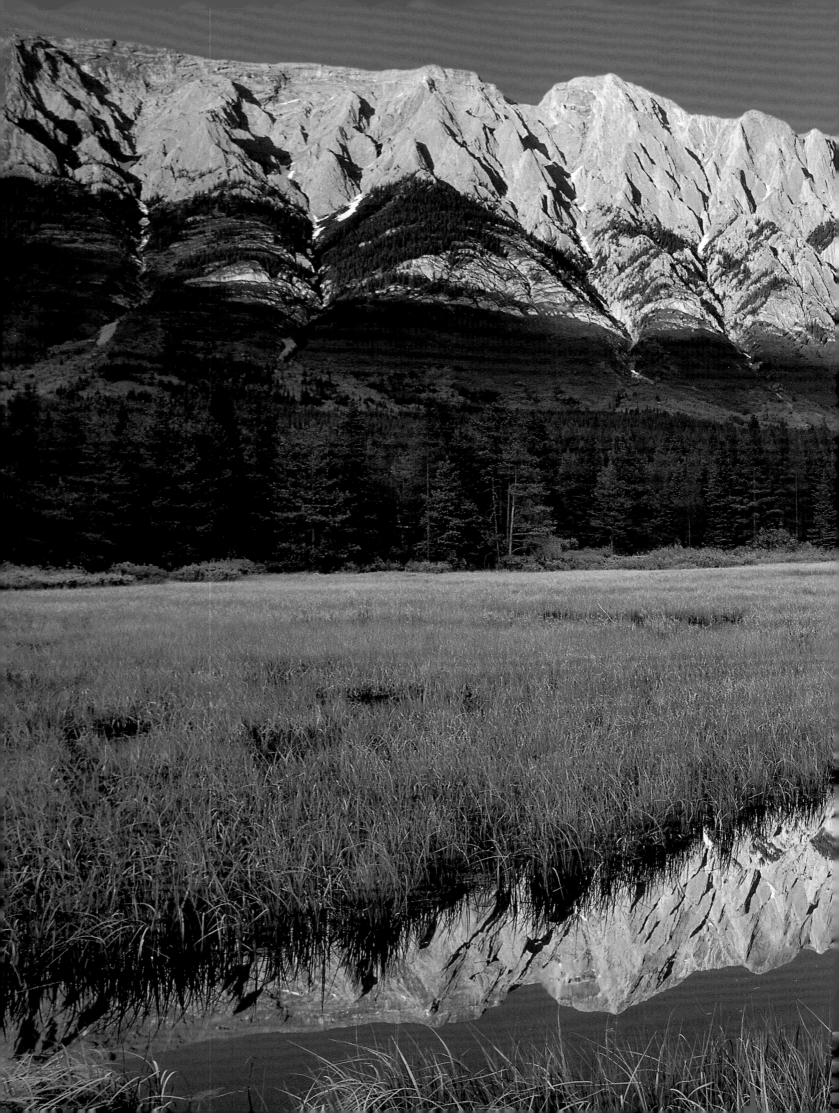

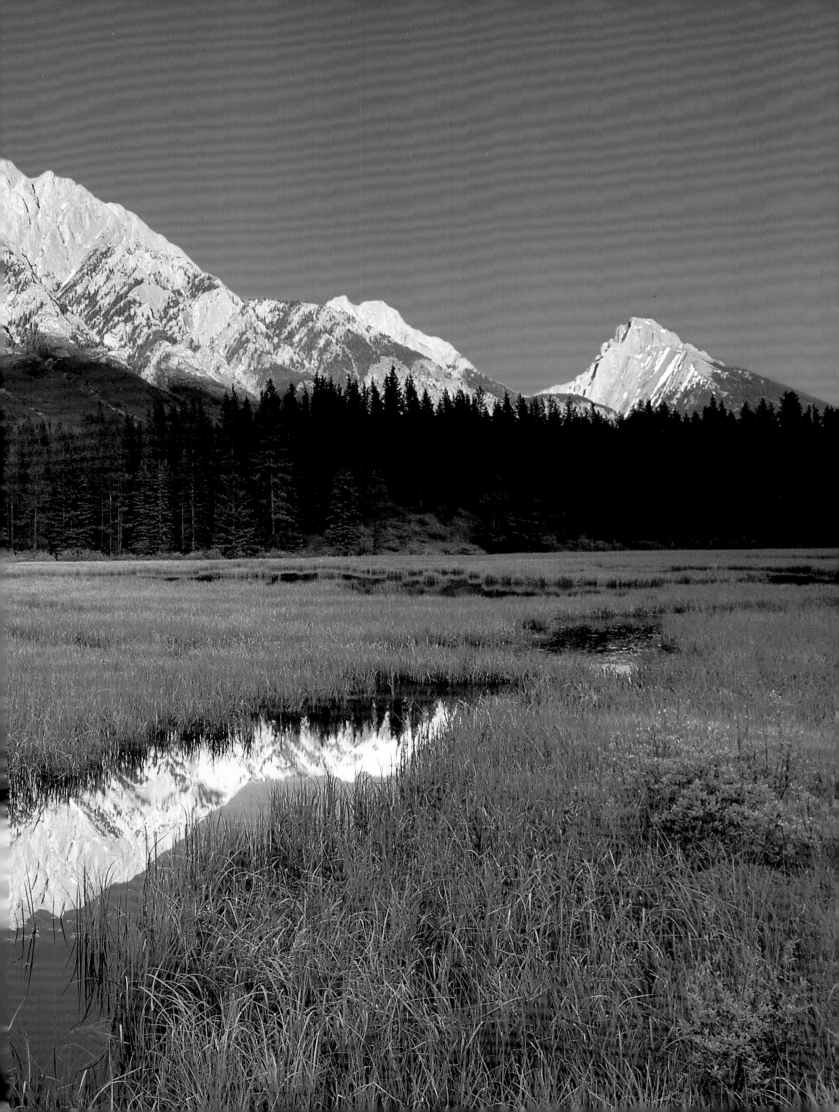

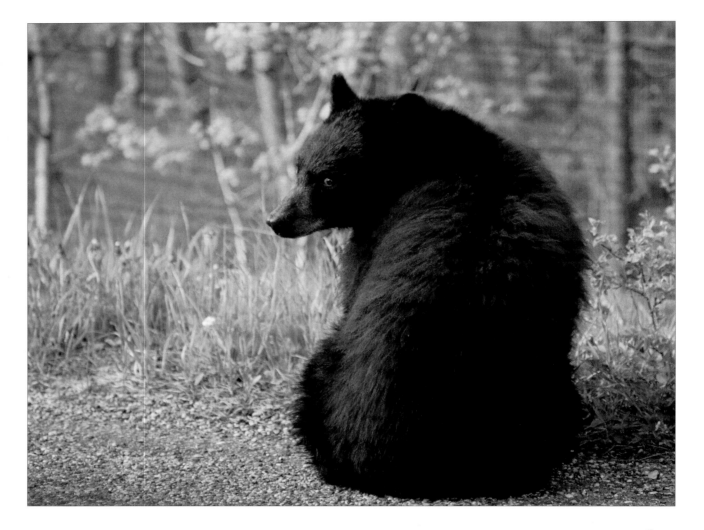

above
Black bear
Waterton Lakes National Park

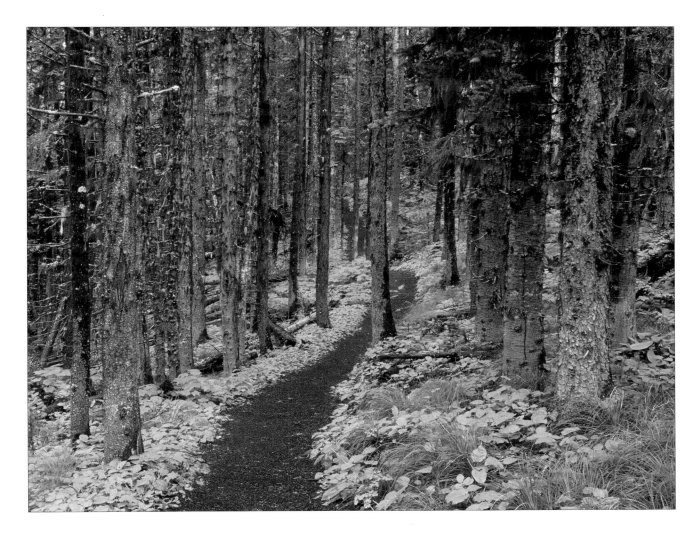

above
Hiking trail
Waterton Lakes National Park

following page, left
Numa Falls
Kootenay National Park

following page, right
Small pool at the bottom of a rock slide
Jasper National Park

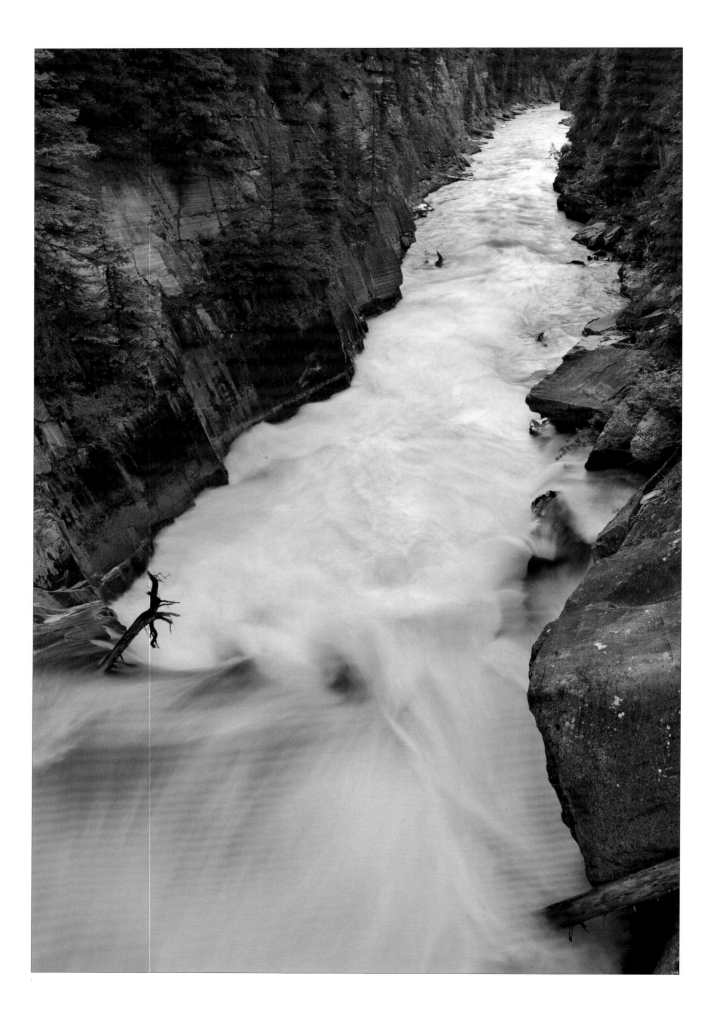

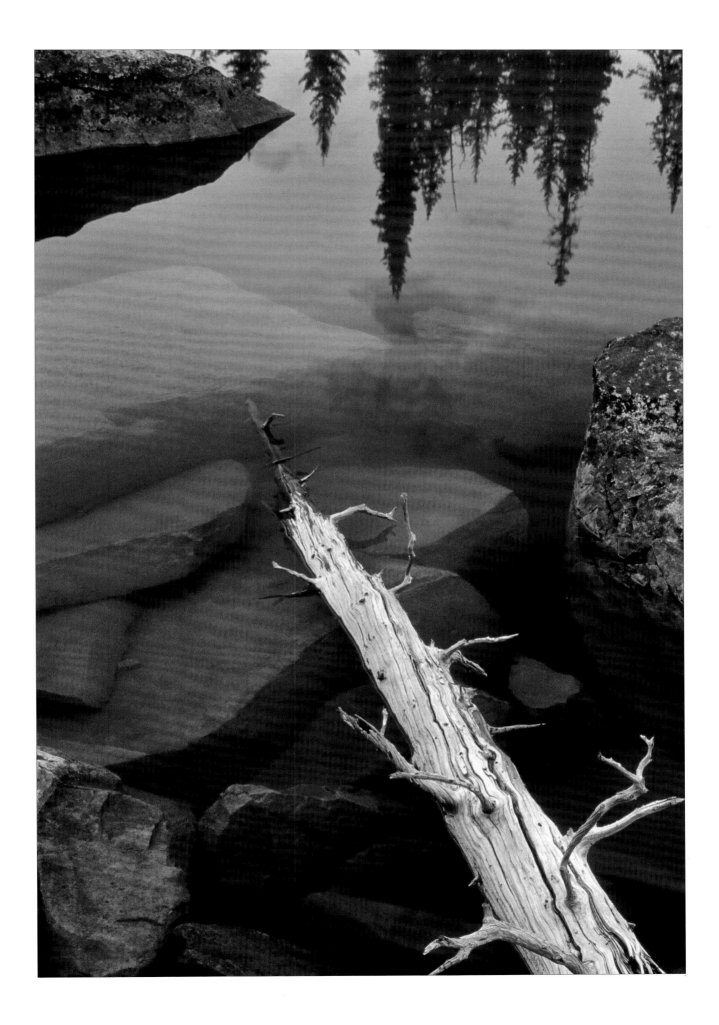

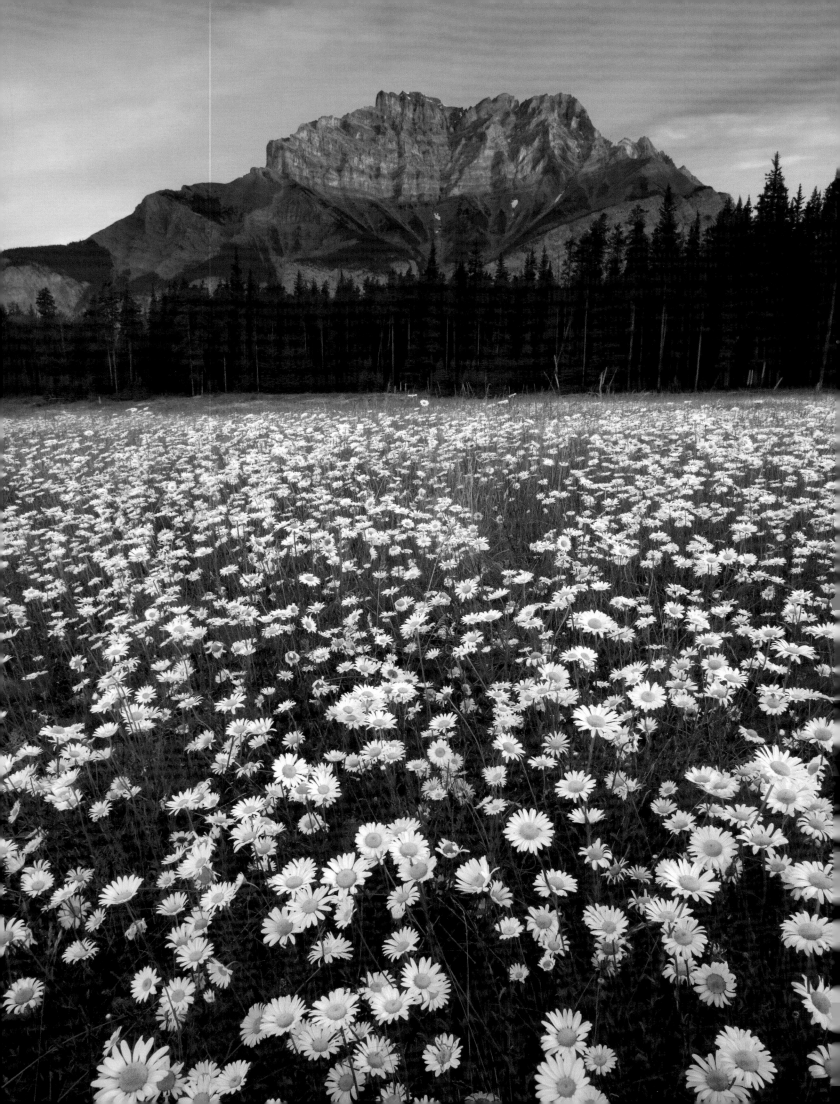

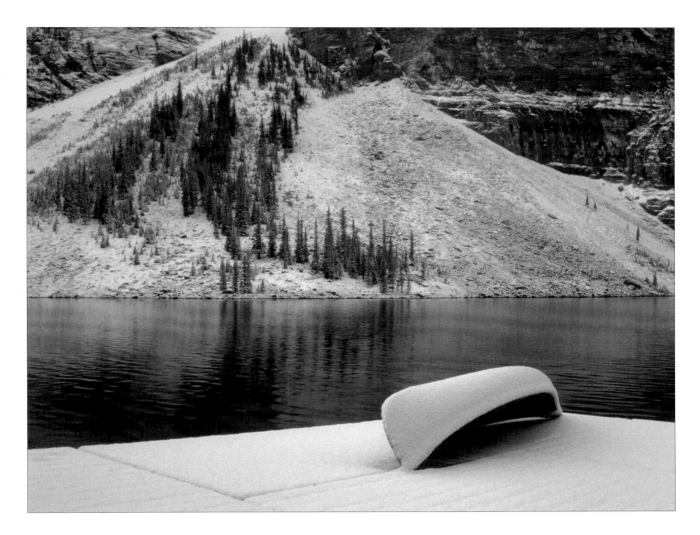

above
Moraine Lake
Banff National Park

opposite
Cascade Mountain
Banff National Park

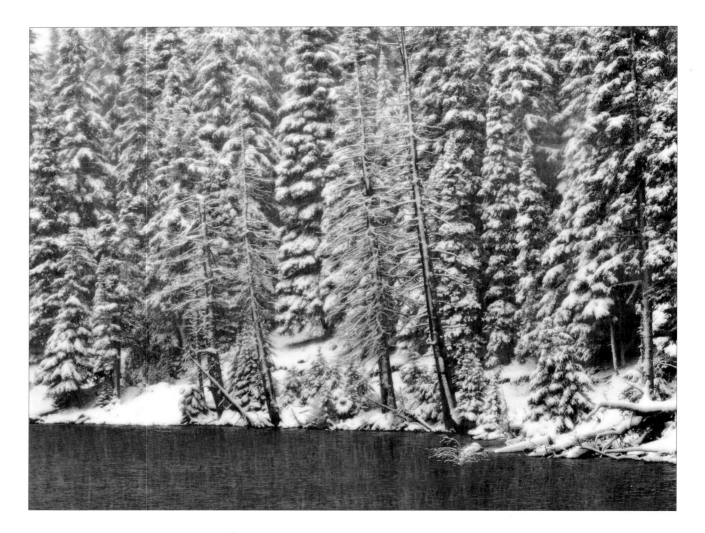

above
Elbow Lake
Kananaskis Country

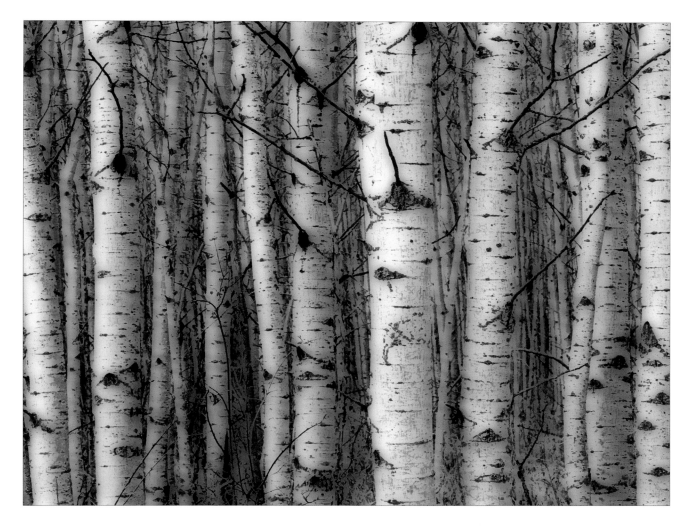

above
Aspen forest
Kananaskis Country

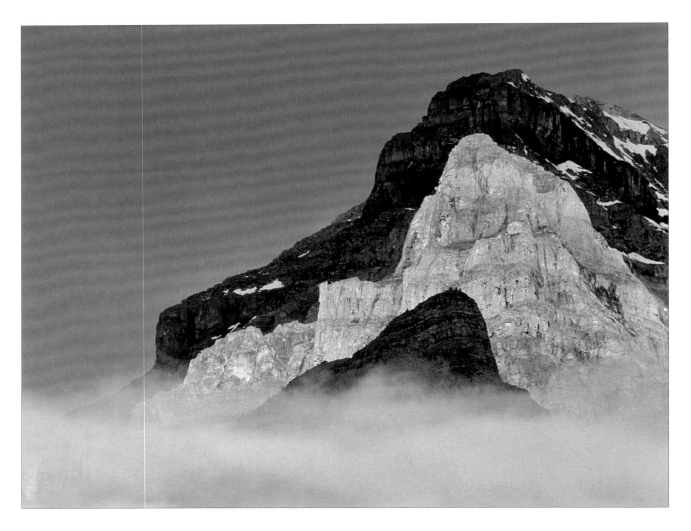

above
Big Beehive, Devil's Thumb, and Mount Whyte
Banff National Park

opposite
Mount Rundle over Two Jack Lake
Banff National Park

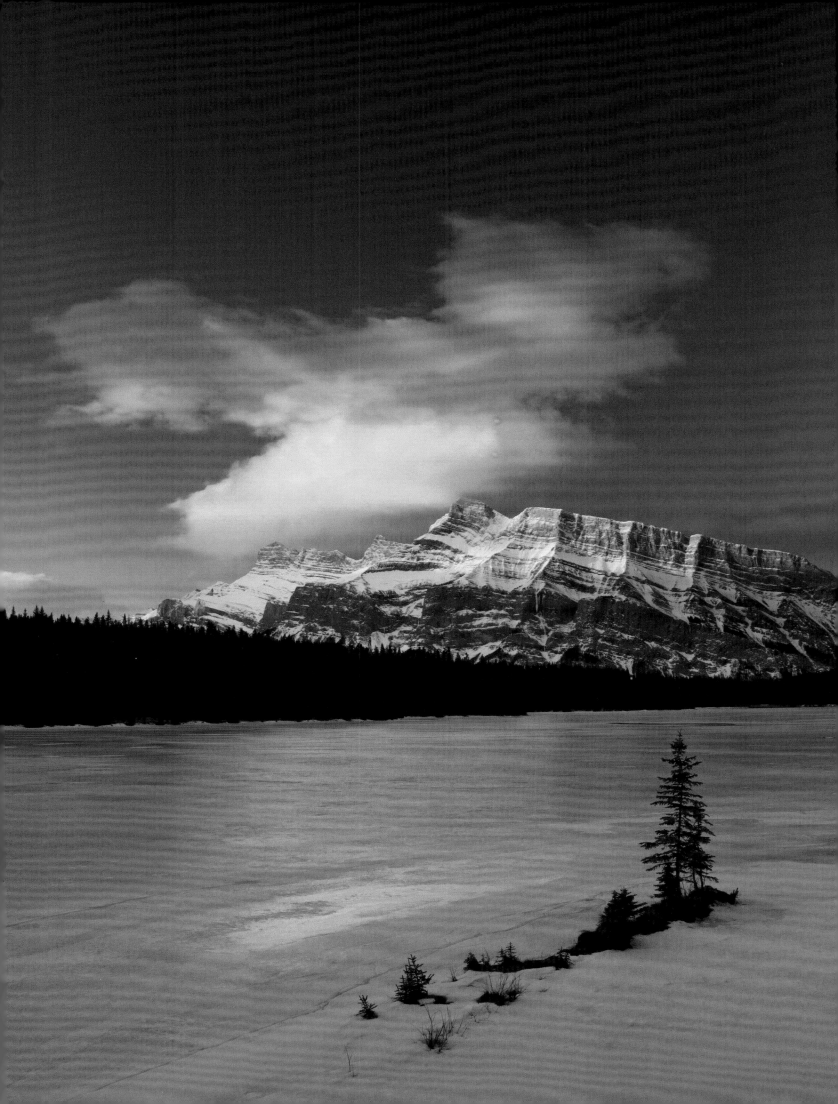

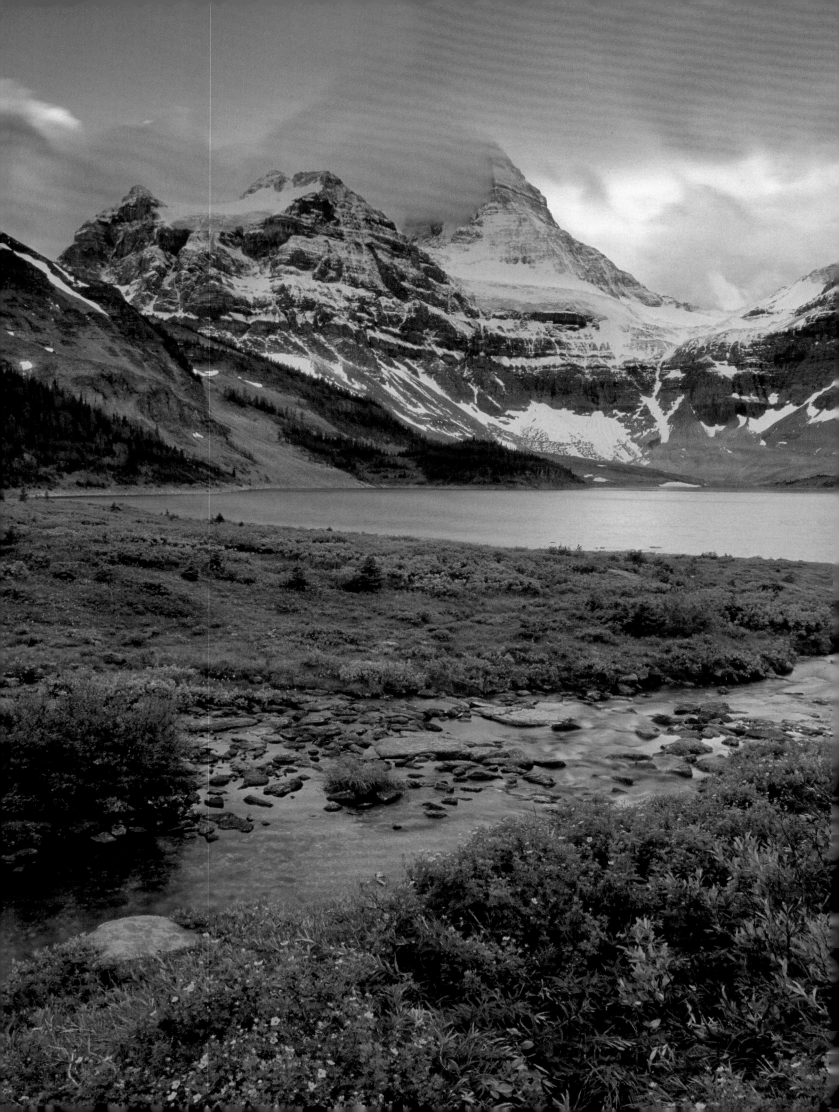

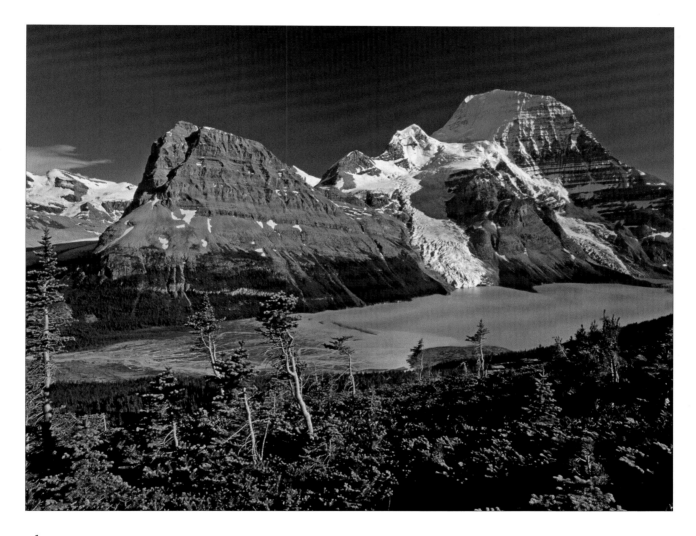

above
Mount Robson over Berg Lake
Mount Robson Provincial Park

opposite
Mount Assiniboine over Lake Magog
Mount Assiniboine Provincial Park

following page, left
Mount Kitchener
Jasper National Park

following page, right
The DeSmet Range and Moberly Flats
Jasper National Park

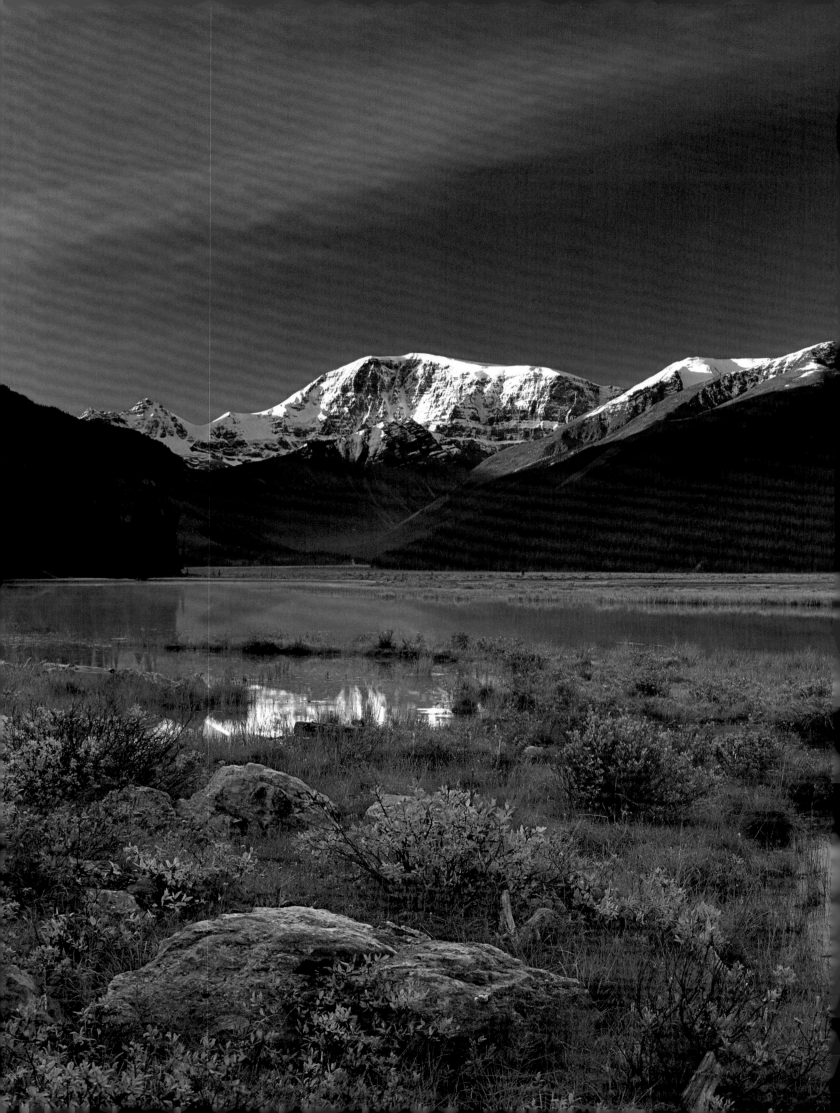

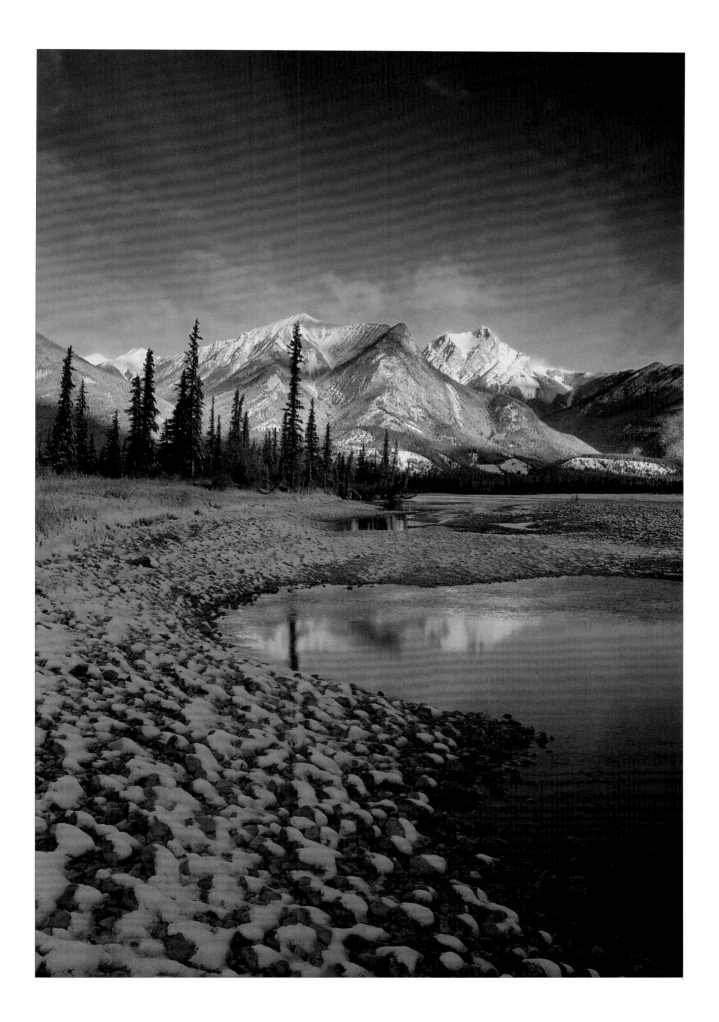

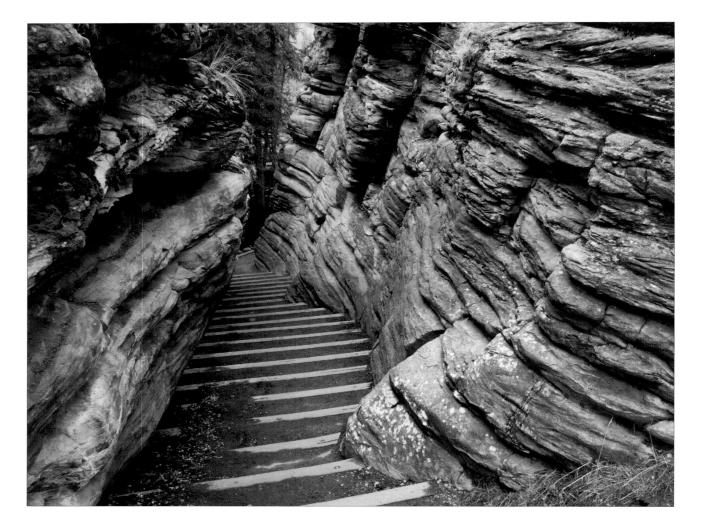

above
Pathway below Athabasca Falls
Jasper National Park

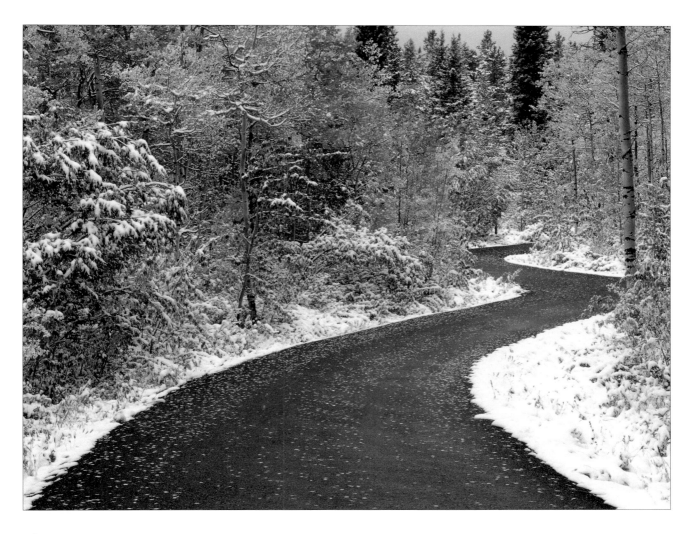

above
Road to Barrier Lake Day Use Area
Kananaskis Country

following pages
Aspen trees and fireweed
Kananaskis Country

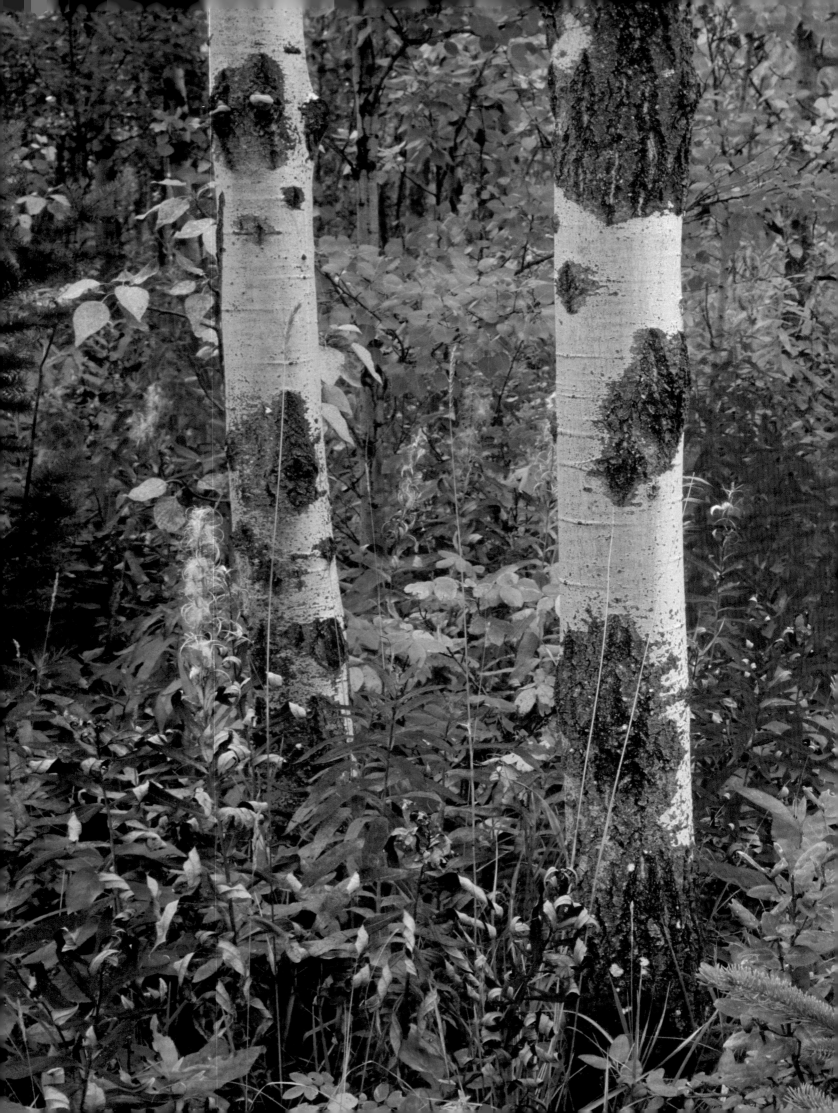

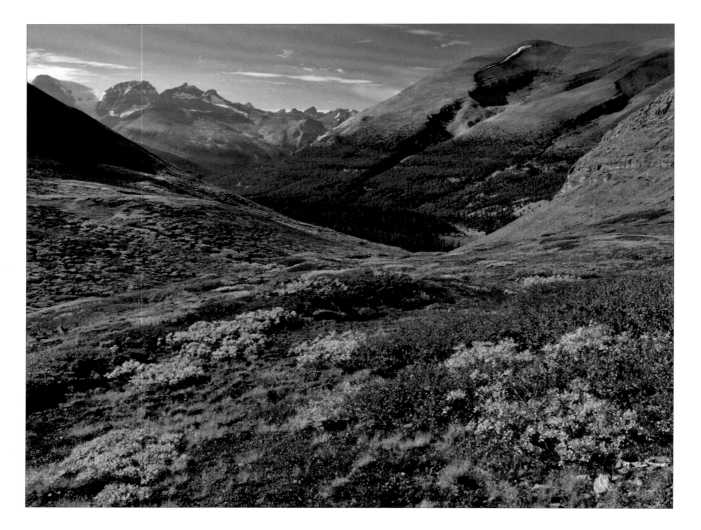

above
Wilcox Pass
Jasper National Park

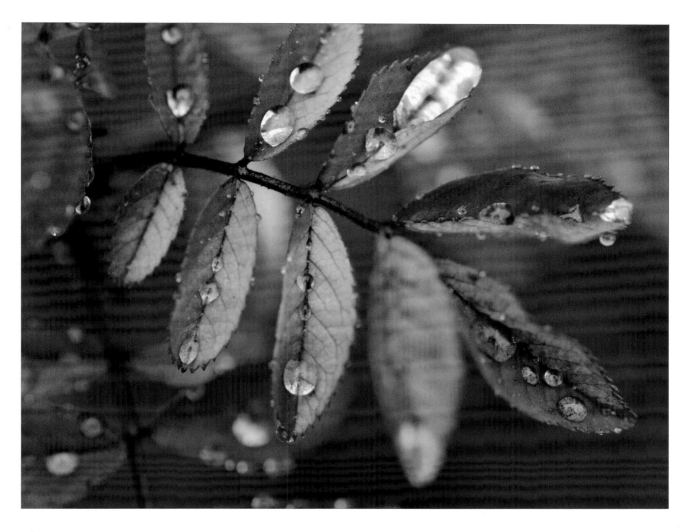

above
Wild rose leaves
Kananaskis Country

following page, left
Angel Glacier
Jasper National Park

following page, right
The Ramparts over Tonquin Valley
Jasper National Park

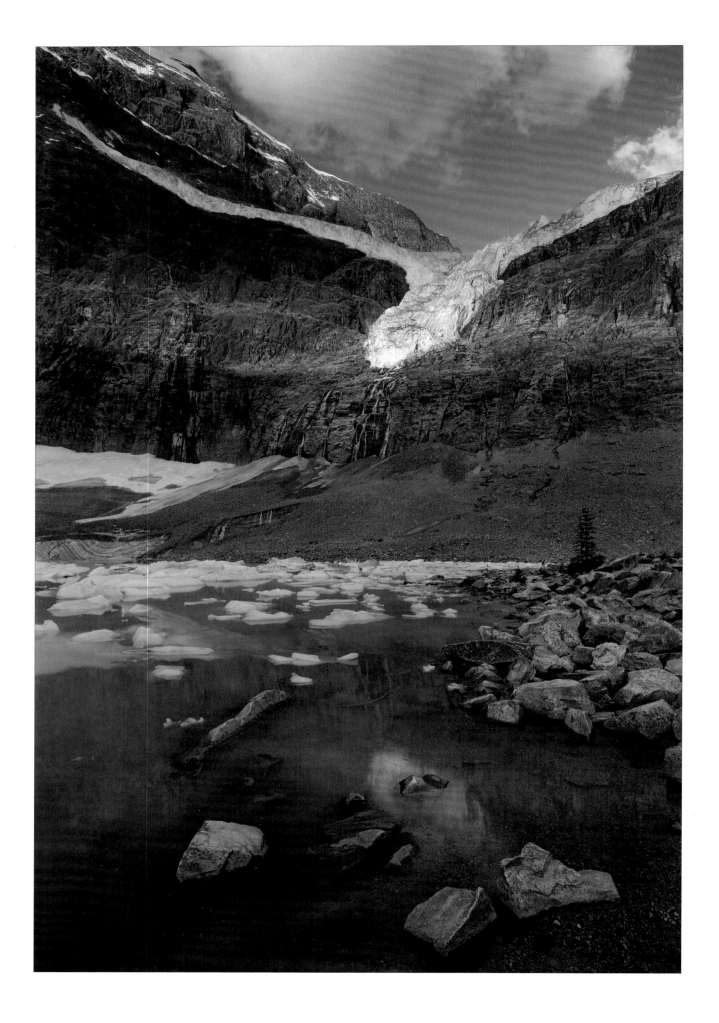

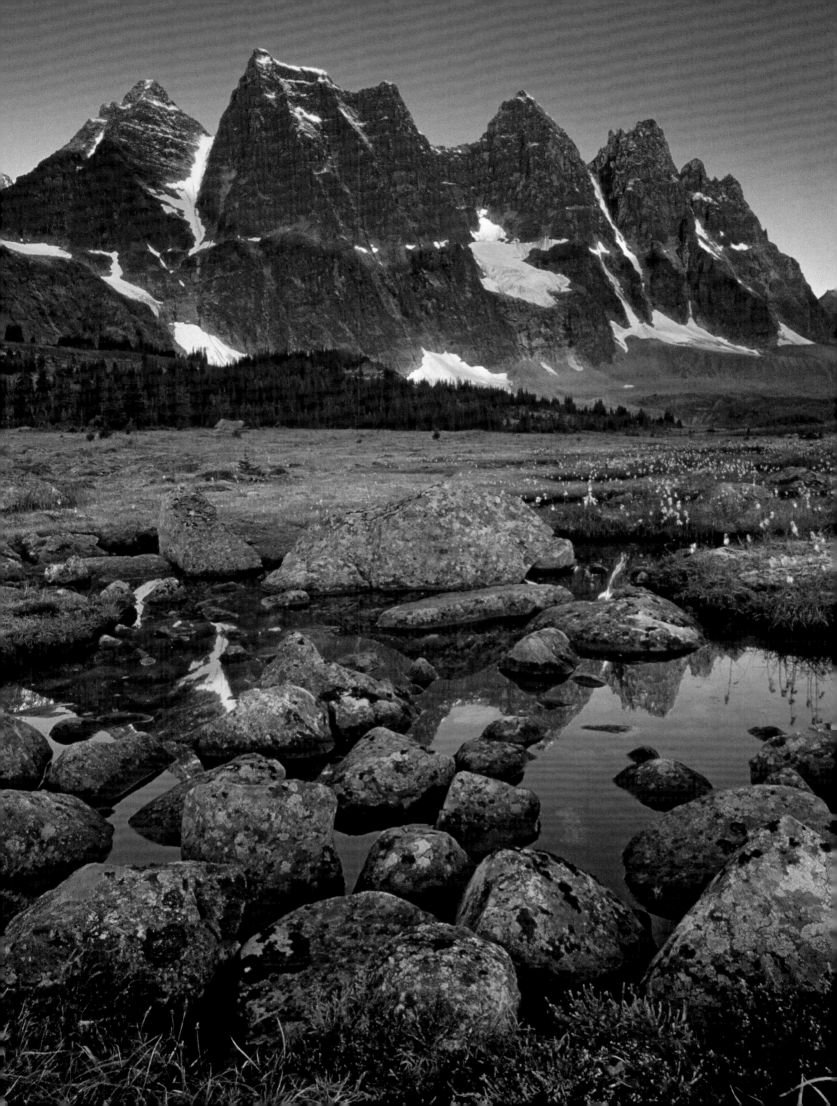

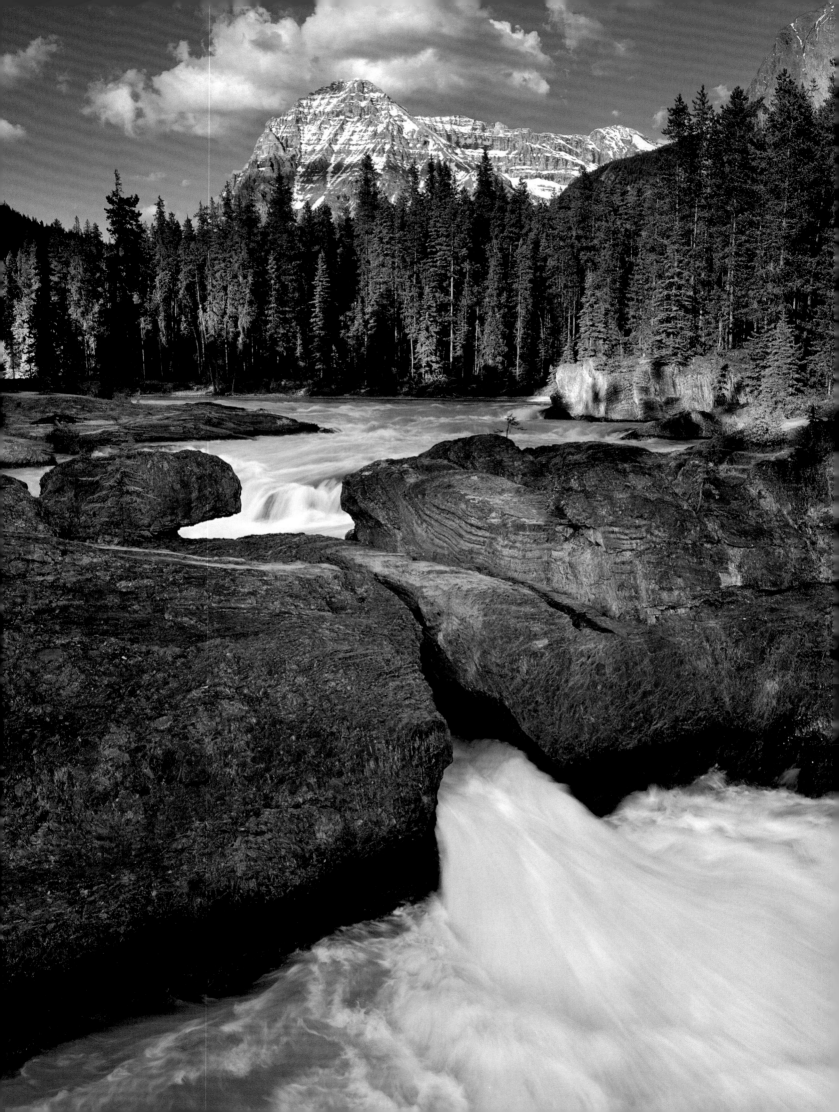

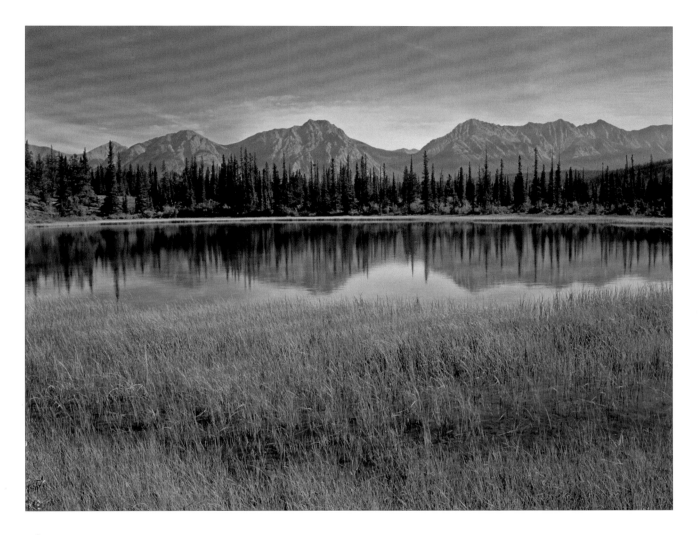

above
The Ram Range from Whirlpool Point
Kootenay Plains

opposite
Mount Stephen over the Natural Bridge
Yoho National Park

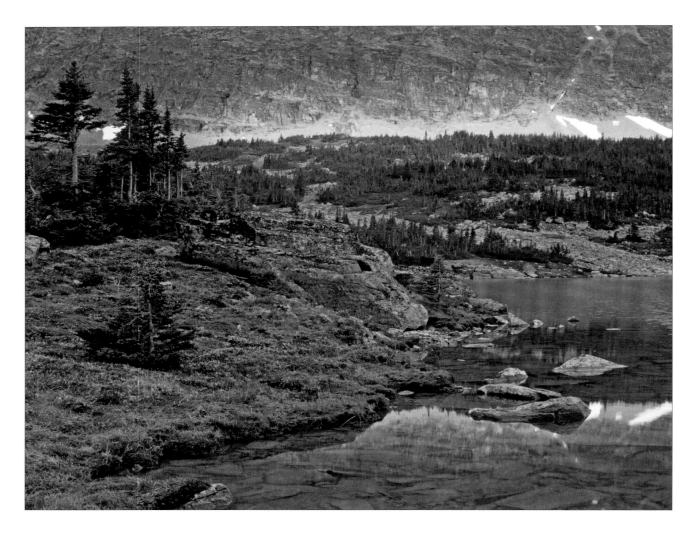

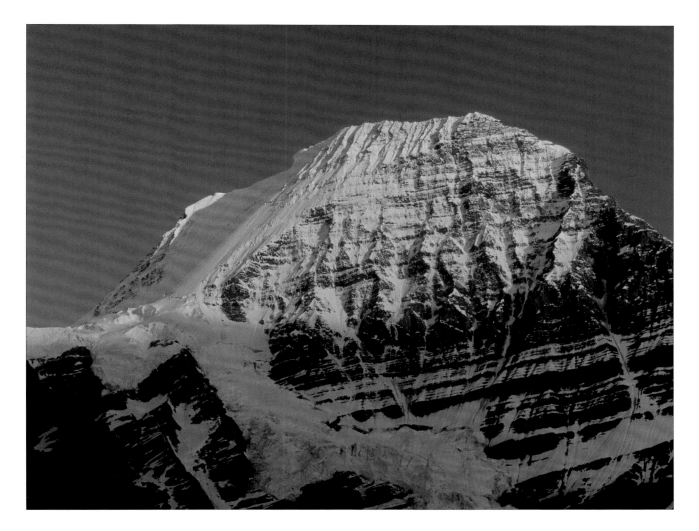

above
Mount Robson
Mount Robson Provincial Park

following pages
Quartzite boulder with lichens
Jasper National Park

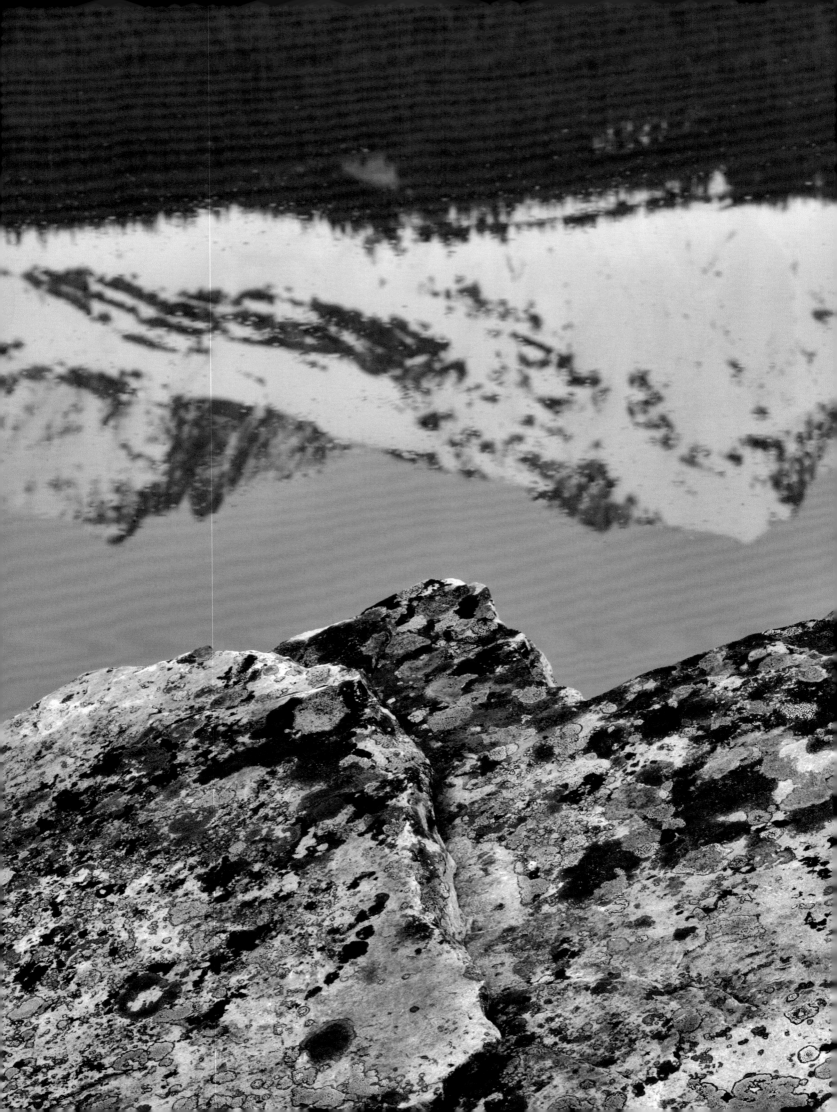

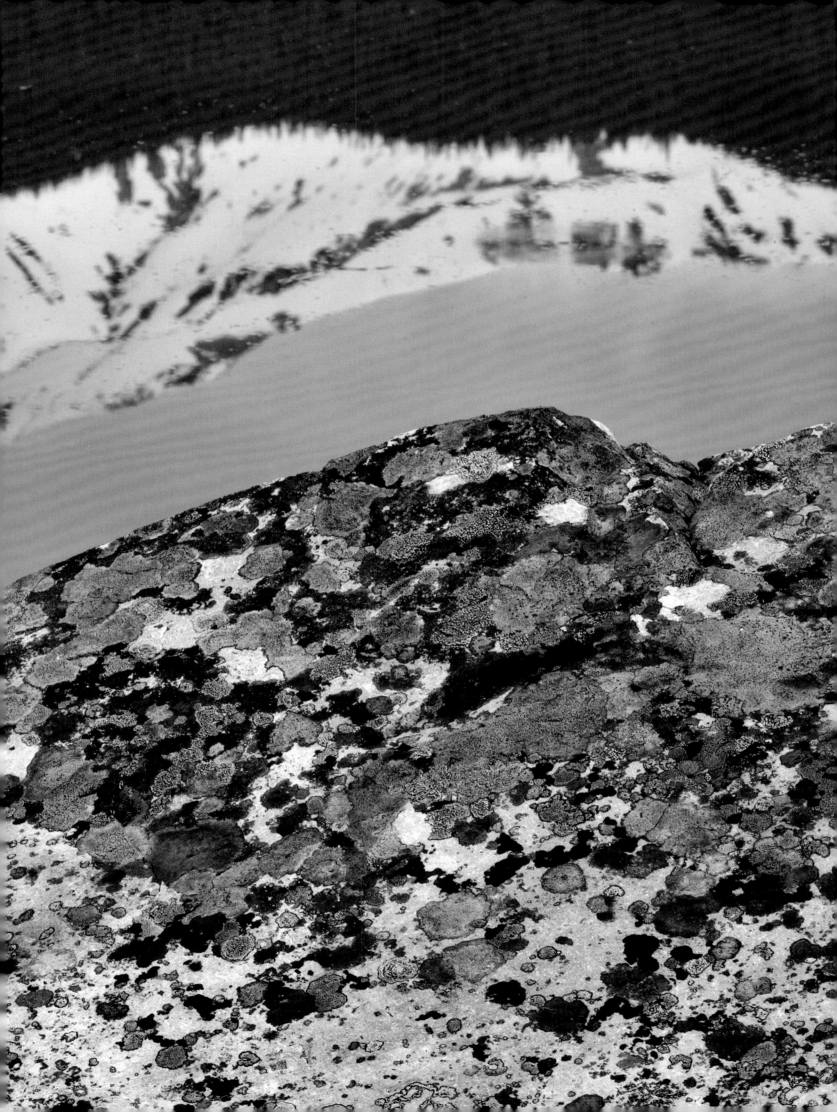

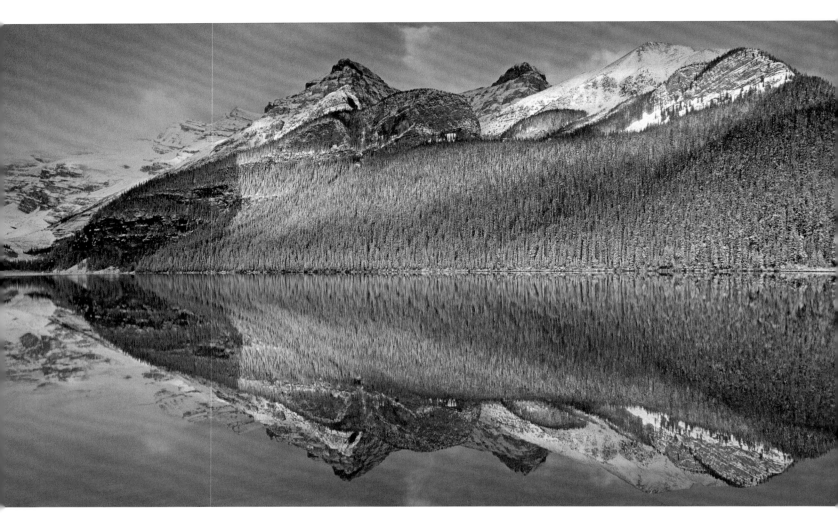

above
Lake Louise
Banff National Park

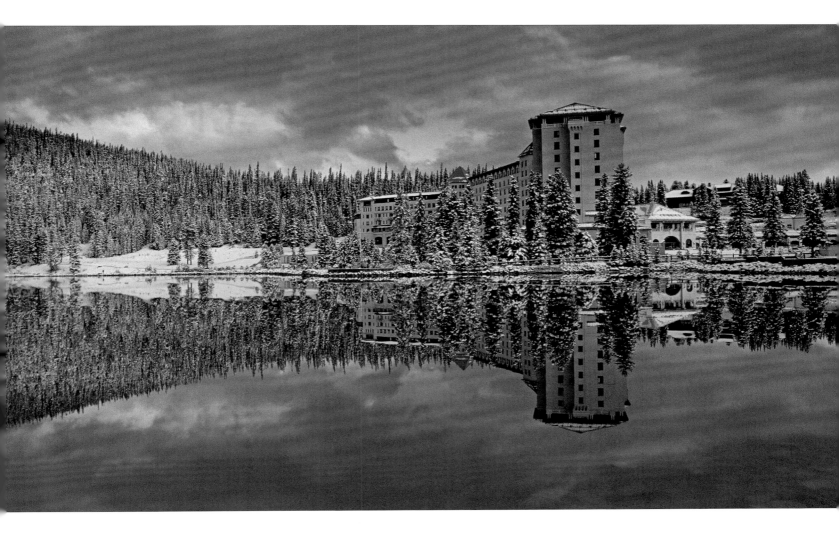

following page, left
Arrowleaf balsam root
Waterton Lakes National Park

following page, right
Glacier lilies in aspen forest
Waterton Lakes National Park

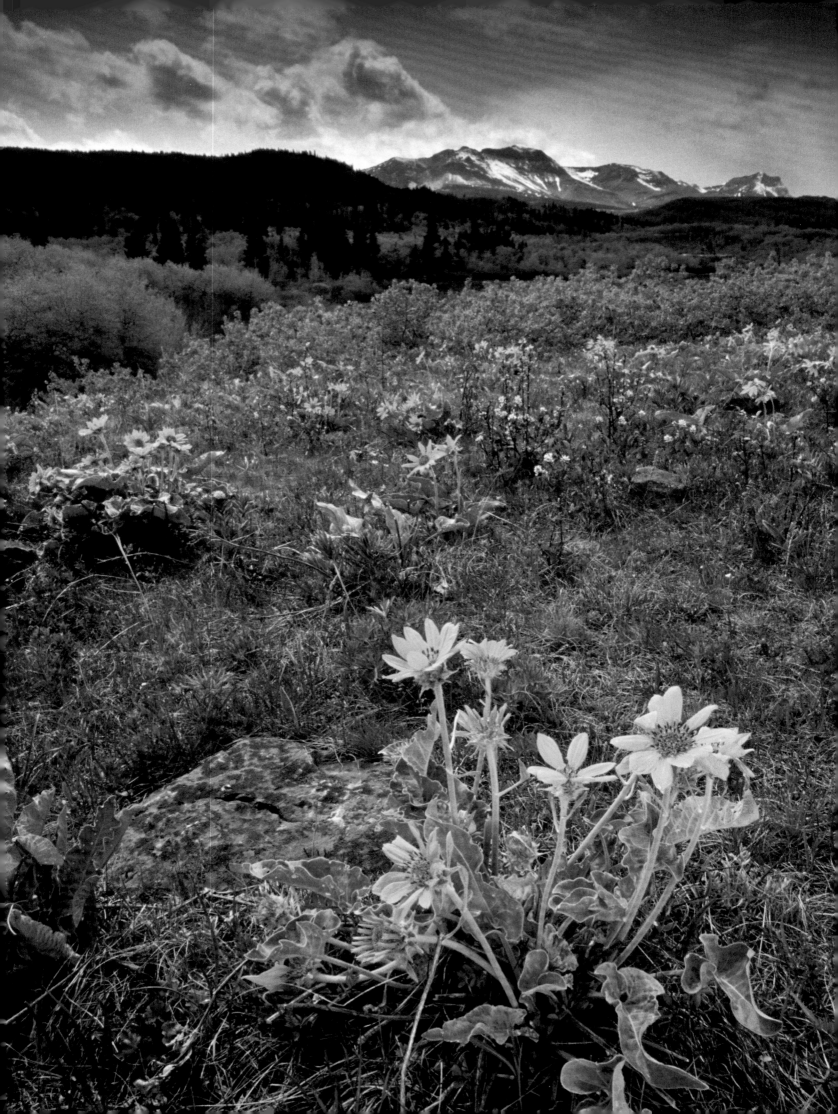

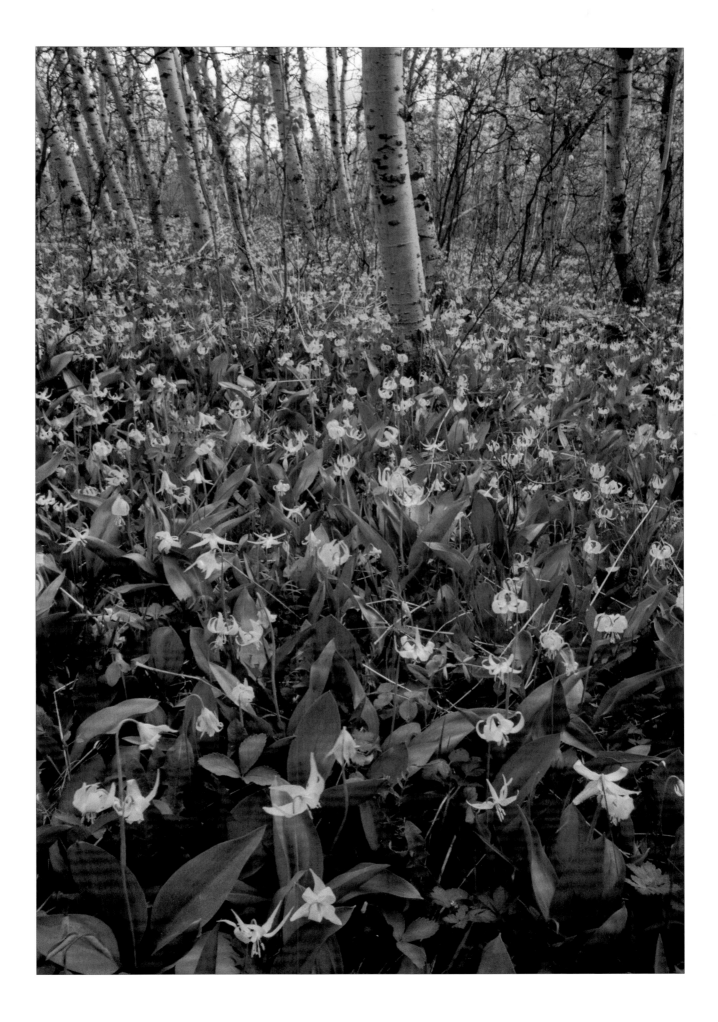

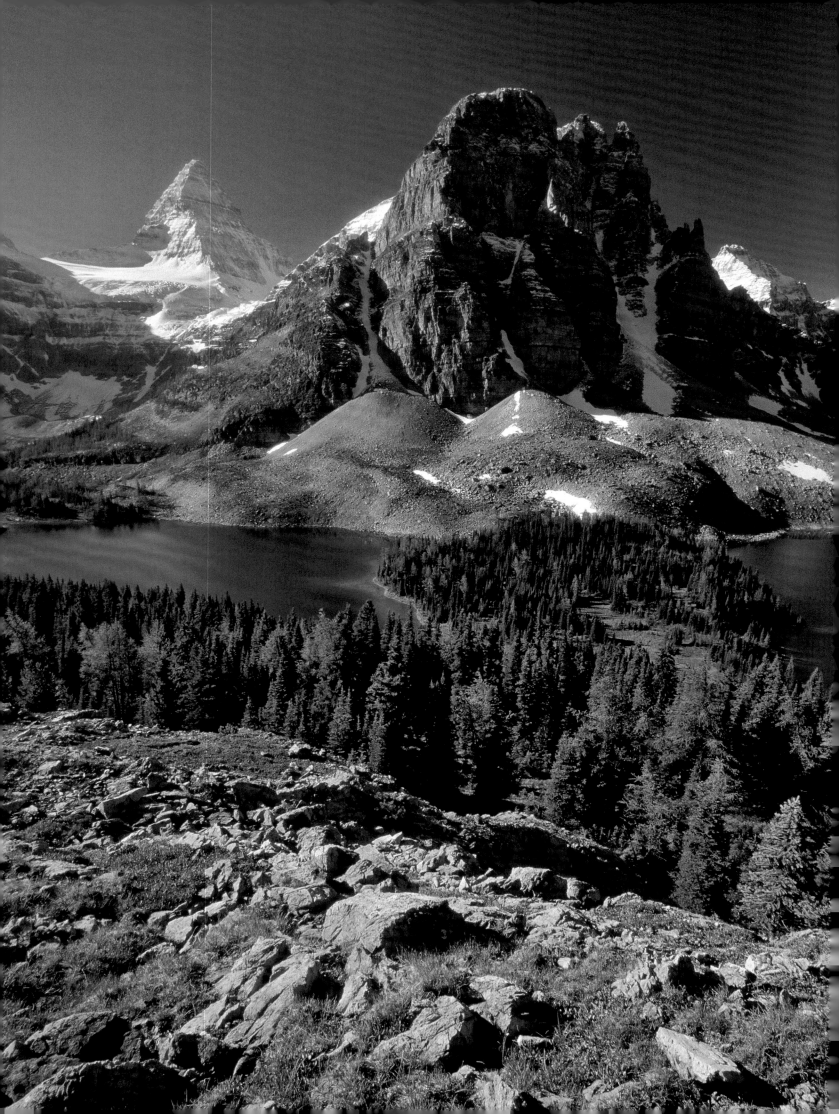

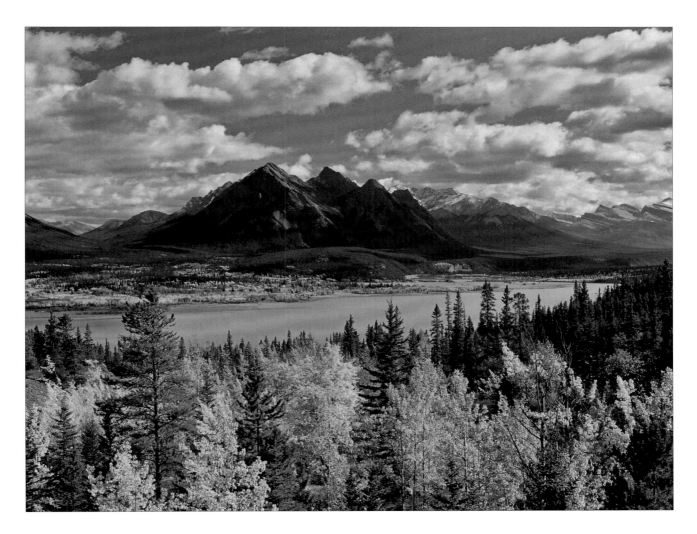

above
Lake Abraham
Kootenay Plains

opposite
The Nub and Mount Assiniboine
Mount Assiniboine Provincial Park

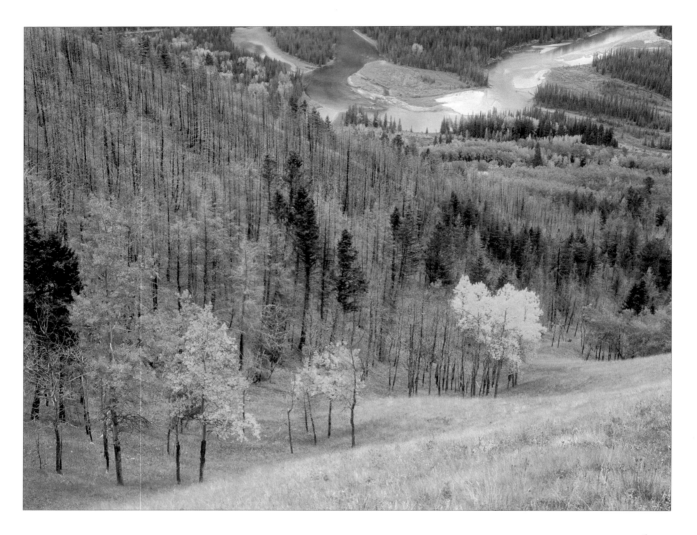

above
Bow River from Muleshoe trail
Banff National Park

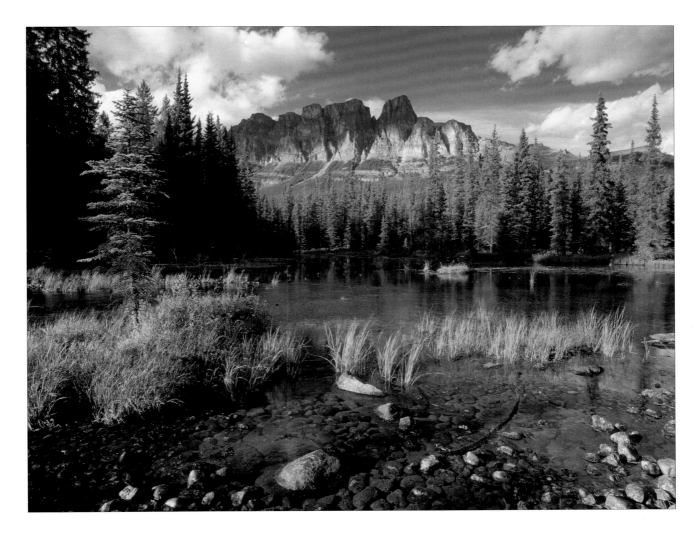

above
Castle Mountain
Banff National Park

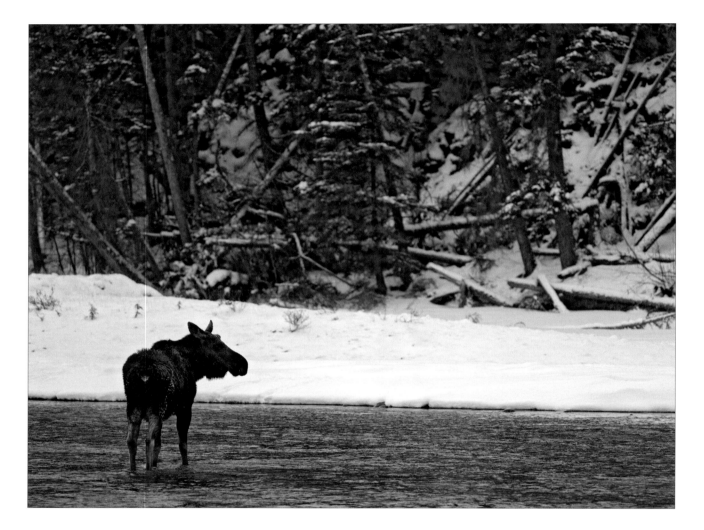

above
Moose in Athabasca River
Jasper National Park

opposite
Tangle Falls
Jasper National Park

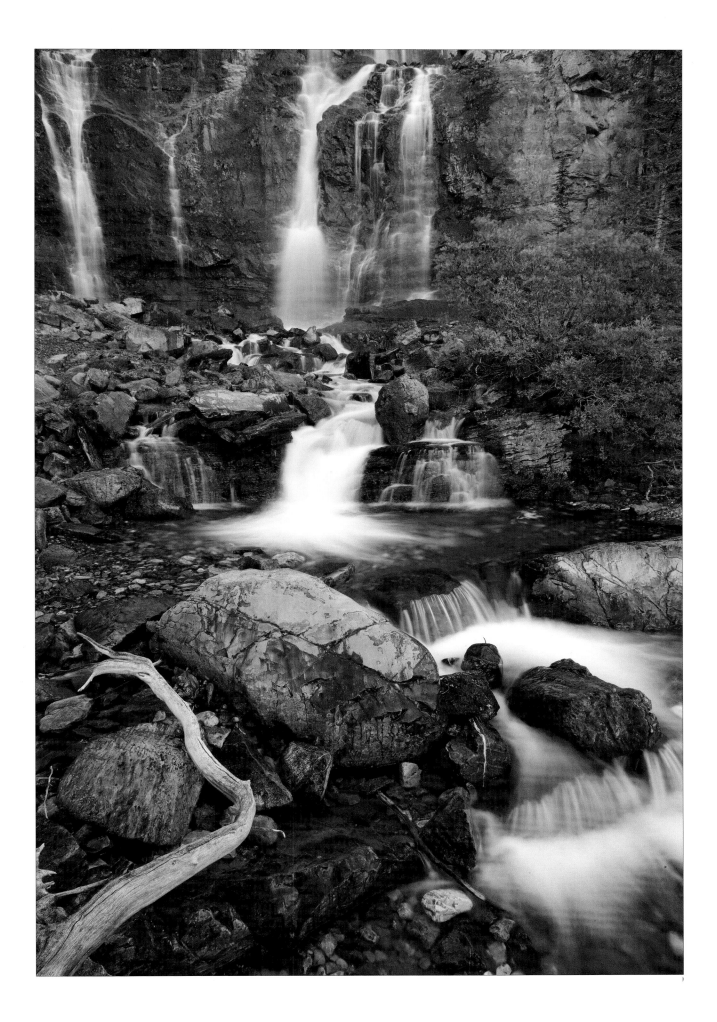

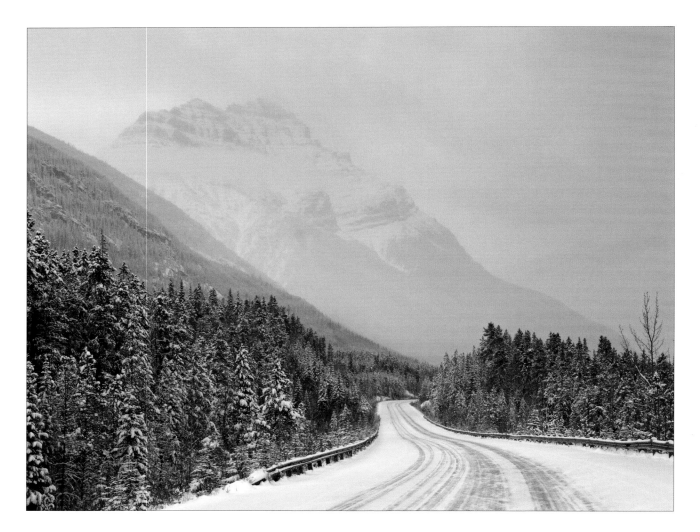

above
Mount Kerkeslin and the Icefields Parkway
Jasper National Park

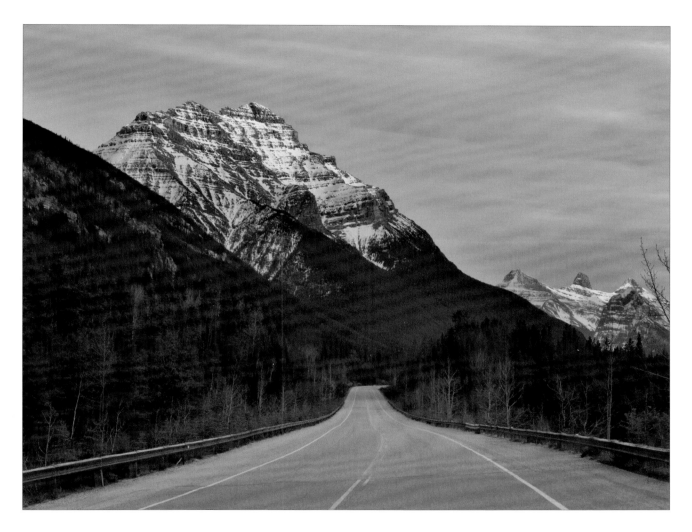

above
Mount Kerkeslin and the Icefields Parkway
Jasper National Park

following page, left
Mount Kidd
Kananaskis Country

following page, right
Maligne River and the Colin Range
Jasper National Park

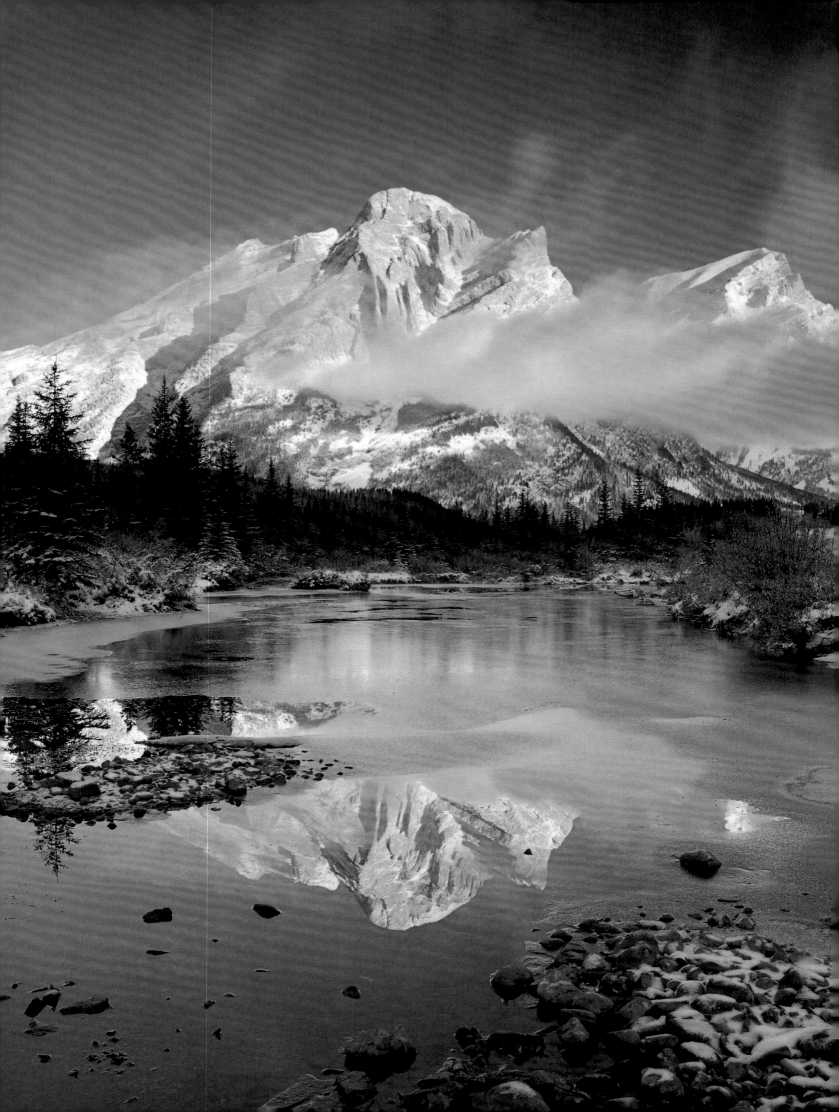

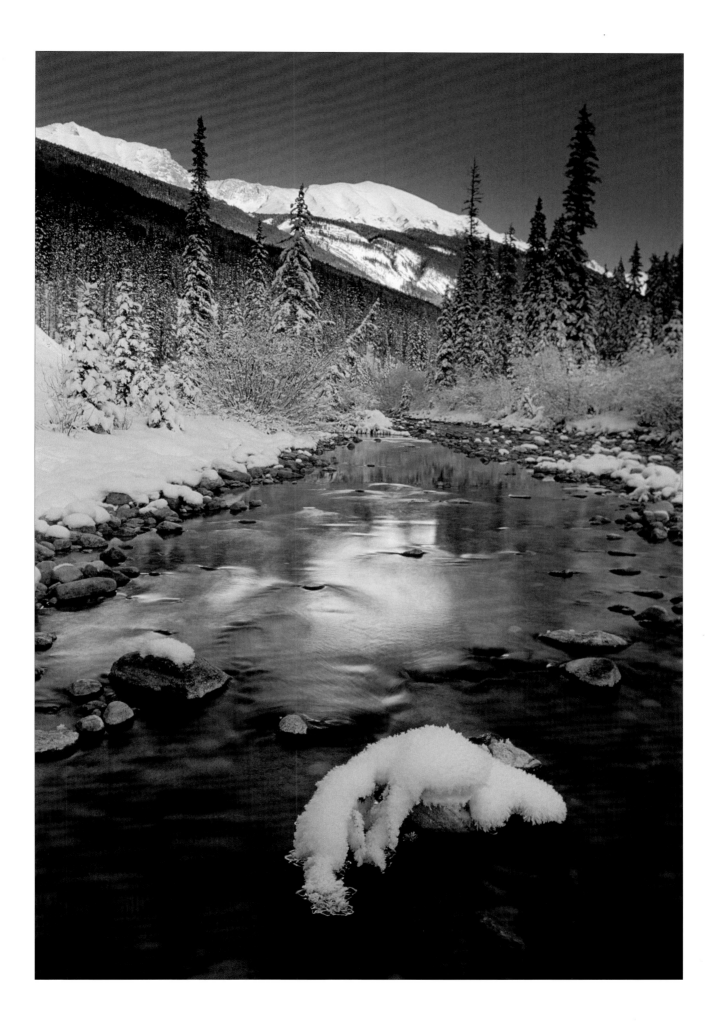

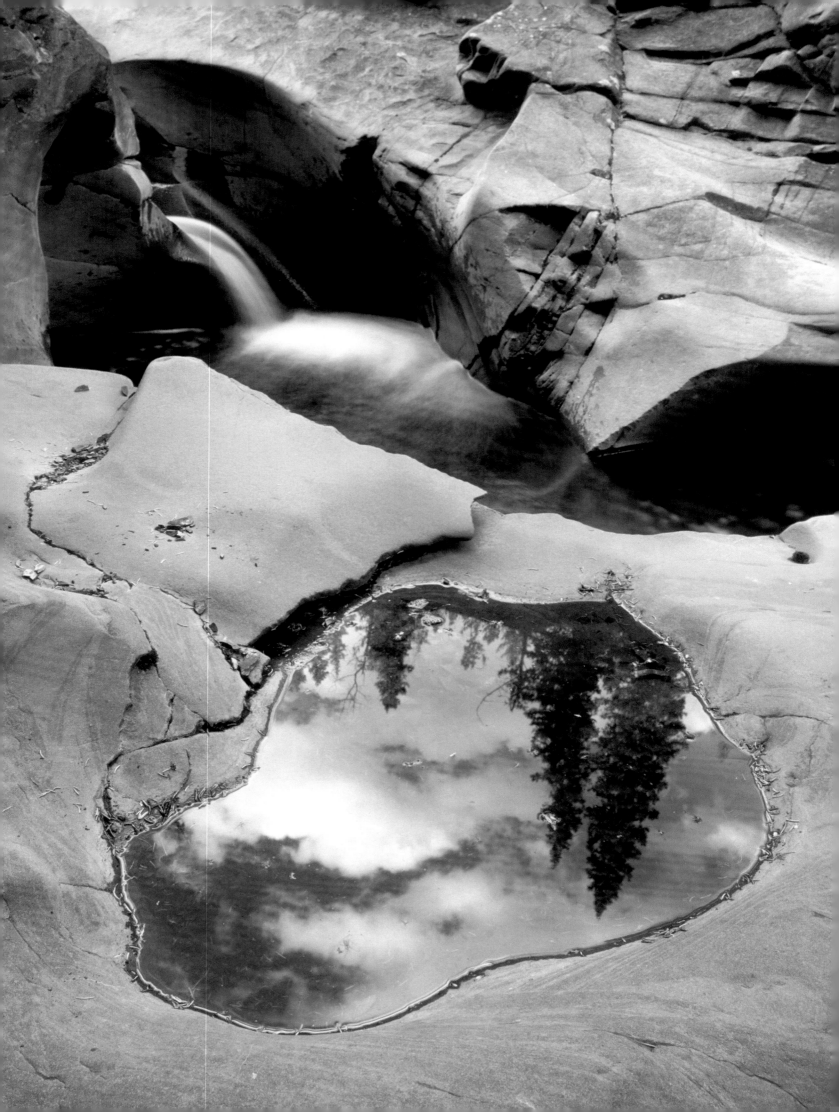

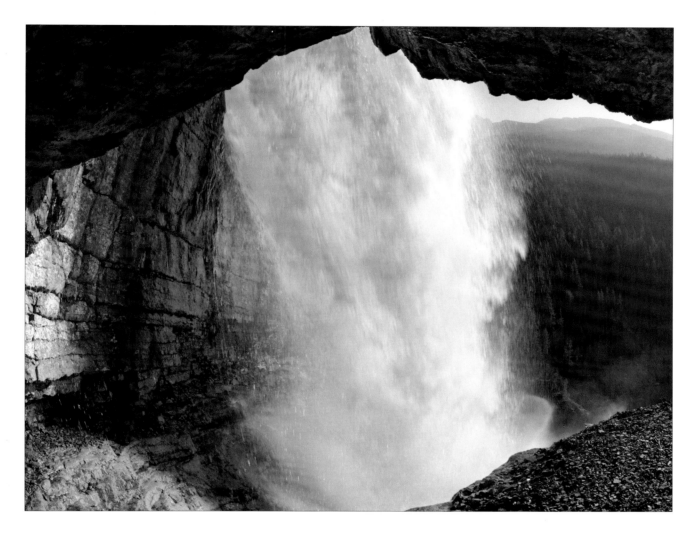

above
Panther Falls
Banff National Park

opposite
Blue Rock Creek
Kananaskis Country

following pages
Horseshoe Lake
Jasper National Park

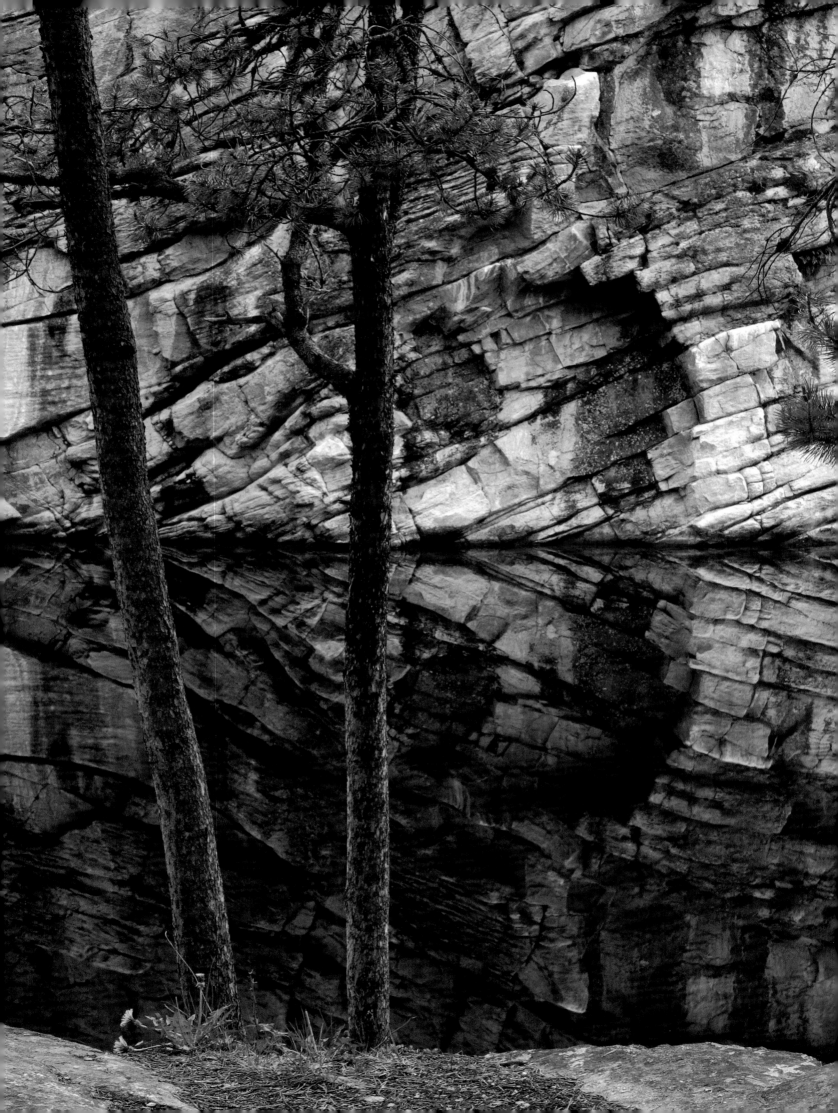

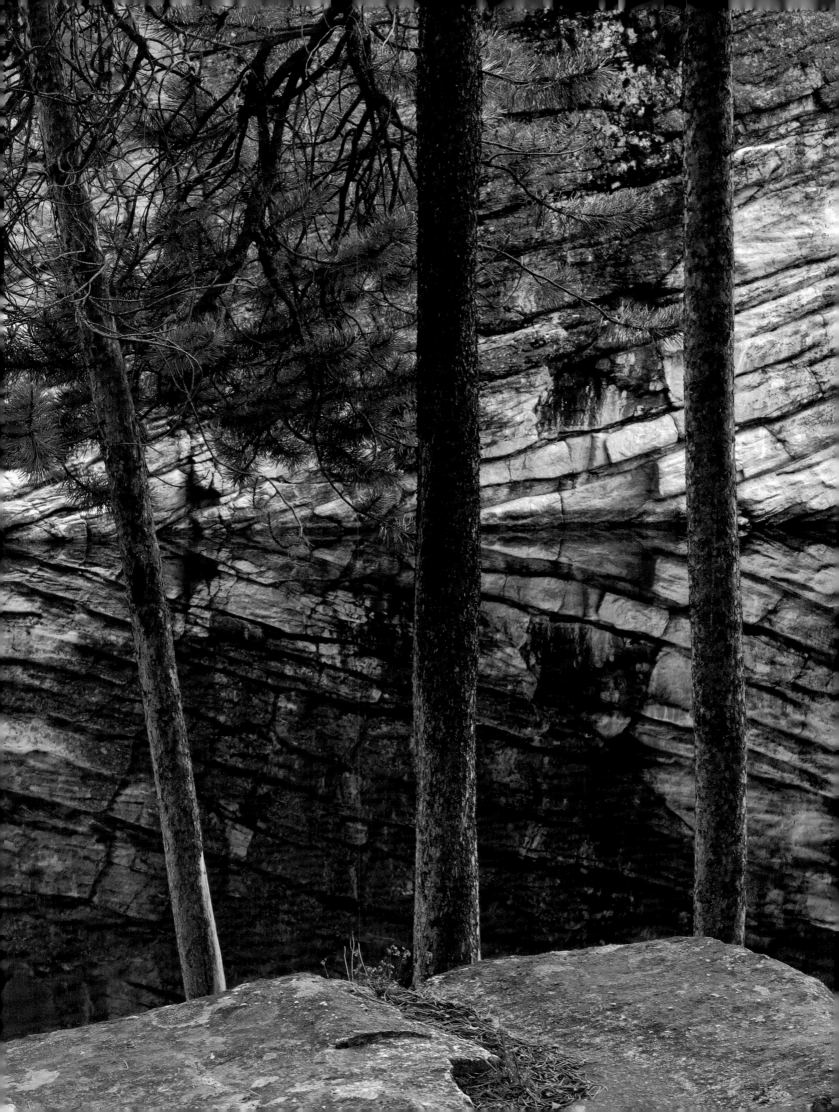

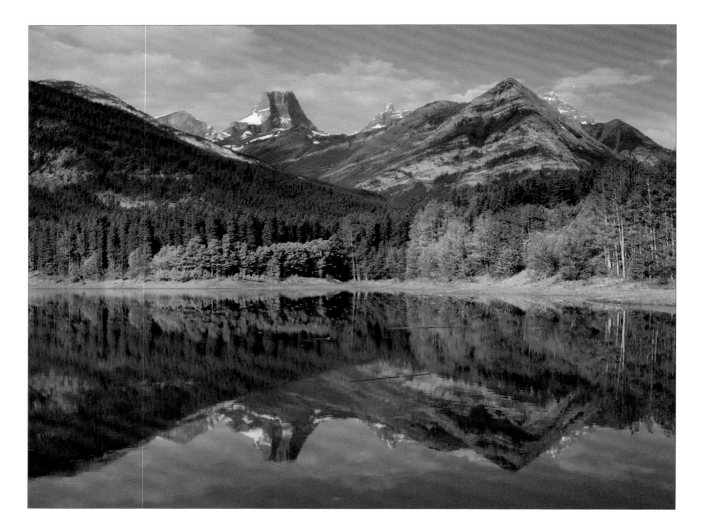

above
Wedge Pond
Kananaskis Country

opposite
Marsh near the Cave and Basin
Banff National Park

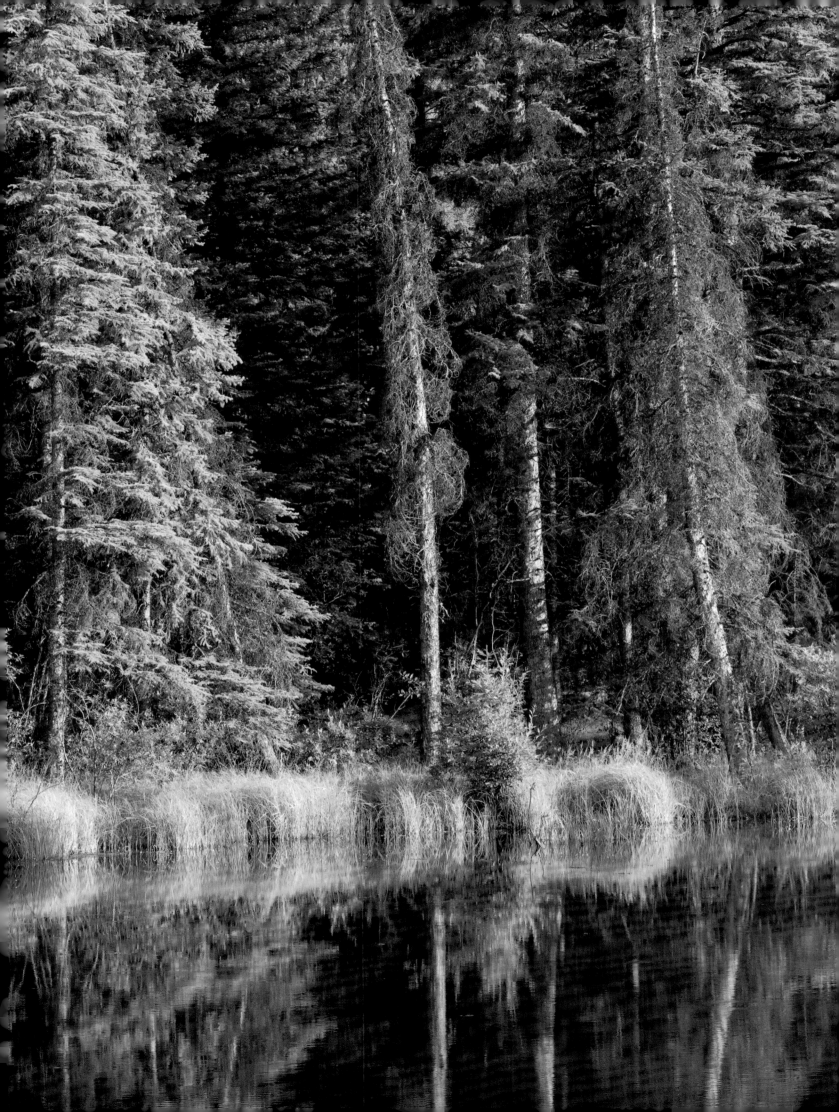

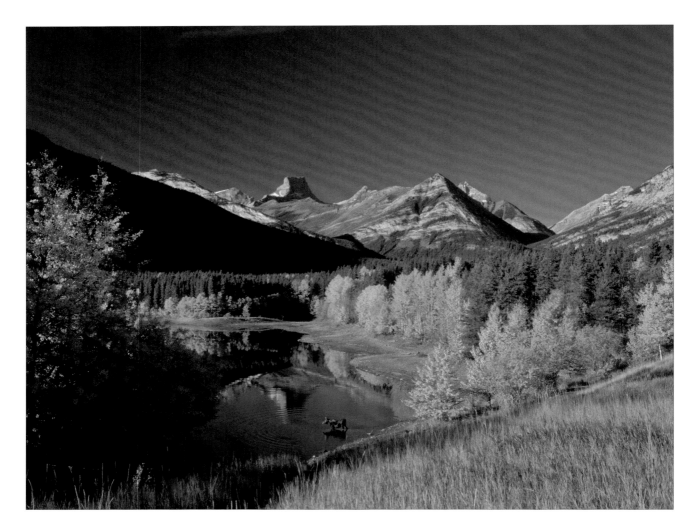

above
Moose in Wedge Pond
Kananaskis Country

opposite
Aspen
Kananaskis Country

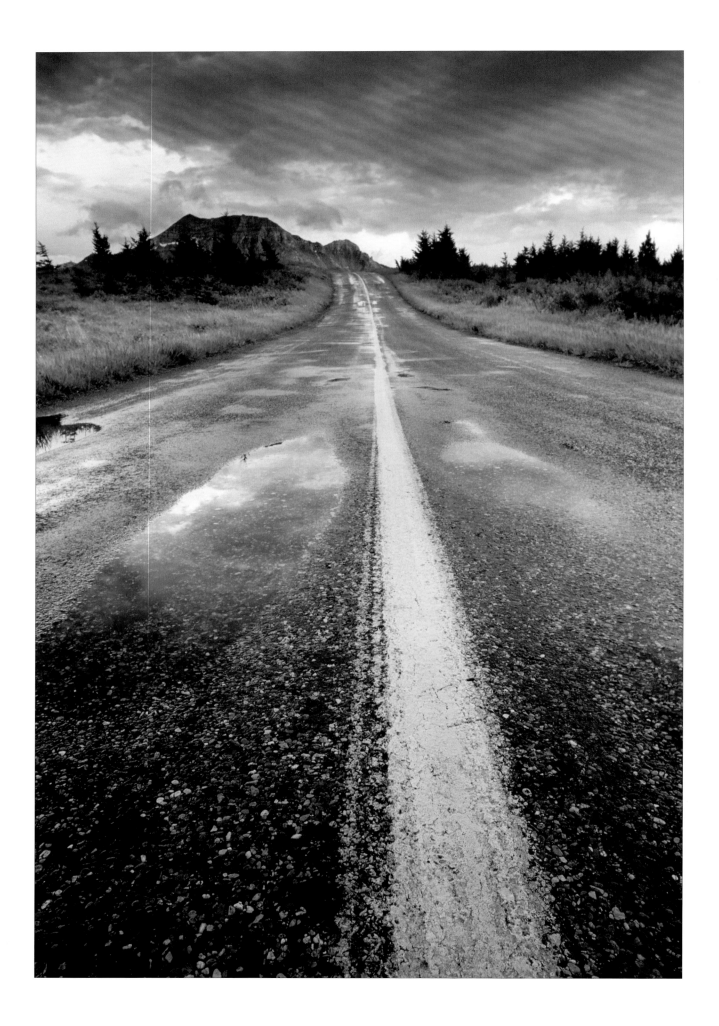

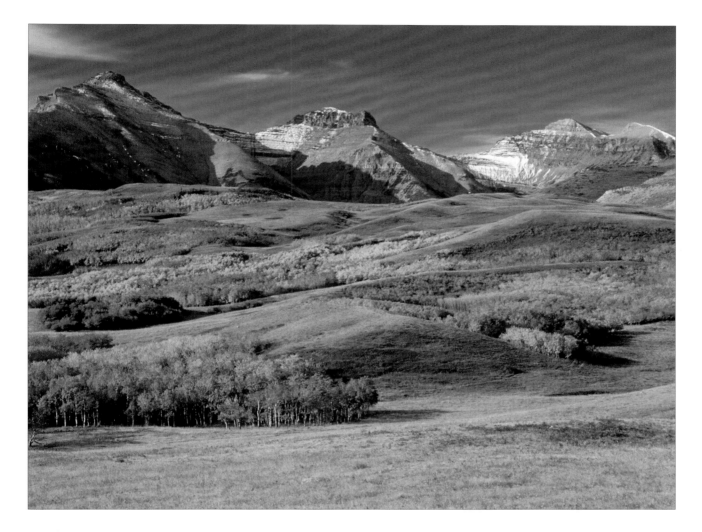

above
Cloudy Ridge
Near Waterton Lakes National Park

opposite
Red Rock Canyon Road
Waterton Lakes National Park

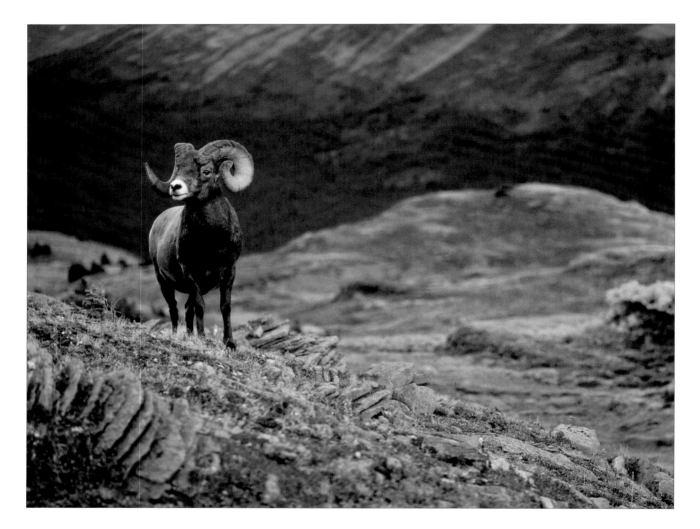

above
Rocky Mountain bighorn sheep in Wilcox Pass
Jasper National Park

opposite
Mount Amery
Banff National Park

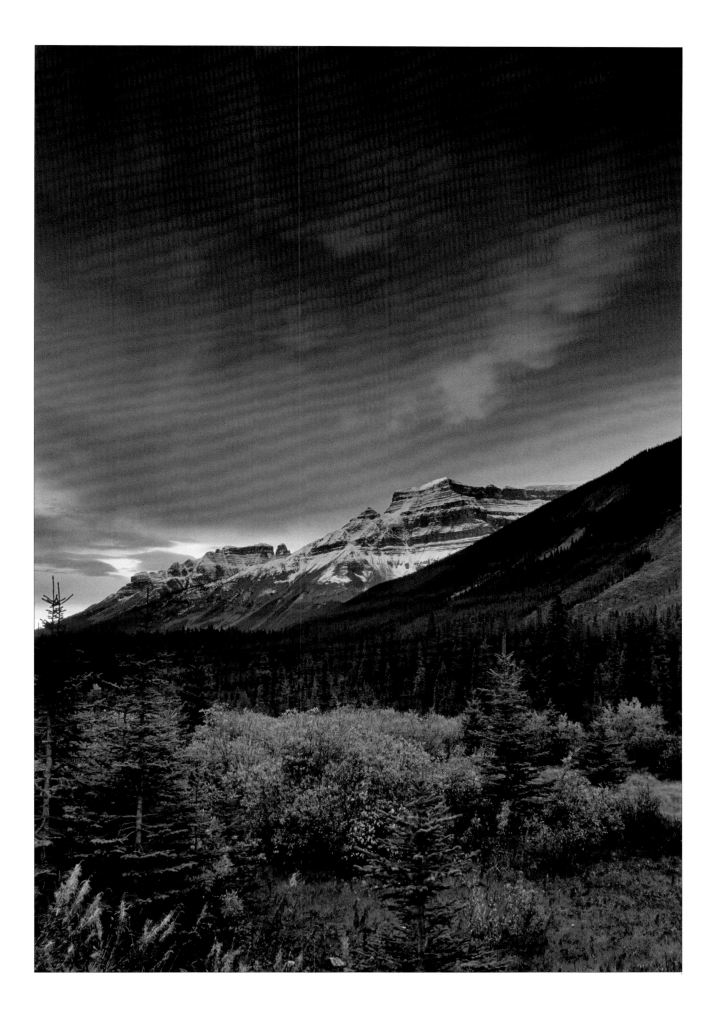

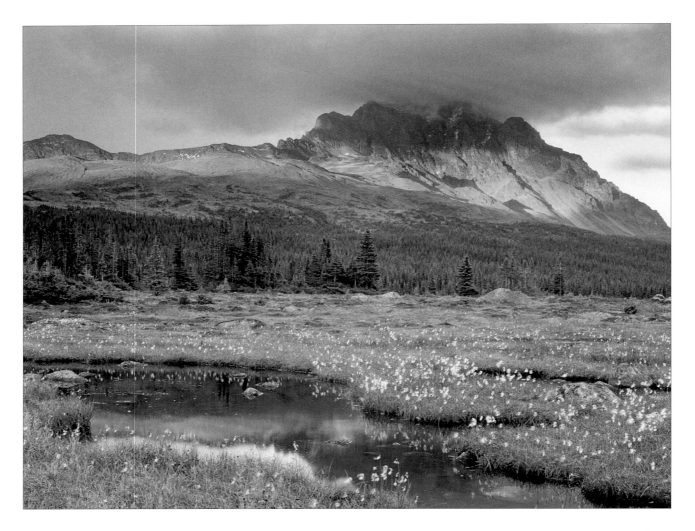

above
Mount Oldhorn in the Tonquin Valley
Jasper National Park

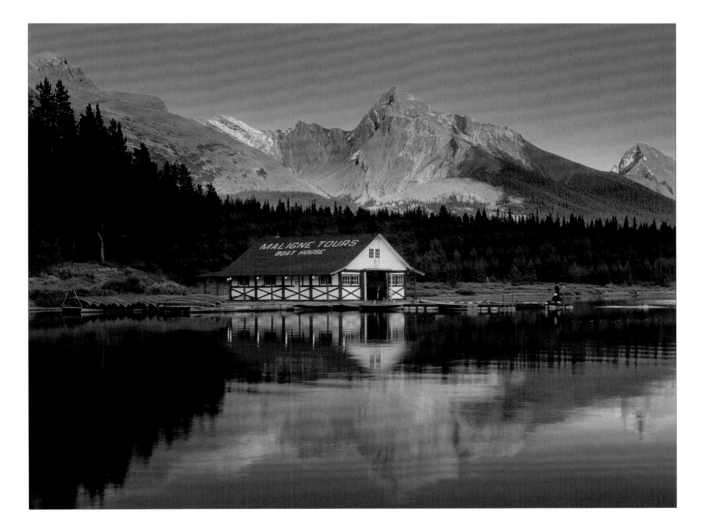

above
Maligne Lake
Jasper National Park

following page, left
Lake Louise
Banff National Park

following page, right
Mount Chephren
Banff National Park

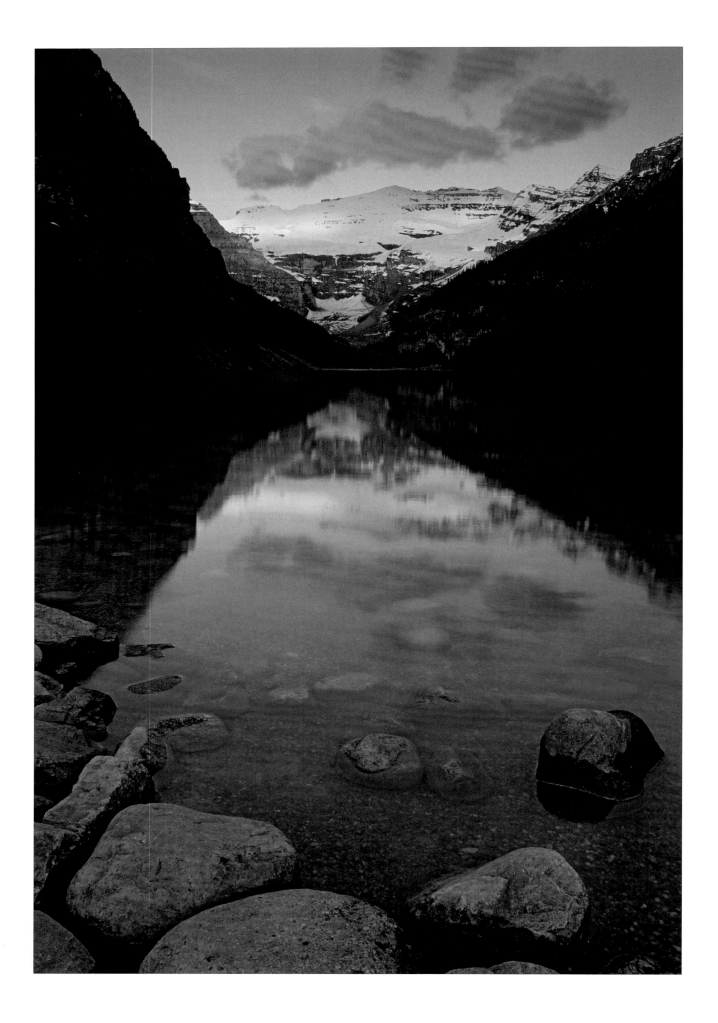

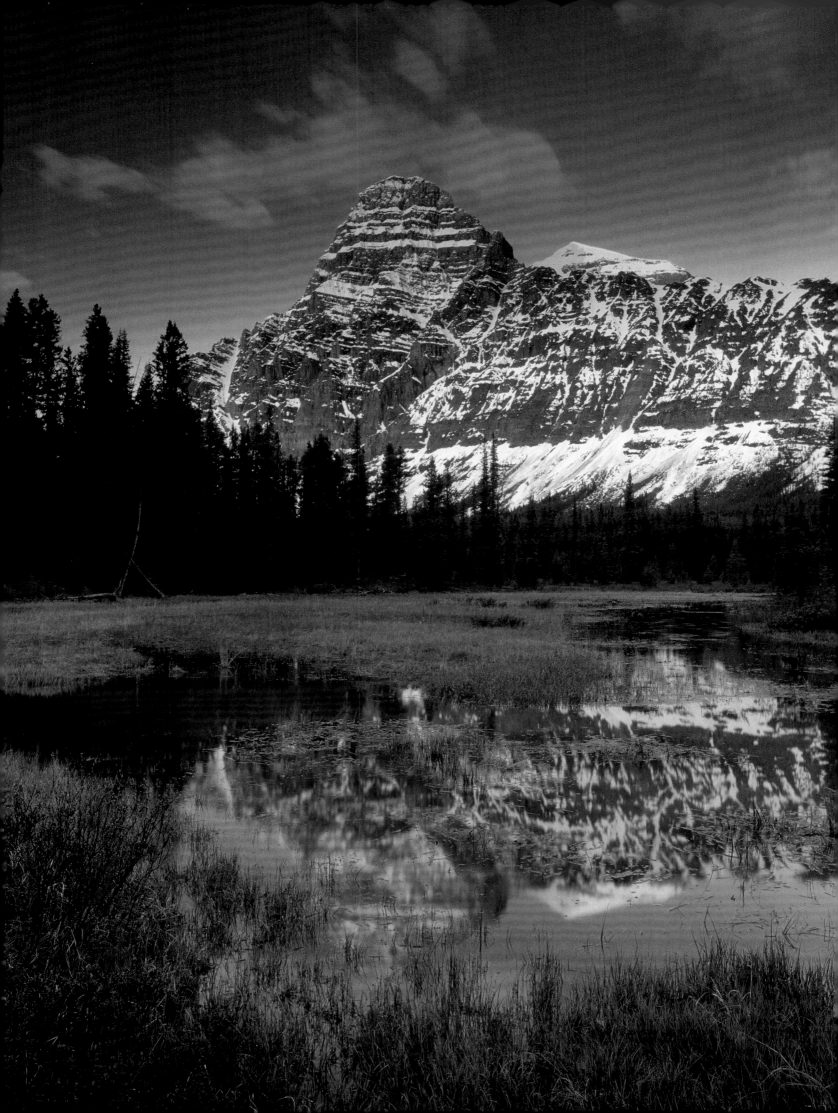

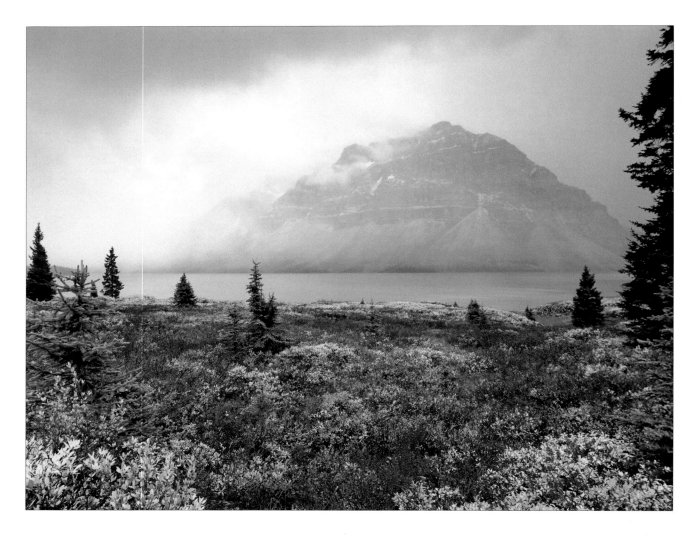

above
Bow Lake
Banff National Park

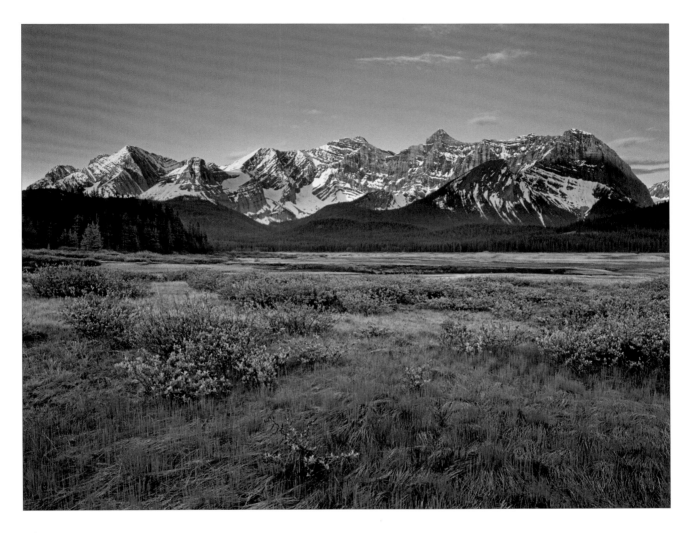

above
Meadow by Lower Kananaskis Lake
Kananaskis Country

following pages
Mount Kitchener reflection
Jasper National Park

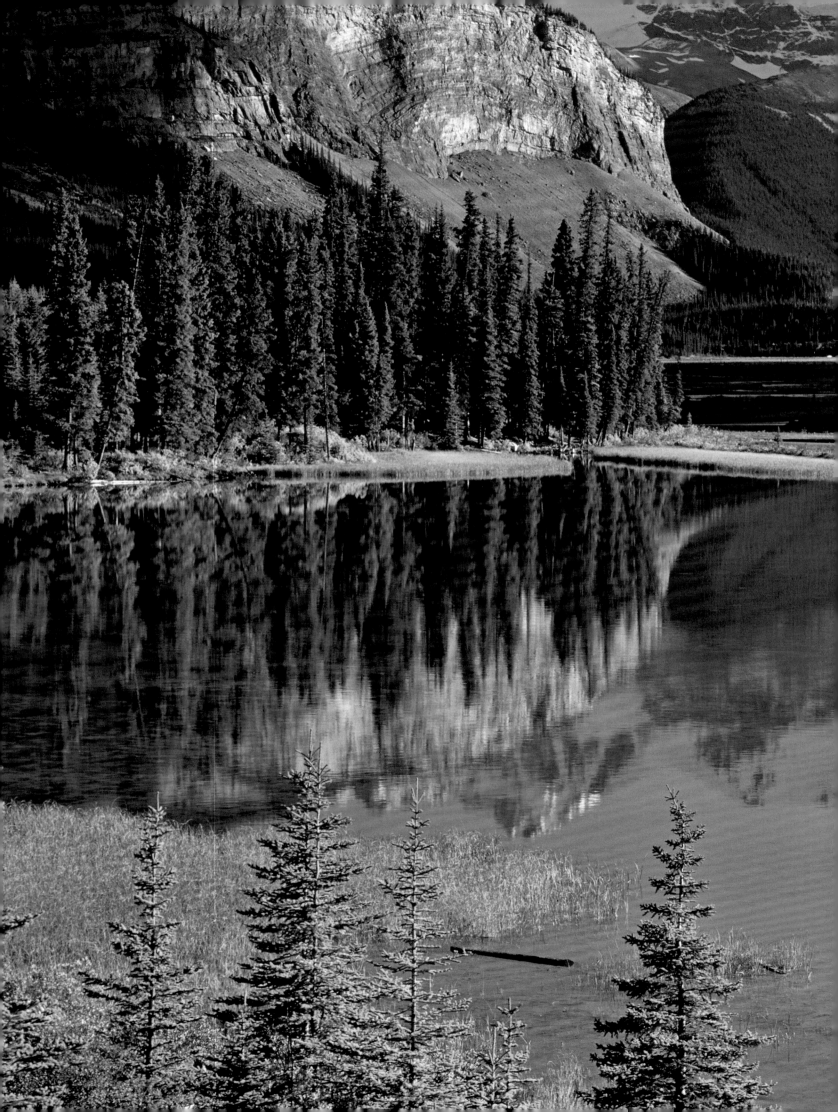

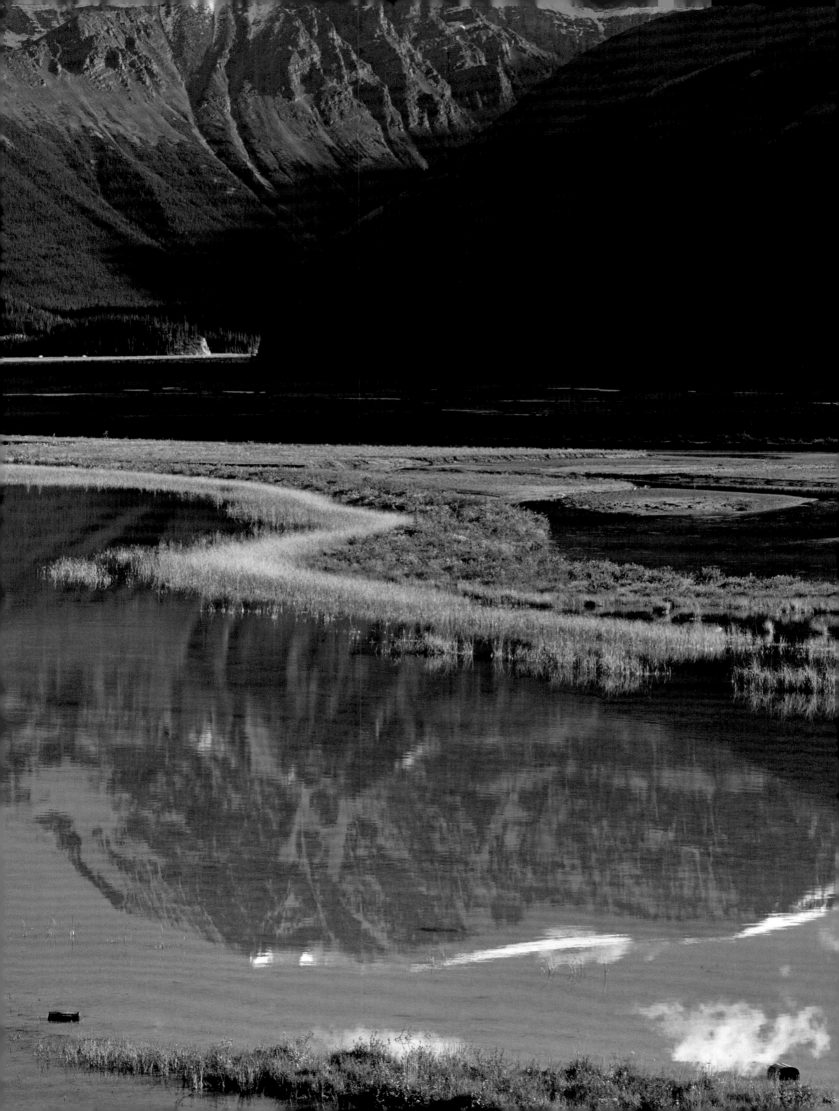

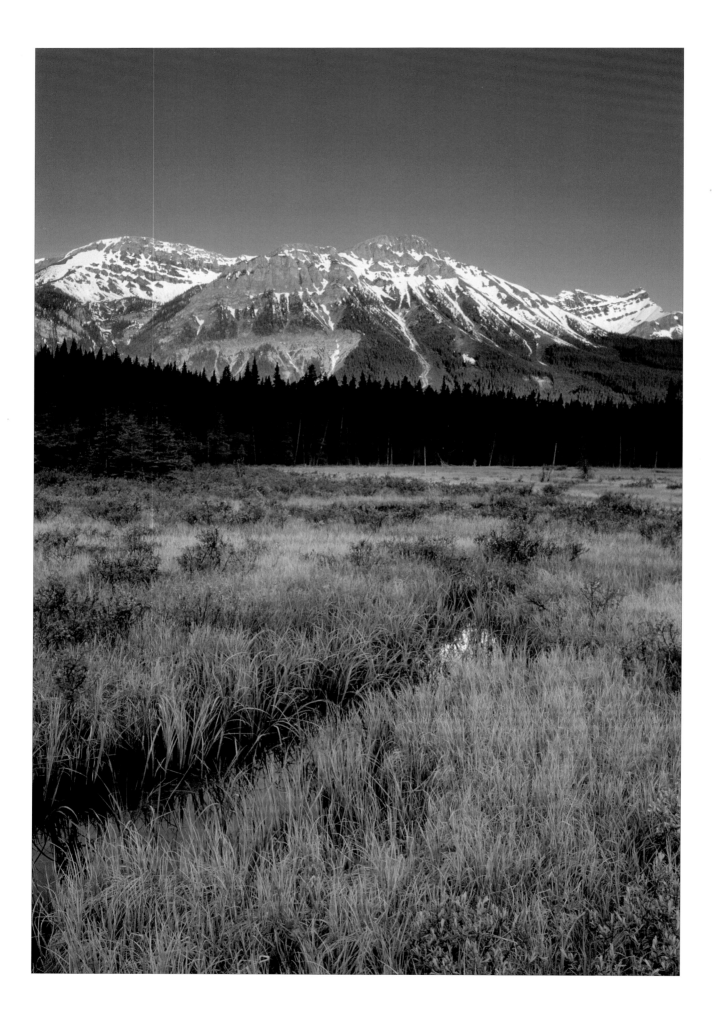

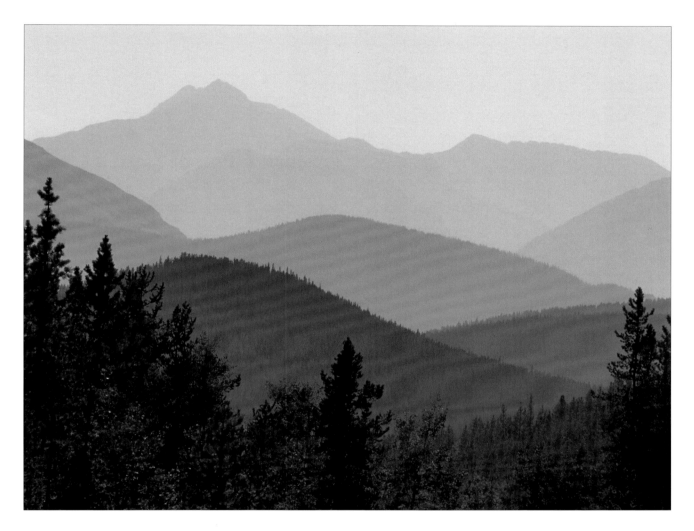

above
Blue Rock Mountain and Gorge Creek Valley
Kananaskis Country

opposite
Mt. Indefatigable
Kananaskis Country

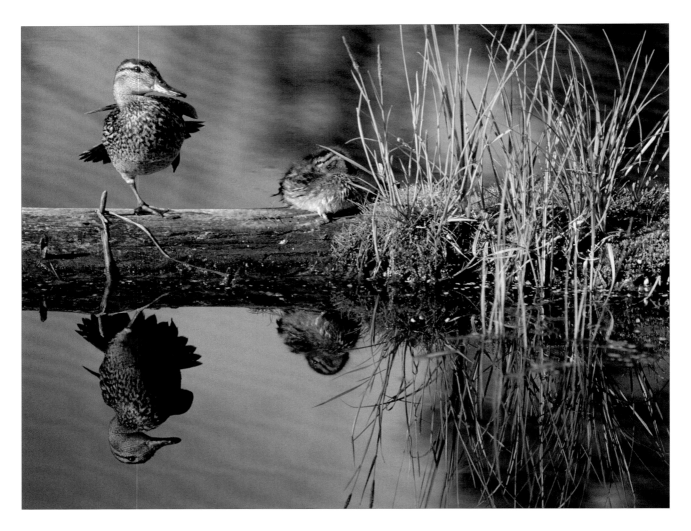

above
Blue-winged teals

opposite
Horseshoe Lake and Mount Kerkeslin
Jasper National Park

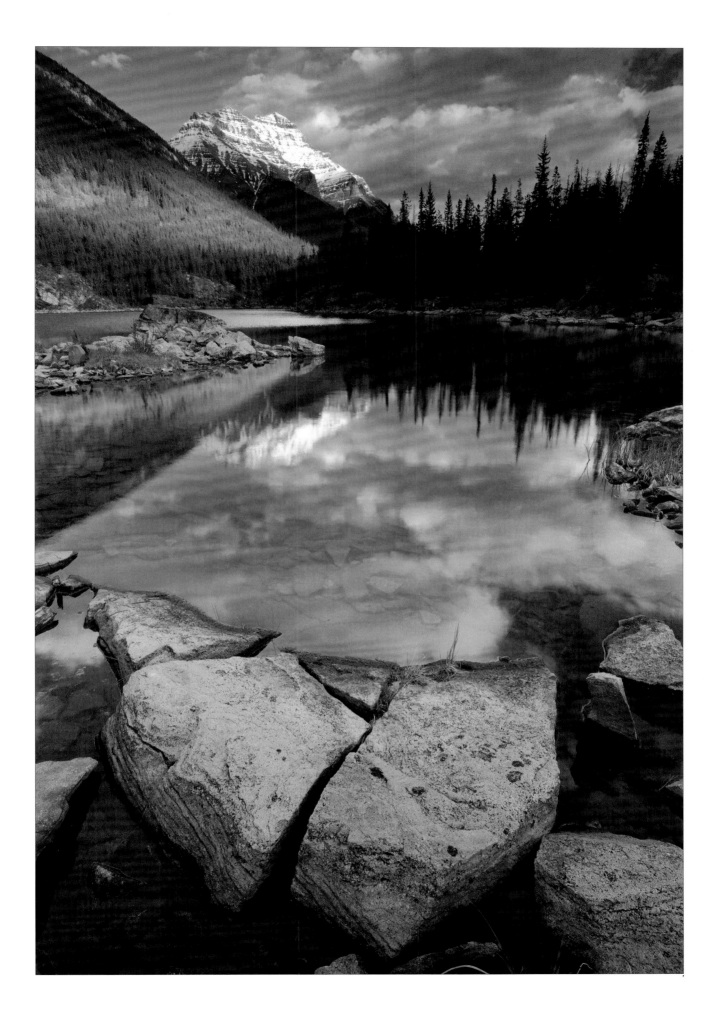

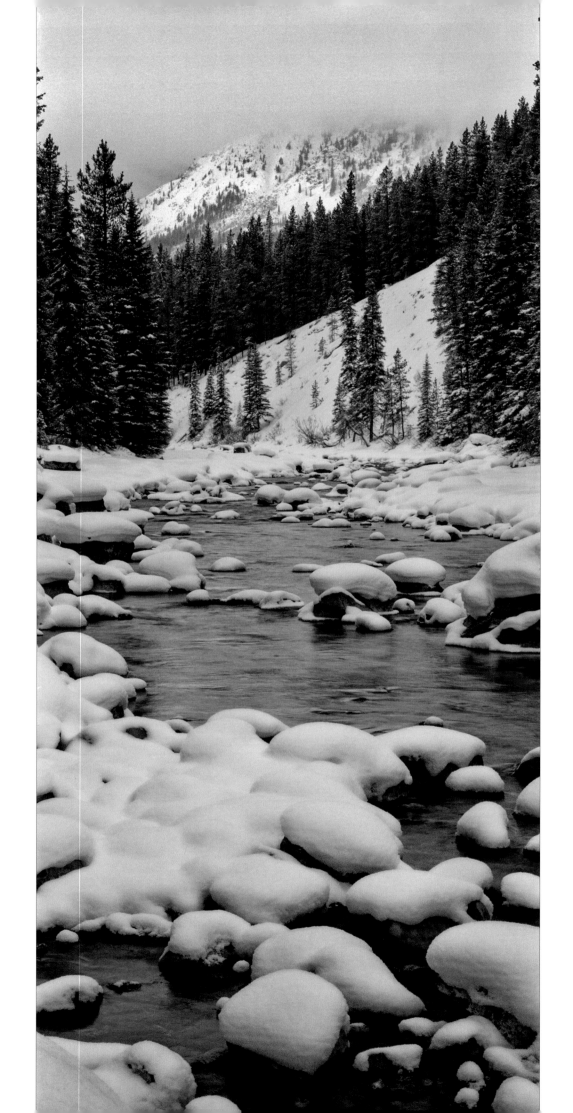

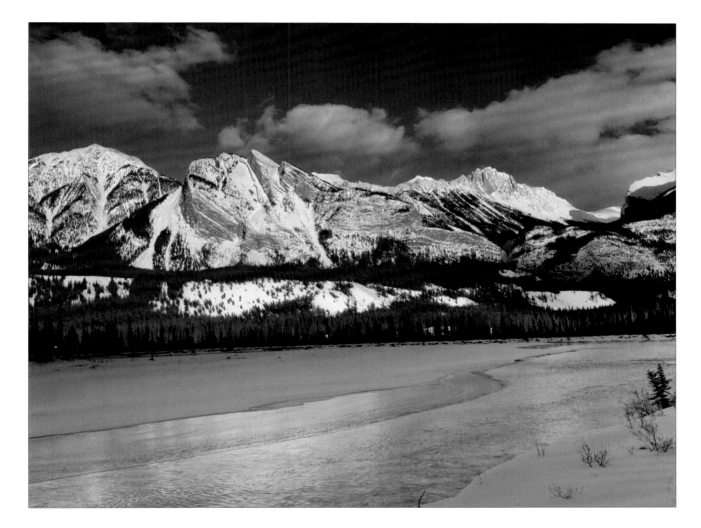

above
Athabasca River and the Colin Range
Jasper National Park

opposite
Maligne River
Jasper National Park

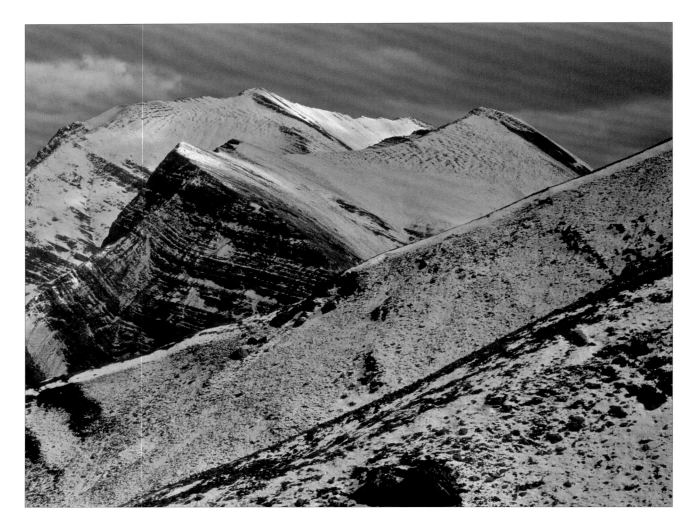

above
Persimmon Range
Willmore Wilderness Park

opposite
Spruce in Johnston Canyon
Banff National Park

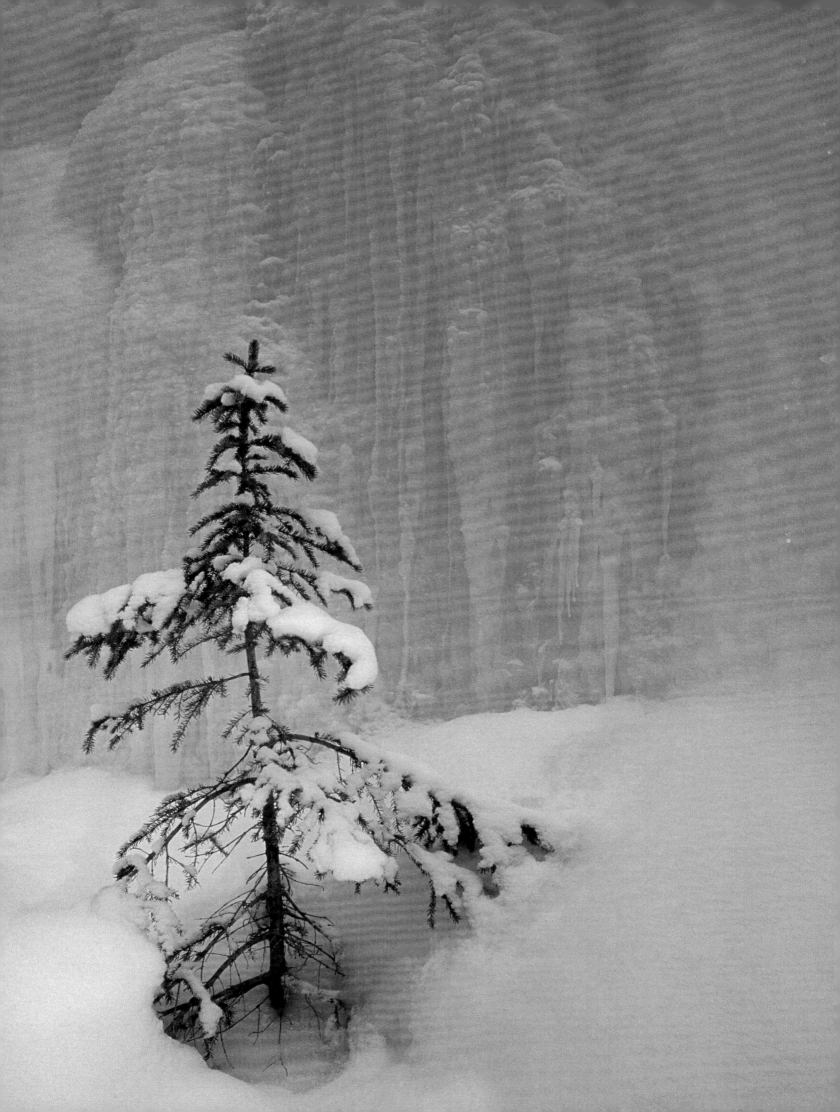

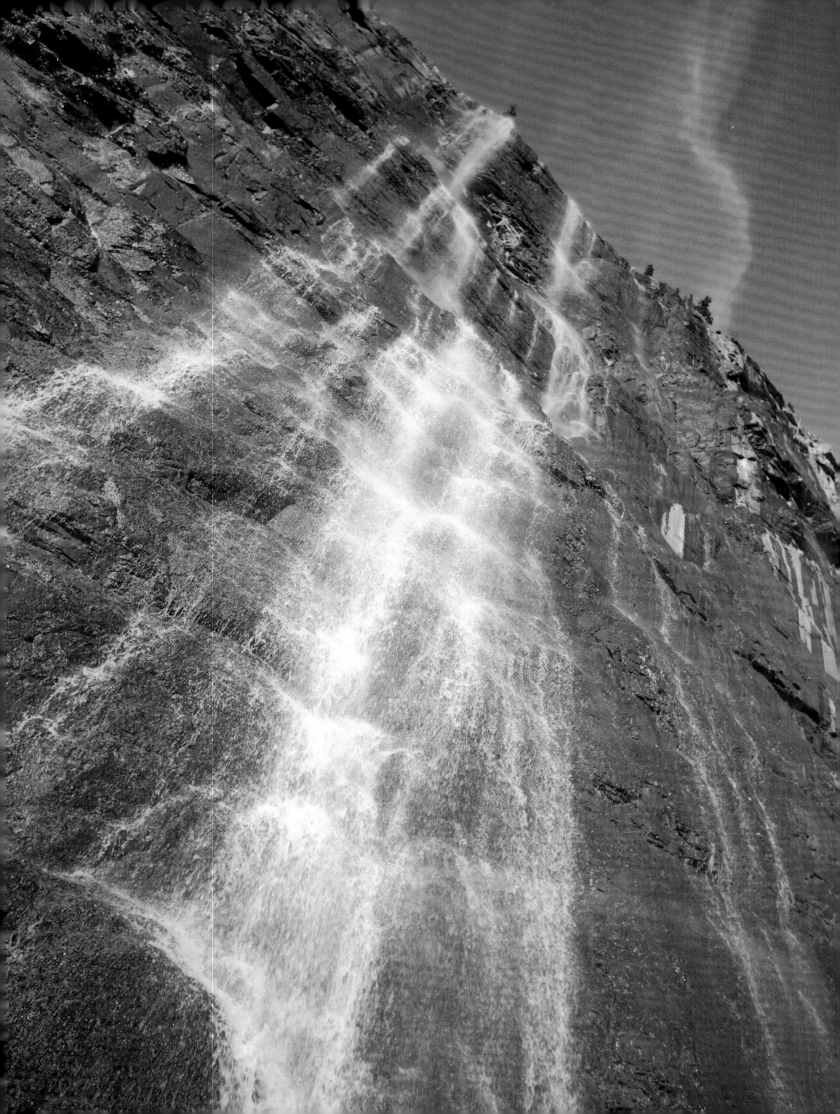

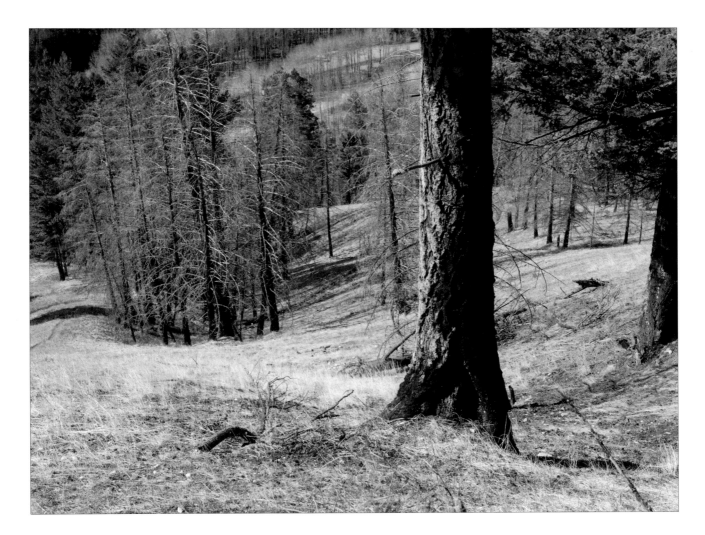

above
Sawback burn
Banff National Park

opposite
The Weeping Wall
Banff National Park

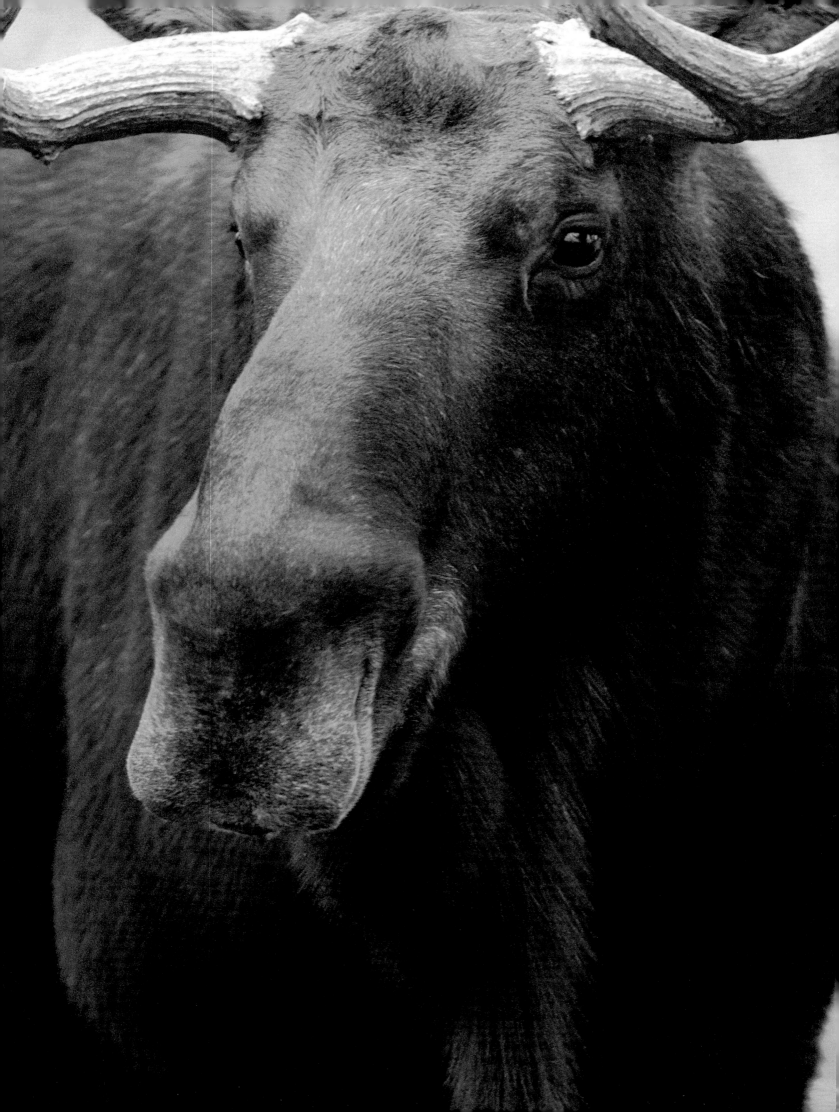

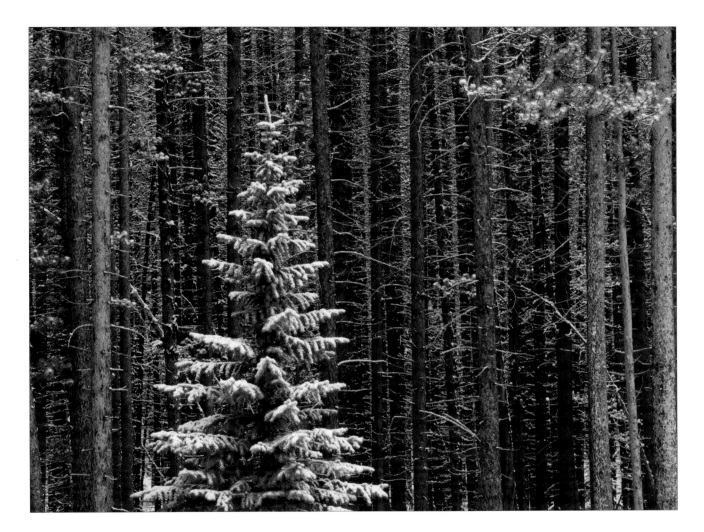

above
Spruce and lodgepole pine in Maligne River Valley
Jasper National Park

opposite
Bull moose
Kananaskis Country

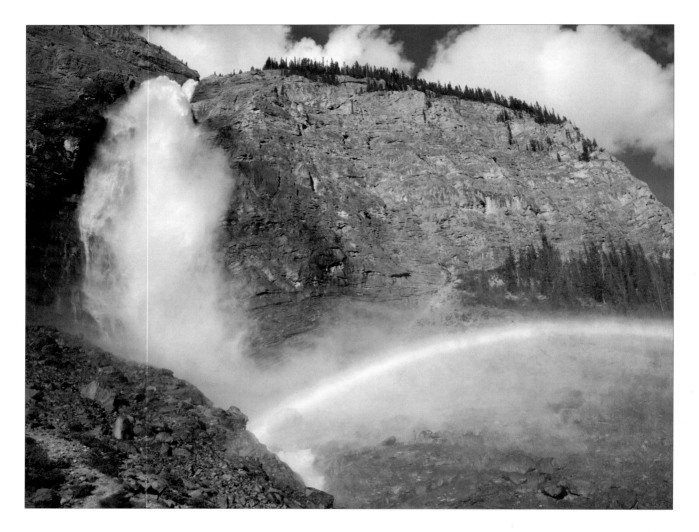

above
Takkakaw Falls
Yoho National Park

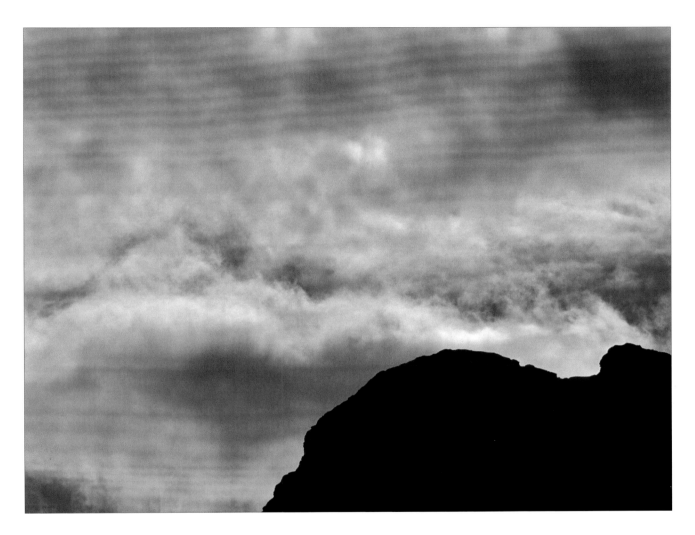

above
Backlit clouds
Banff National Park

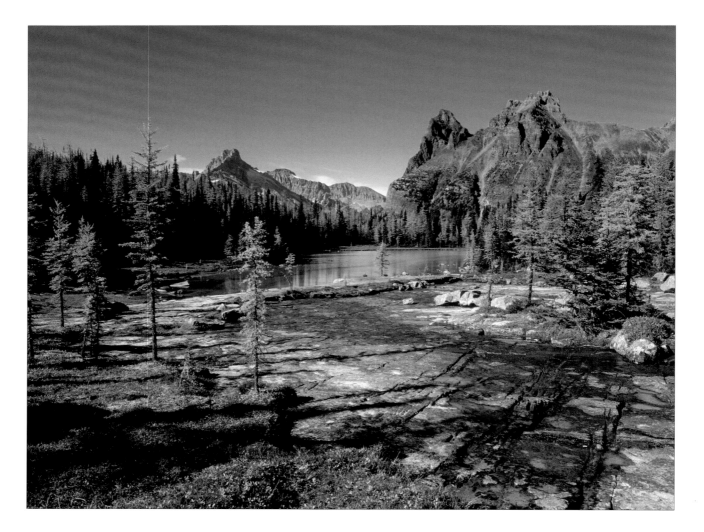

above
Wiwaxy Peaks
Yoho National Park

opposite
Mount Edith Cavell
Jasper National Park

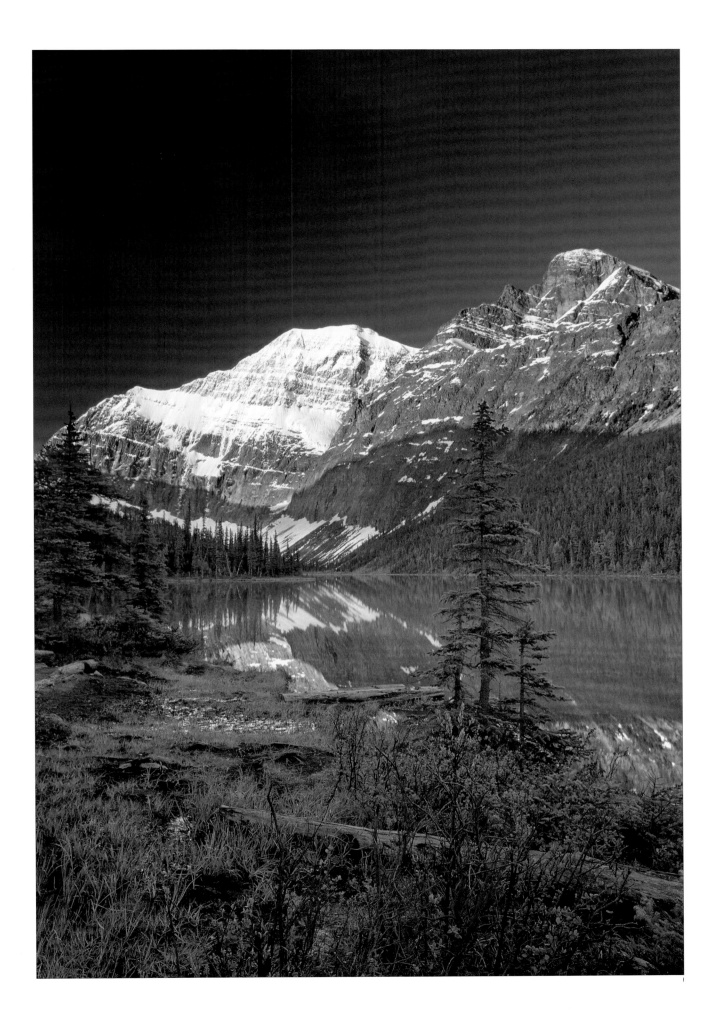

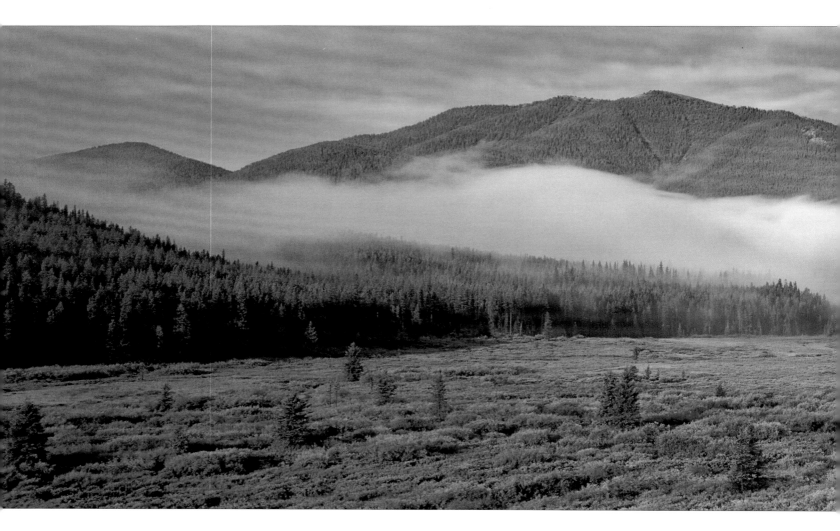

above
Cataract Creek Valley
Kananaskis Country

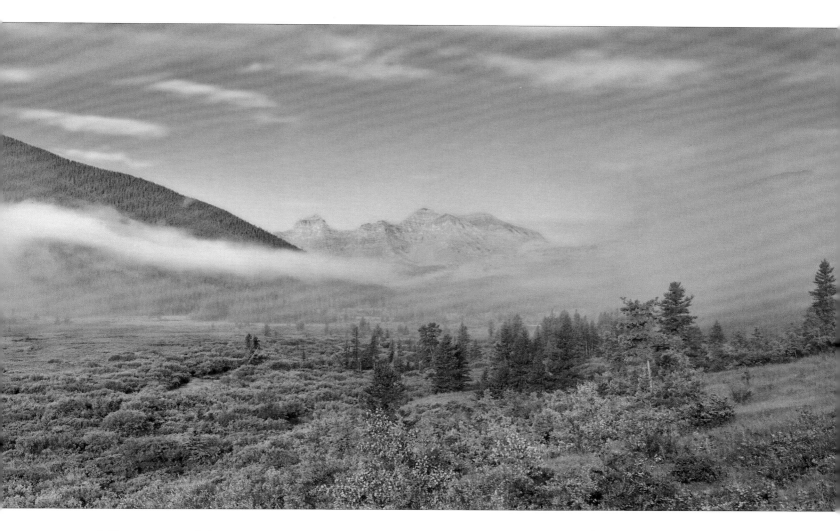

following page, left
Wildflowers in Sawback burn
Banff National Park

following page, right
Frontier Peak
Mount Robson Provincial Park

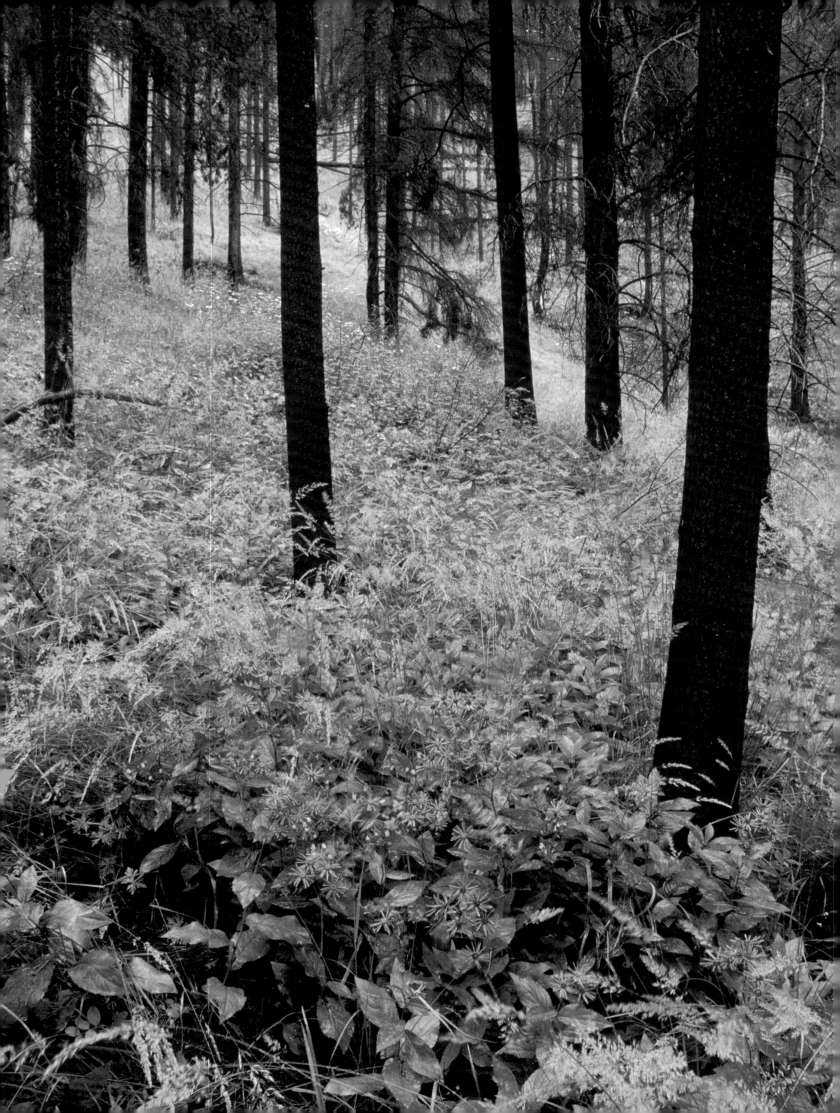

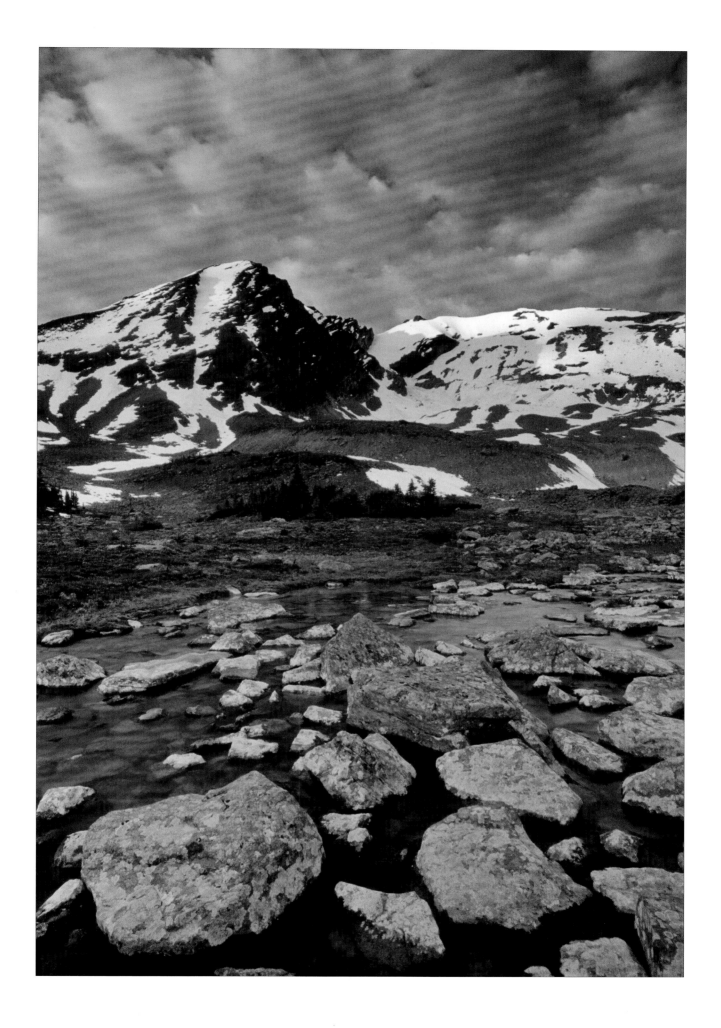

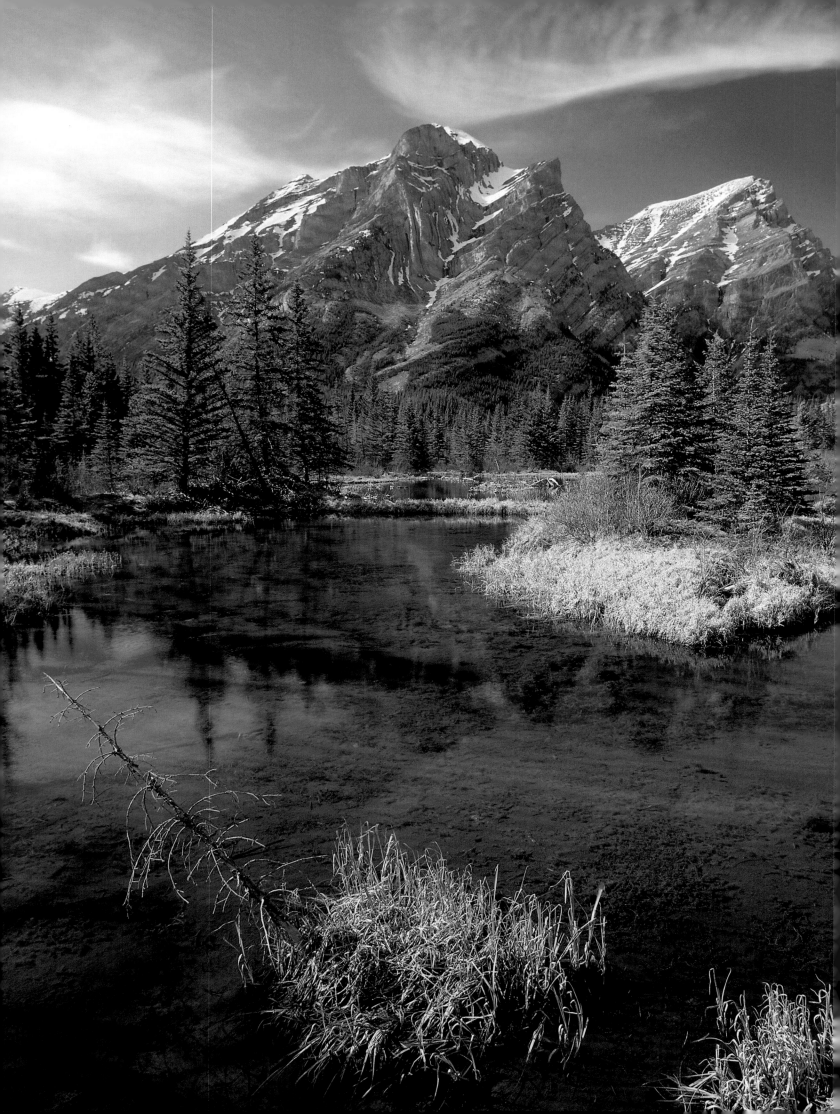

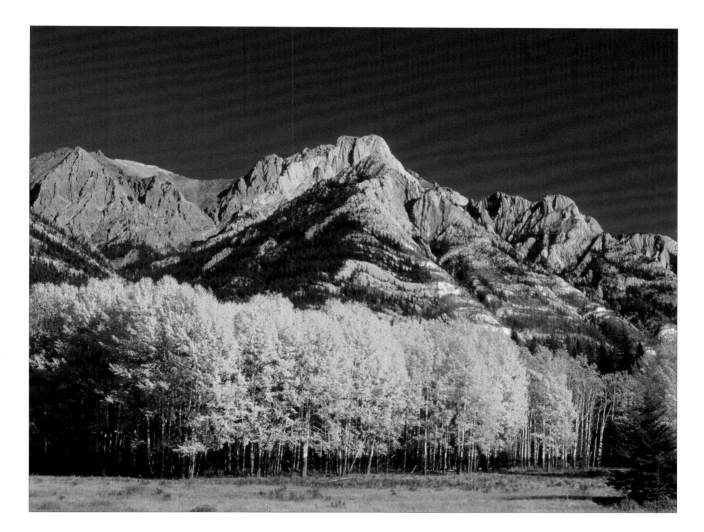

above
Sawback Range
Banff National Park

opposite
Mount Kidd
Kananaskis Country

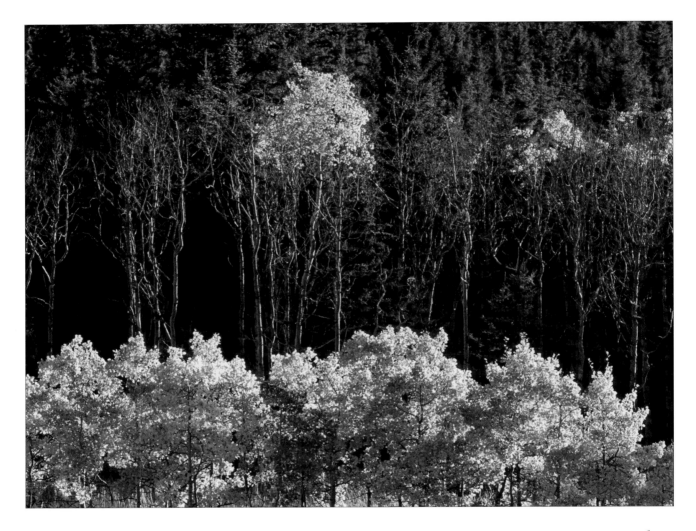

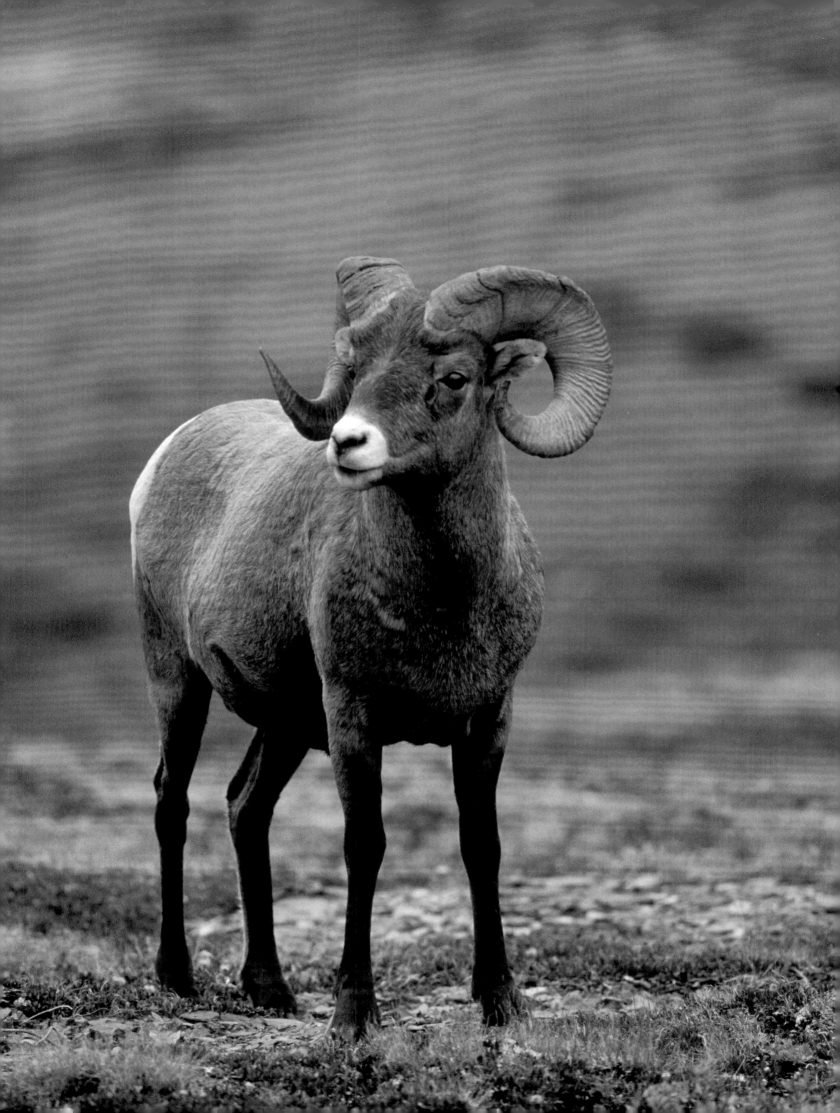

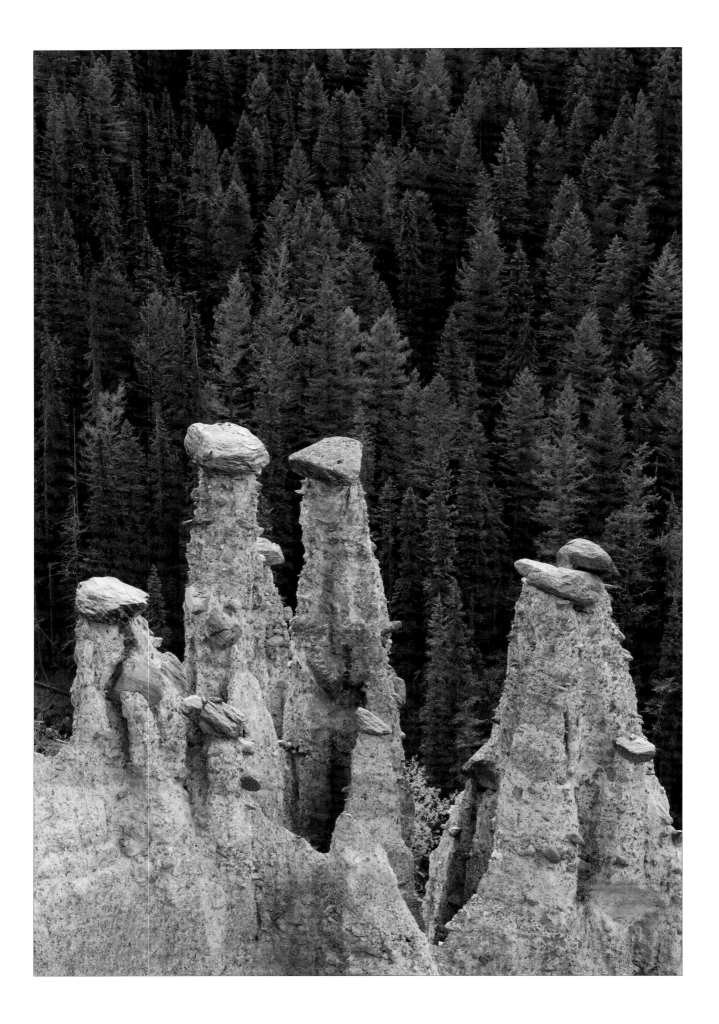

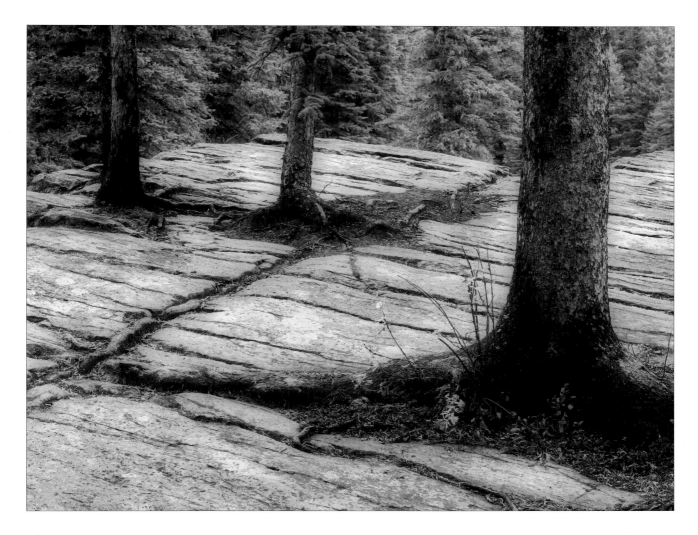

above
Rocks by Livingston Falls
Kananaskis Country

opposite
Leanchoil Hoodoos by Hoodoo Creek
Yoho National Park

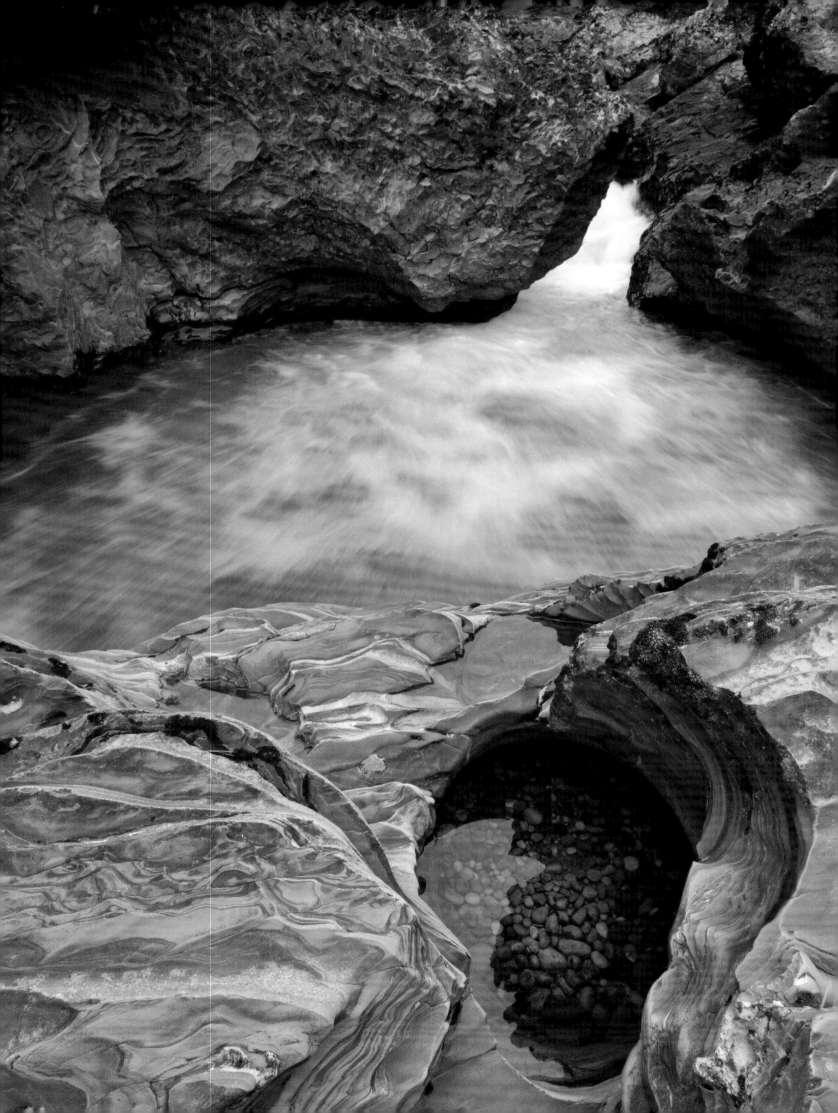

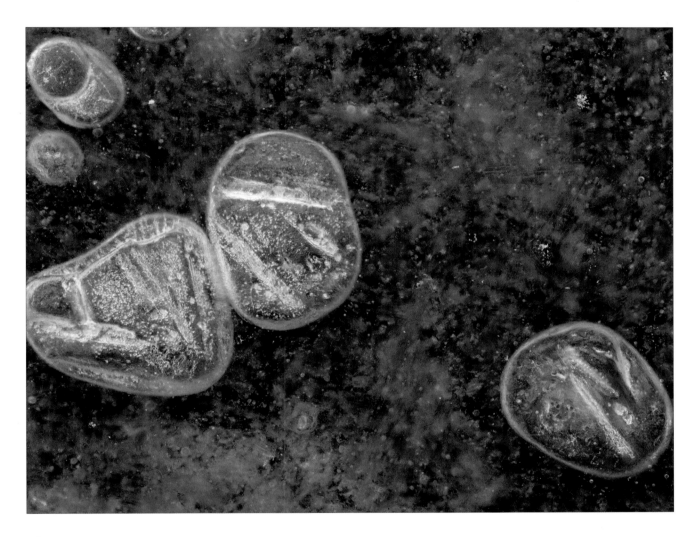

above
Air bubbles in ice
Kananaskis Country

opposite
Kicking Horse River below the Natural Bridge
Yoho National Park

following page, left
Pyramid Mountain over Patricia Lake
Jasper National Park

following page, right
Persimmon Range near Eagle's Nest Pass
Willmore Wilderness Park

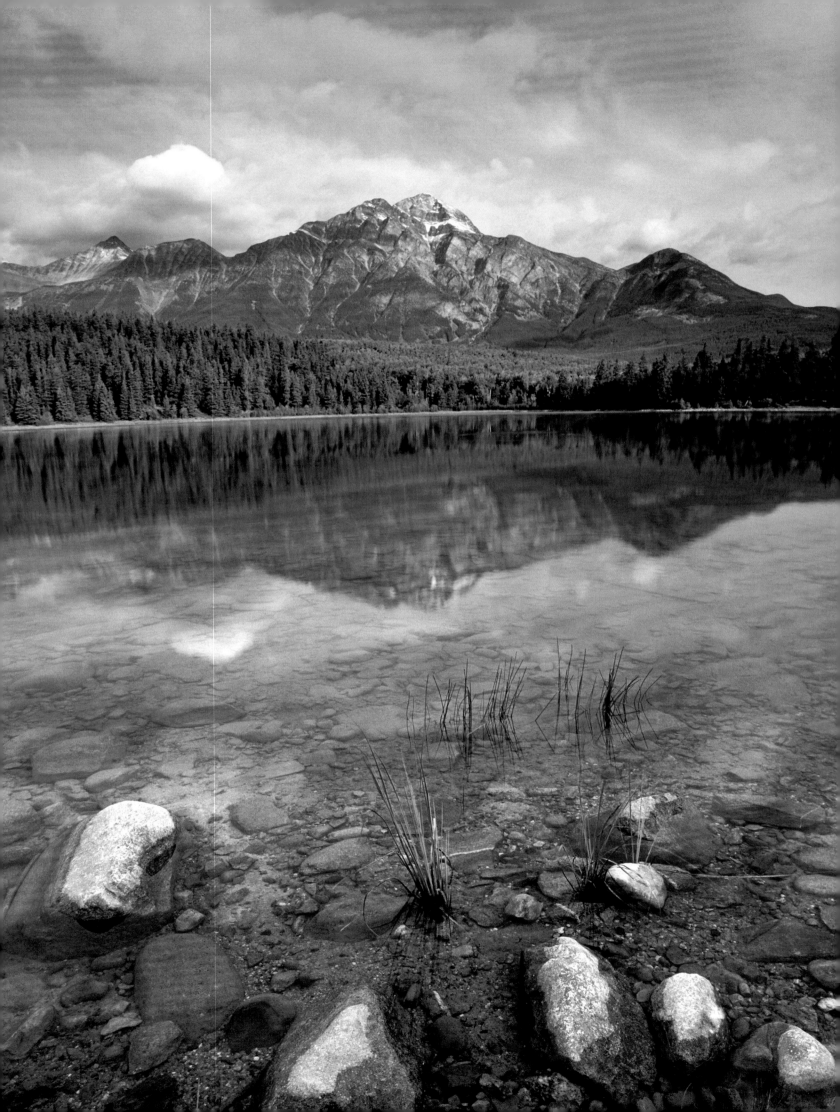

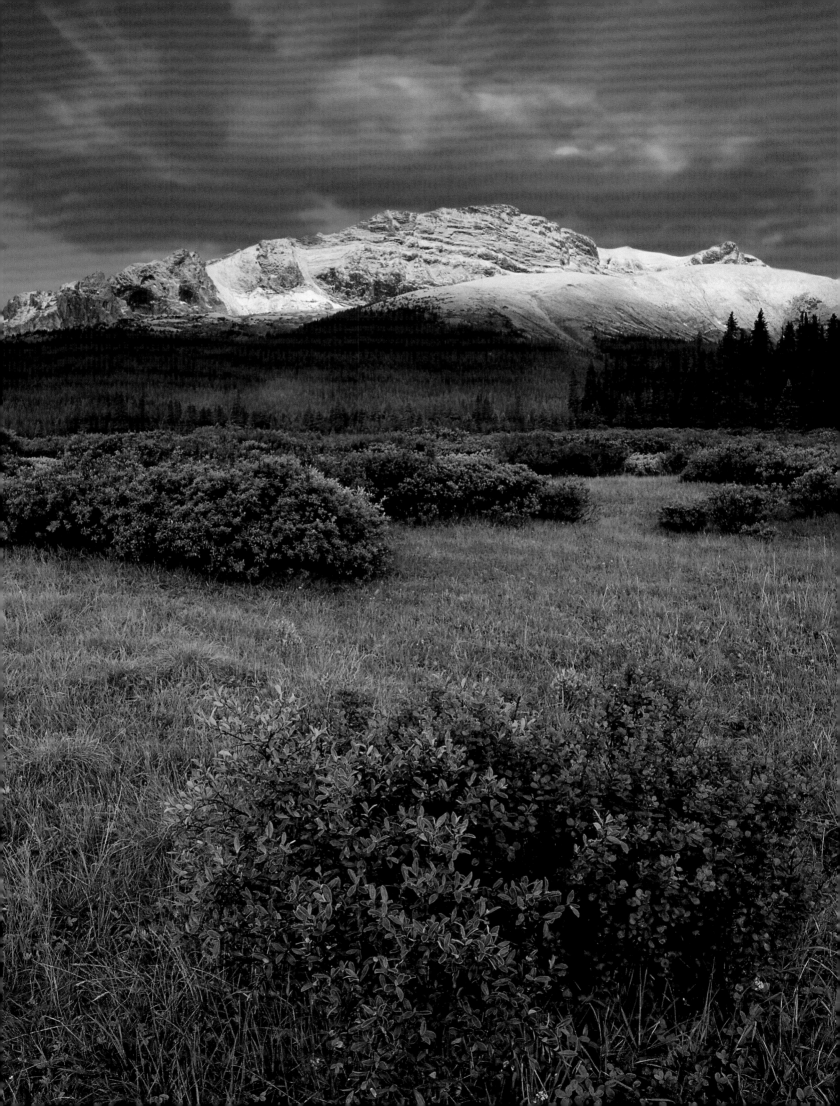

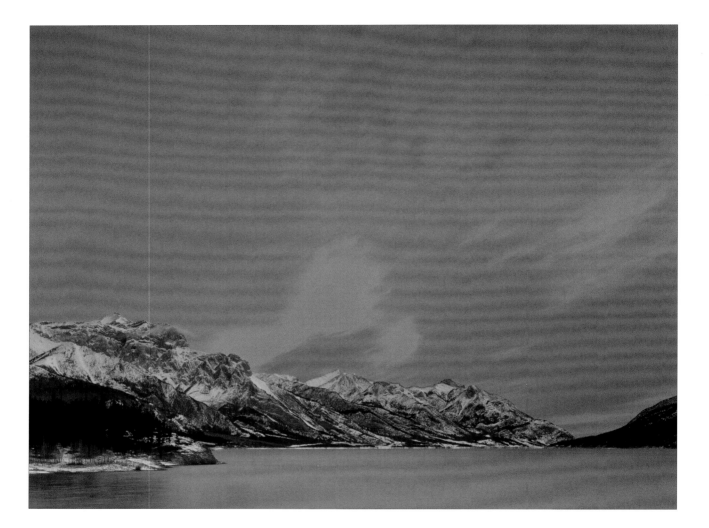

above
Lake Abraham
Kootenay Plains

opposite
Wedge Pond
Kananaskis Country

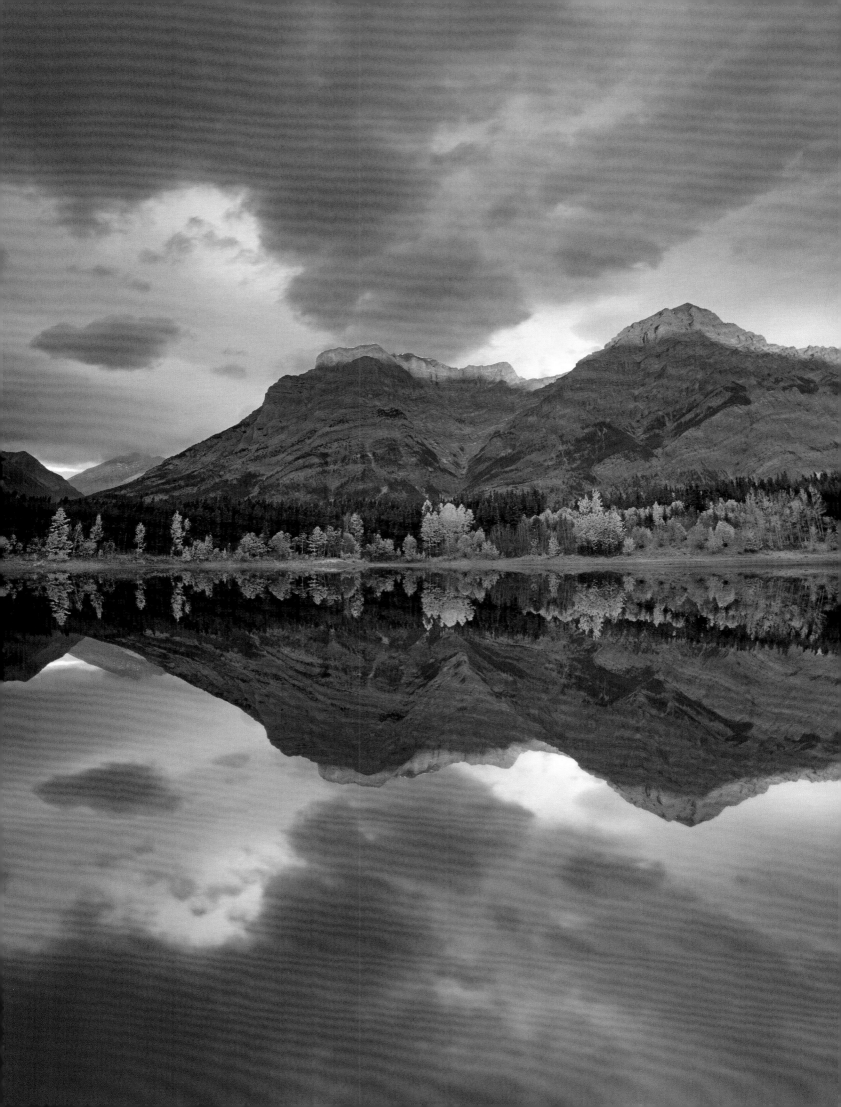

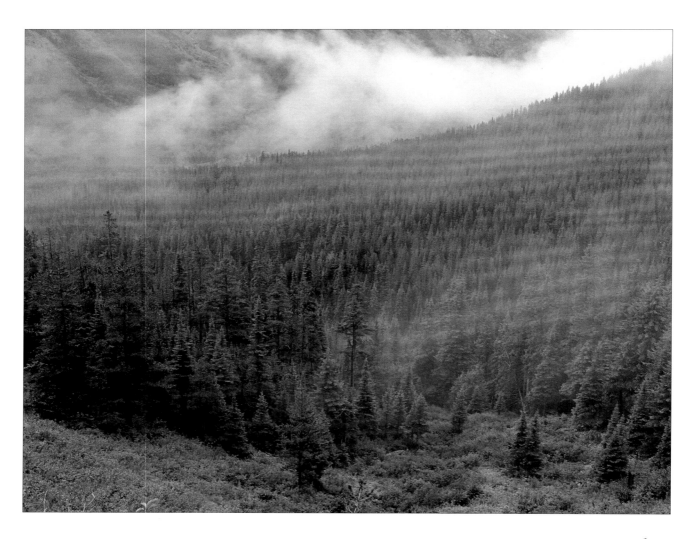

above
Lineham Creek Valley
Waterton Lakes National Park

opposite
Wild roses
Kananaskis Country

following pages
Pyramid Mountain over Patricia Lake
Jasper National Park

136

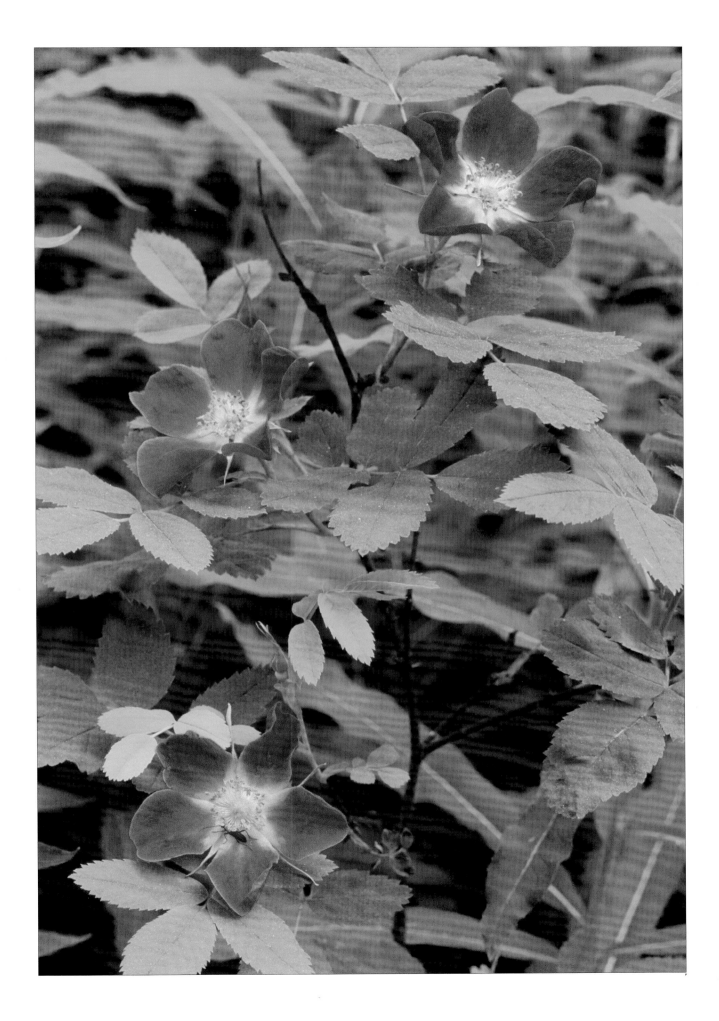

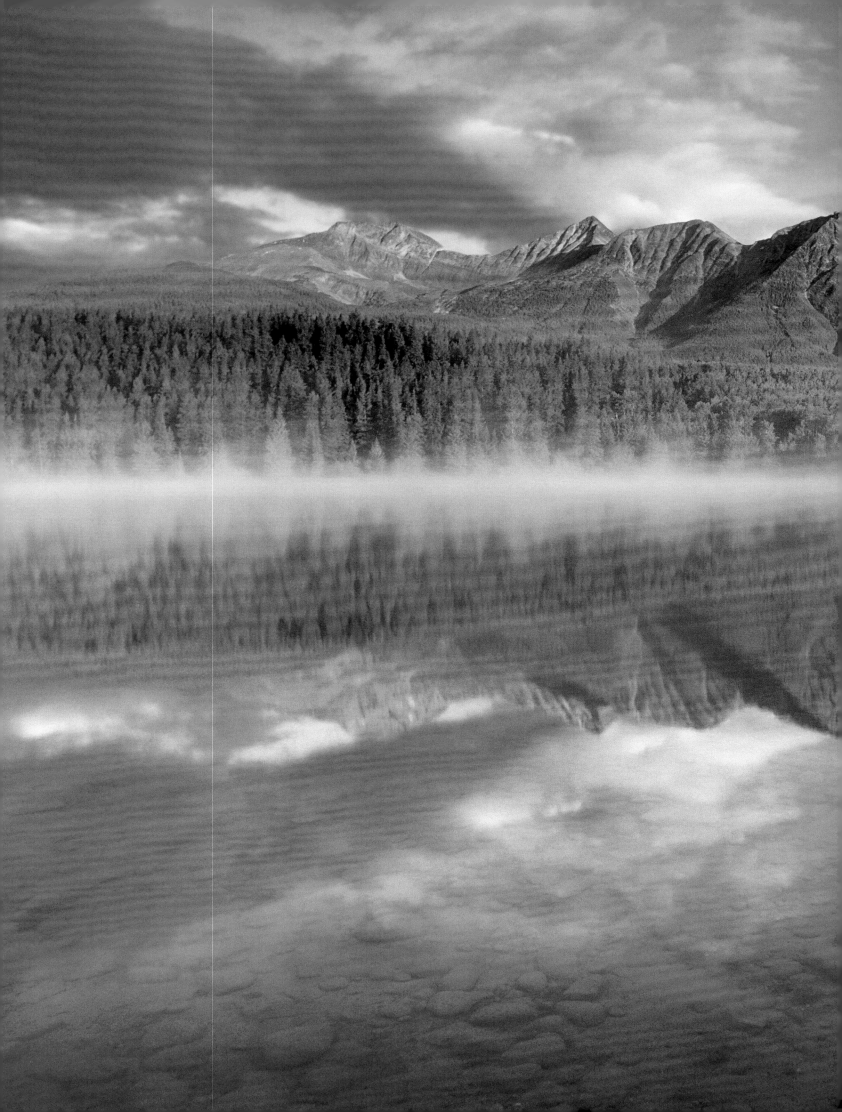

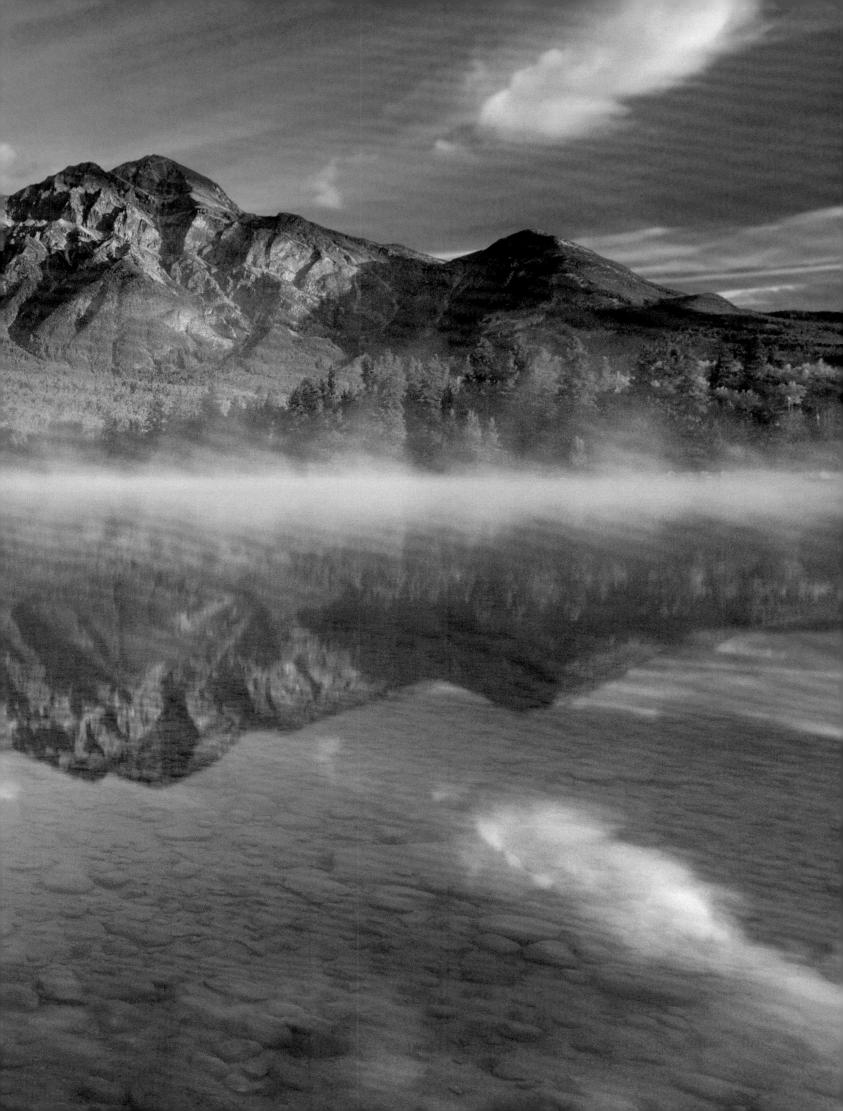

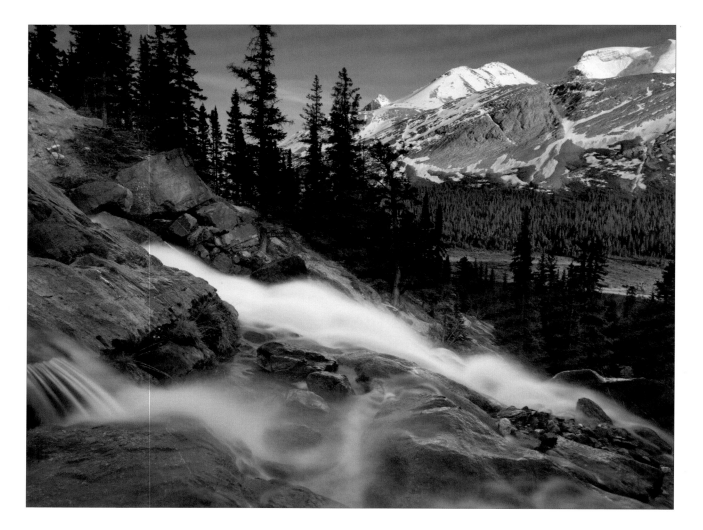

above
Mount Athabasca
Jasper National Park

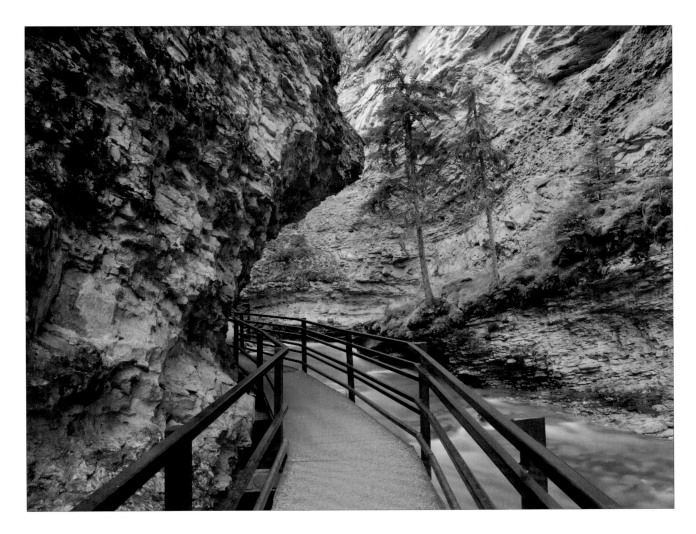

above
Johnston Canyon
Banff National Park

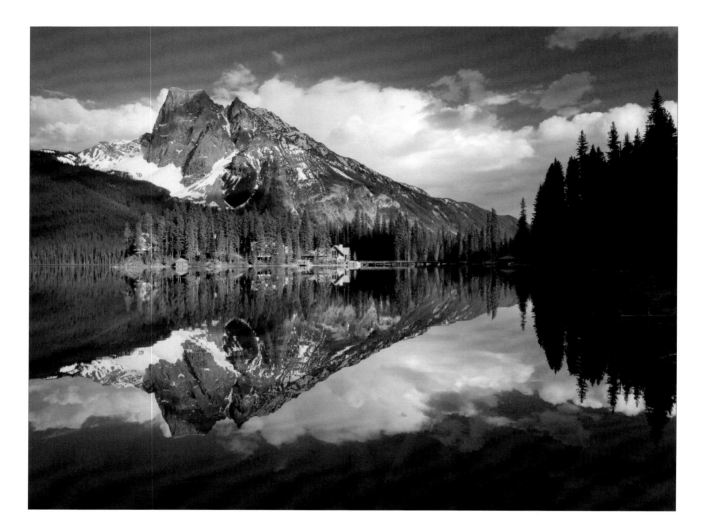

above
Emerald Lake
Yoho National Park

opposite
Opal Falls
Kananaskis Country

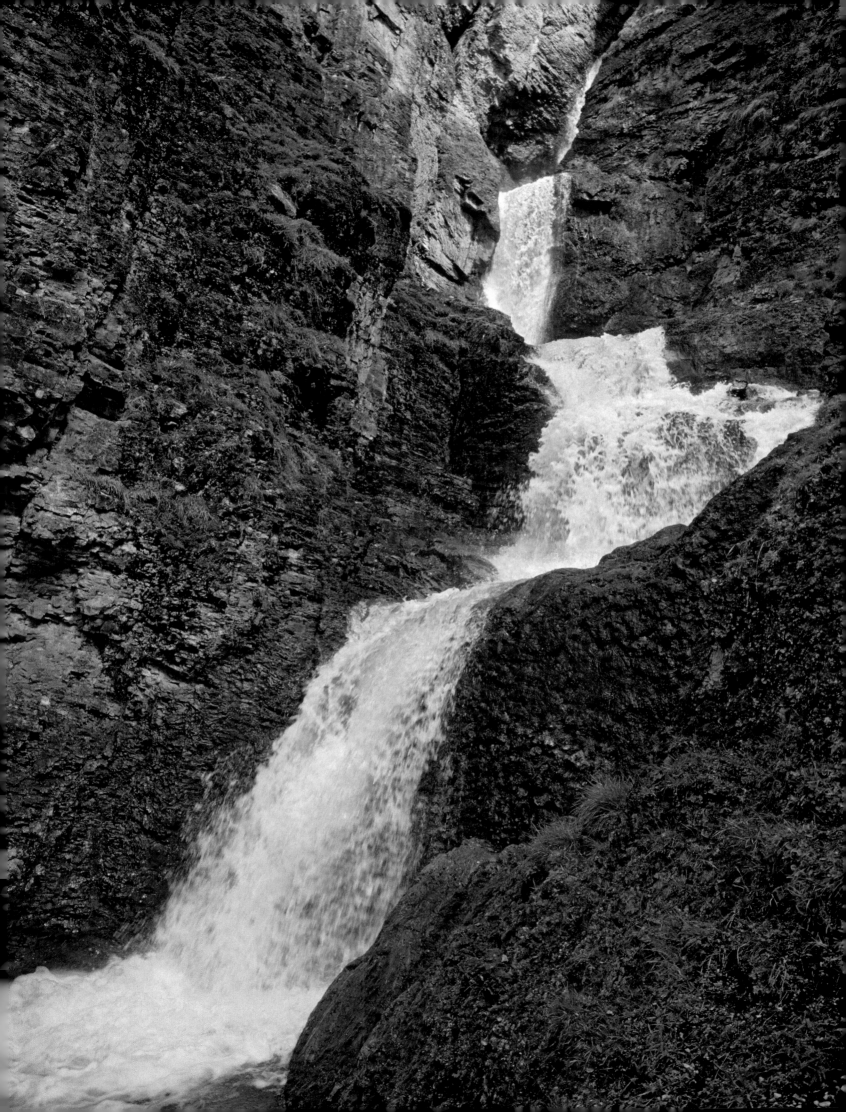

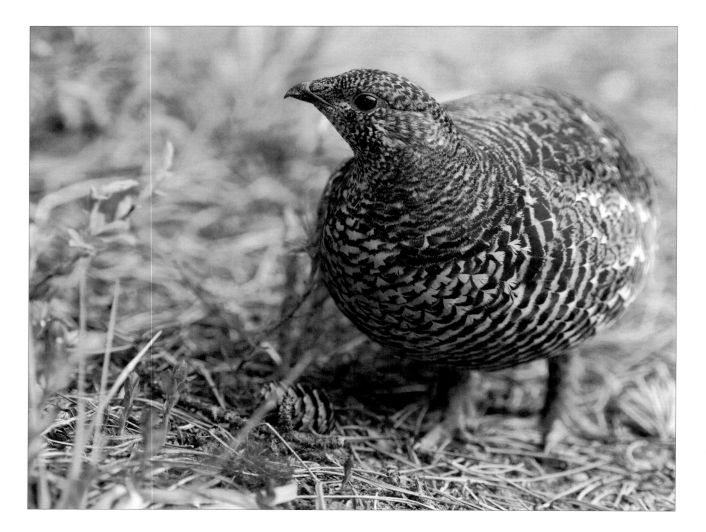

above
Spruce grouse
Kootenay National Park

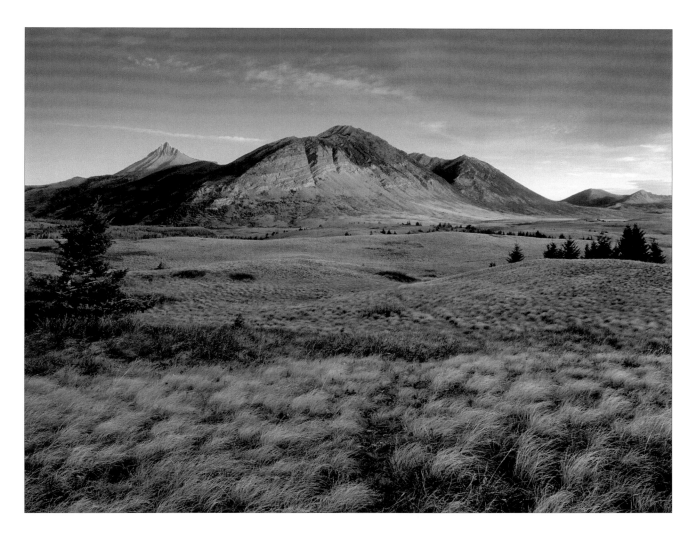

above
Bellevue Hill and Mount Galwey
Waterton Lakes National Park

following page, left
Quartzite boulder pile by Icefields Parkway
Jasper National Park

following page, right
Lake O'Hara
Yoho National Park

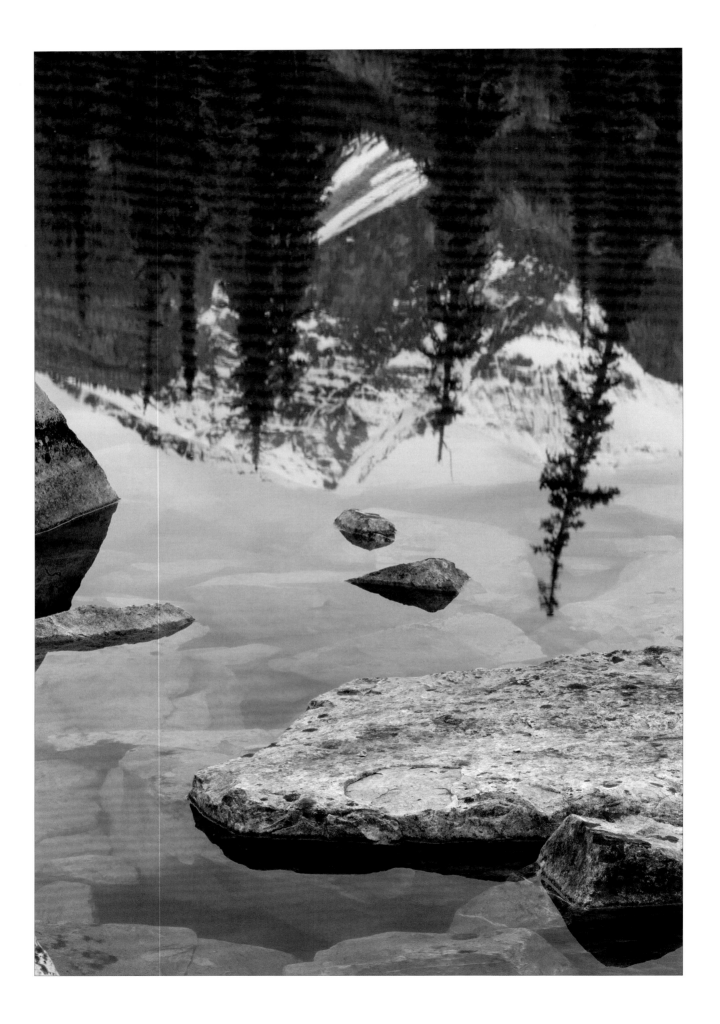

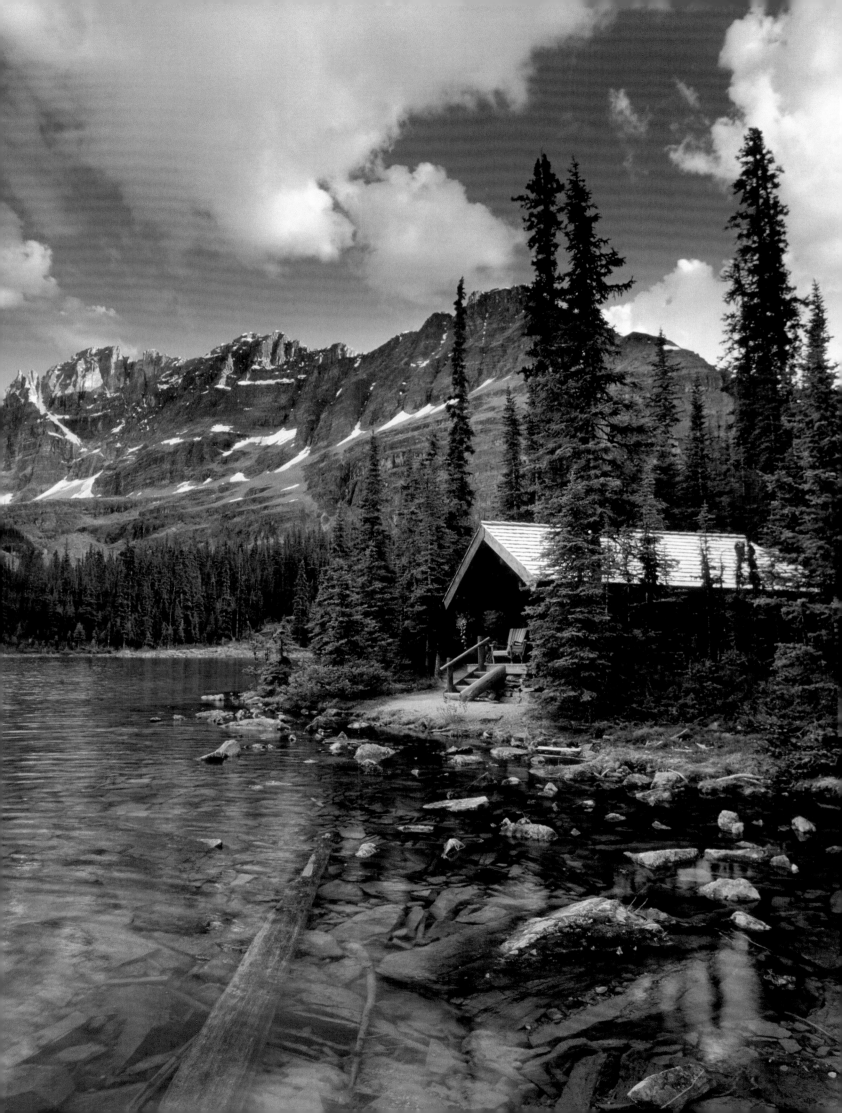

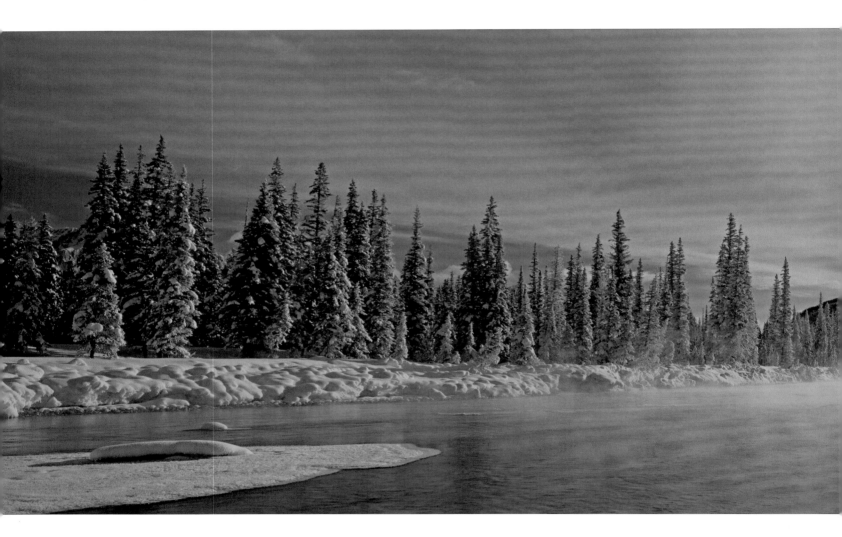

above
Bow River
Banff National Park

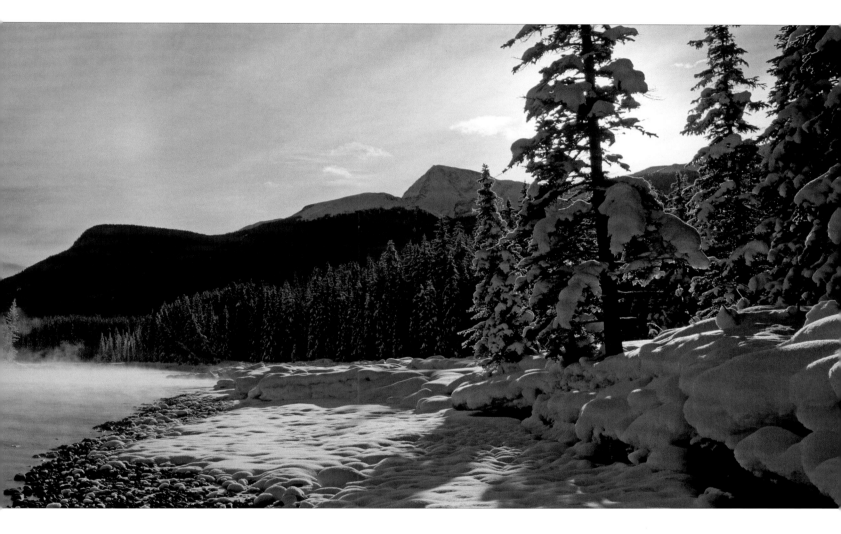

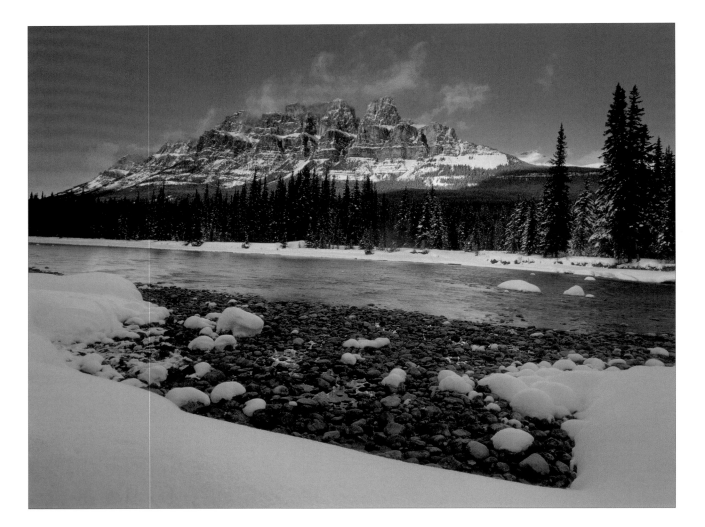

above
Castle Mountain
Banff National Park

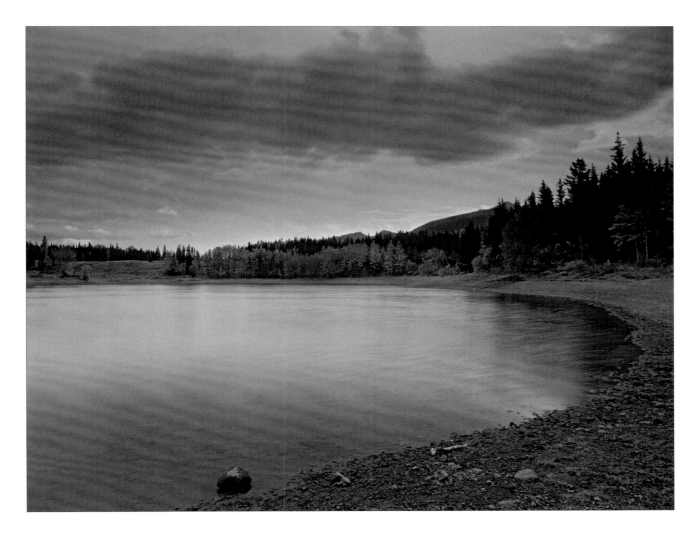

above
Wedge Pond
Kananaskis Country

following pages
Wiwaxy Peaks and Cathedral Mountain
Yoho National Park

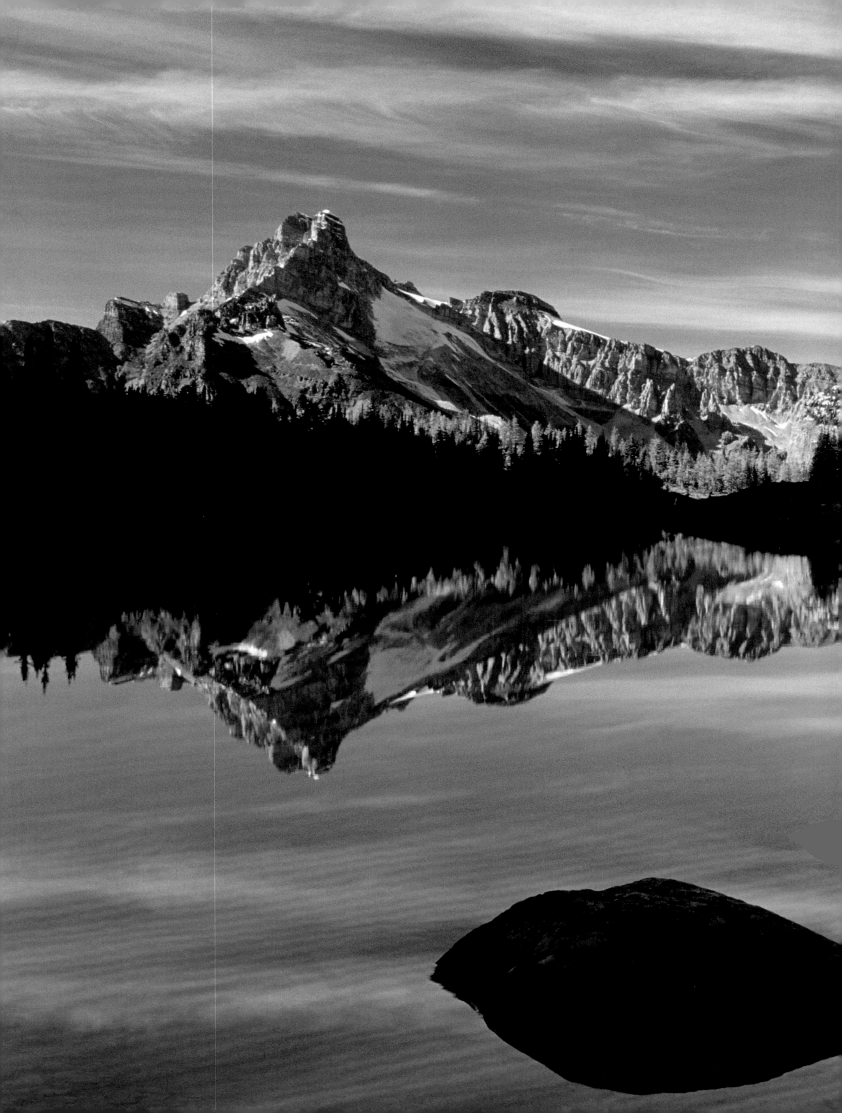

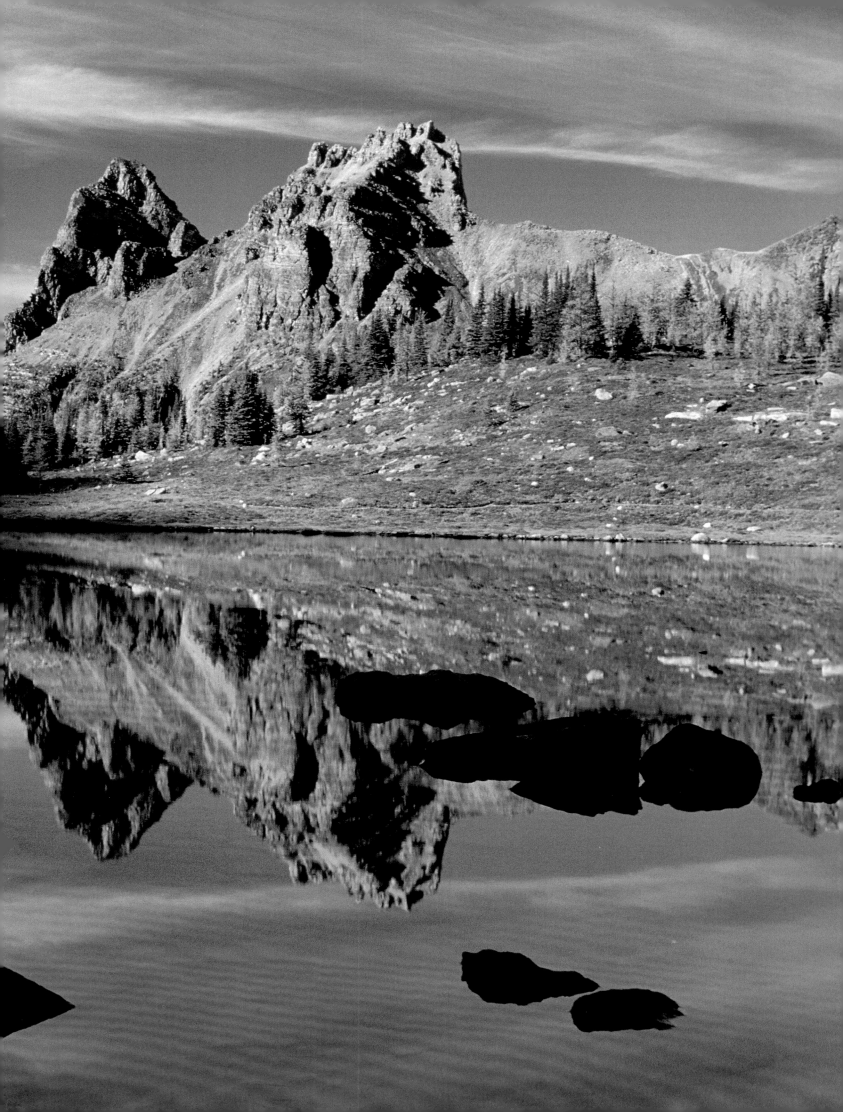

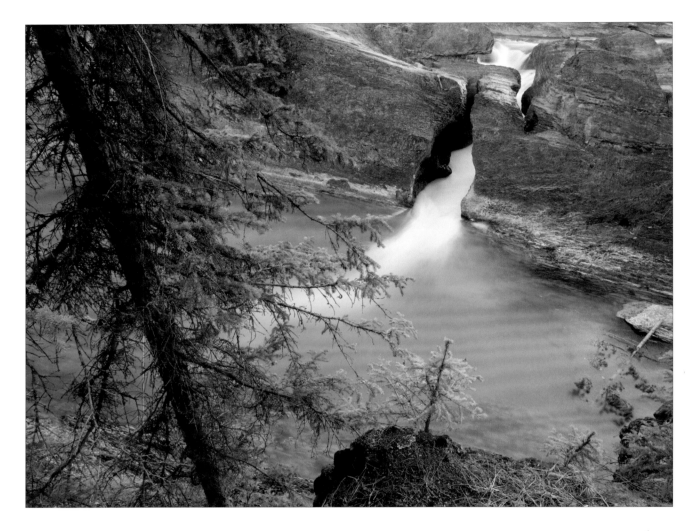

above
Natural Bridge
Yoho National Park

opposite
Peaks near Cameron Lake
Waterton Lakes National Park

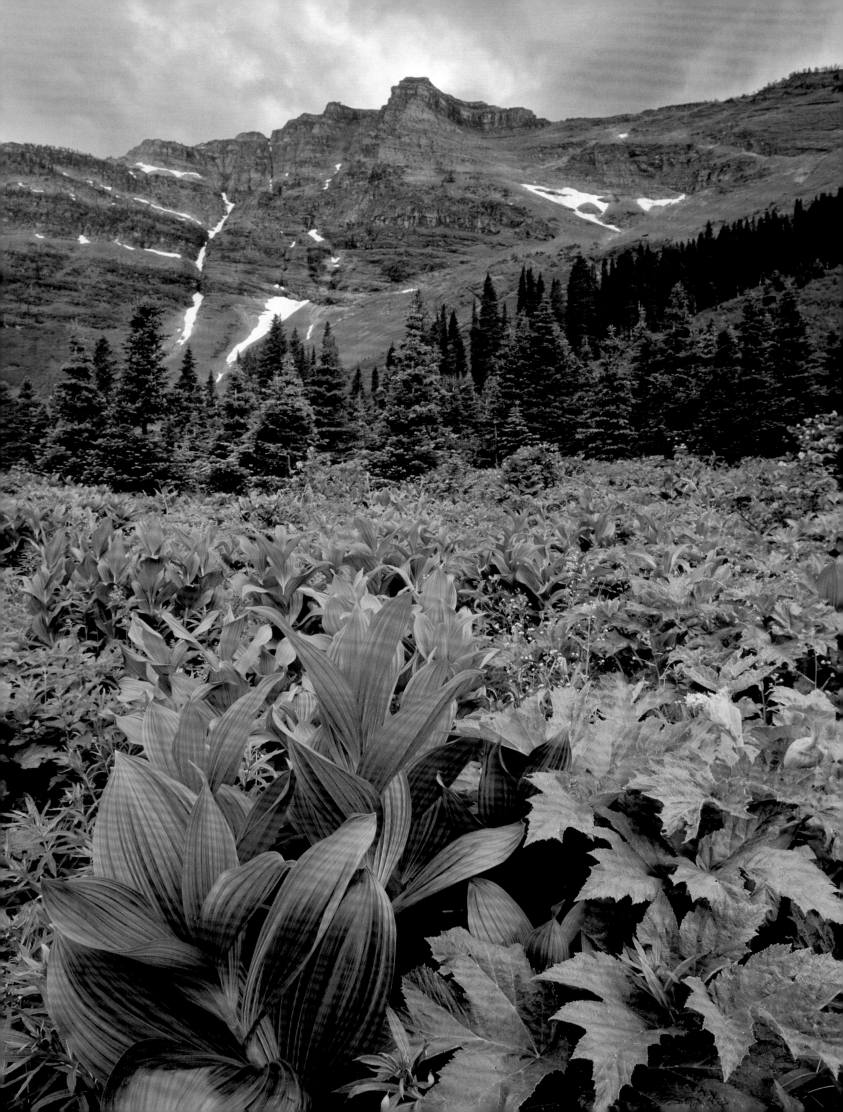

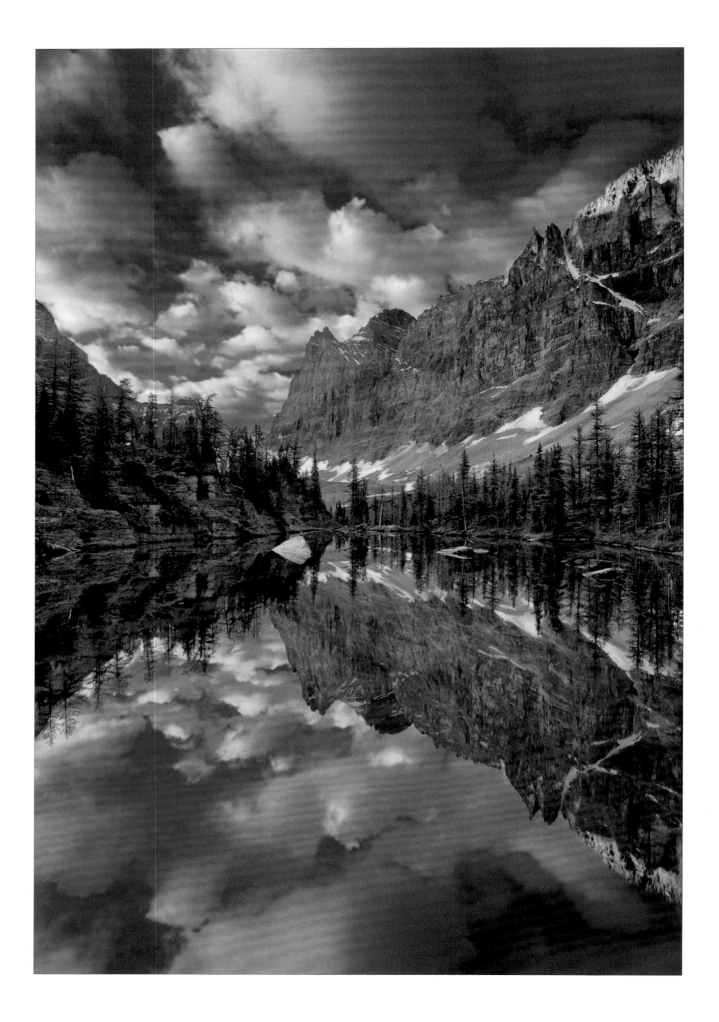

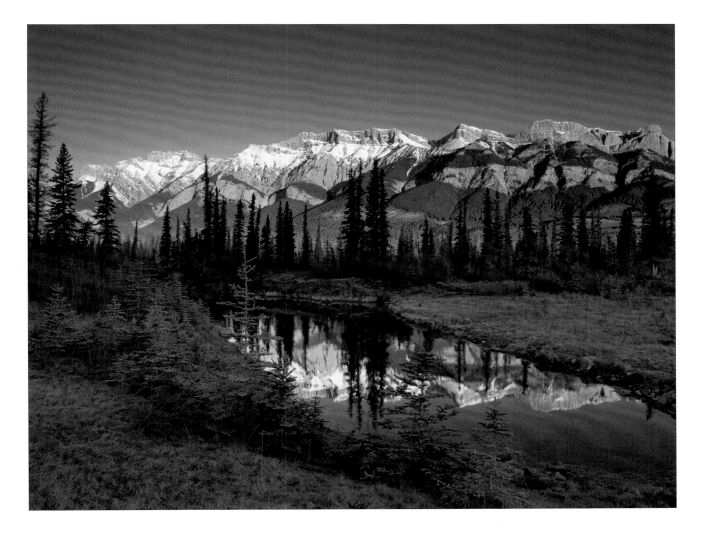

above
Miette Range
Jasper National Park

opposite
Schaffer Ridge from Opabin Plateau
Yoho National Park

following pages
Siffleur Range
Kootenay Plains

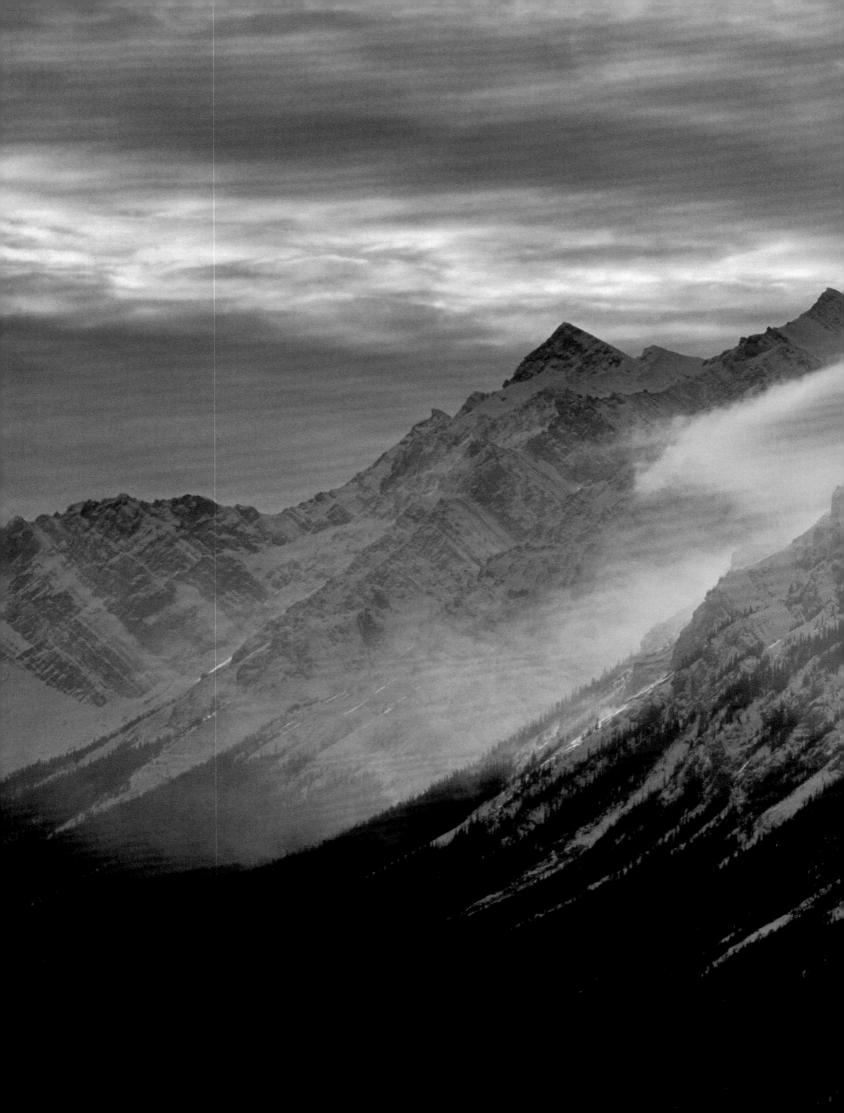

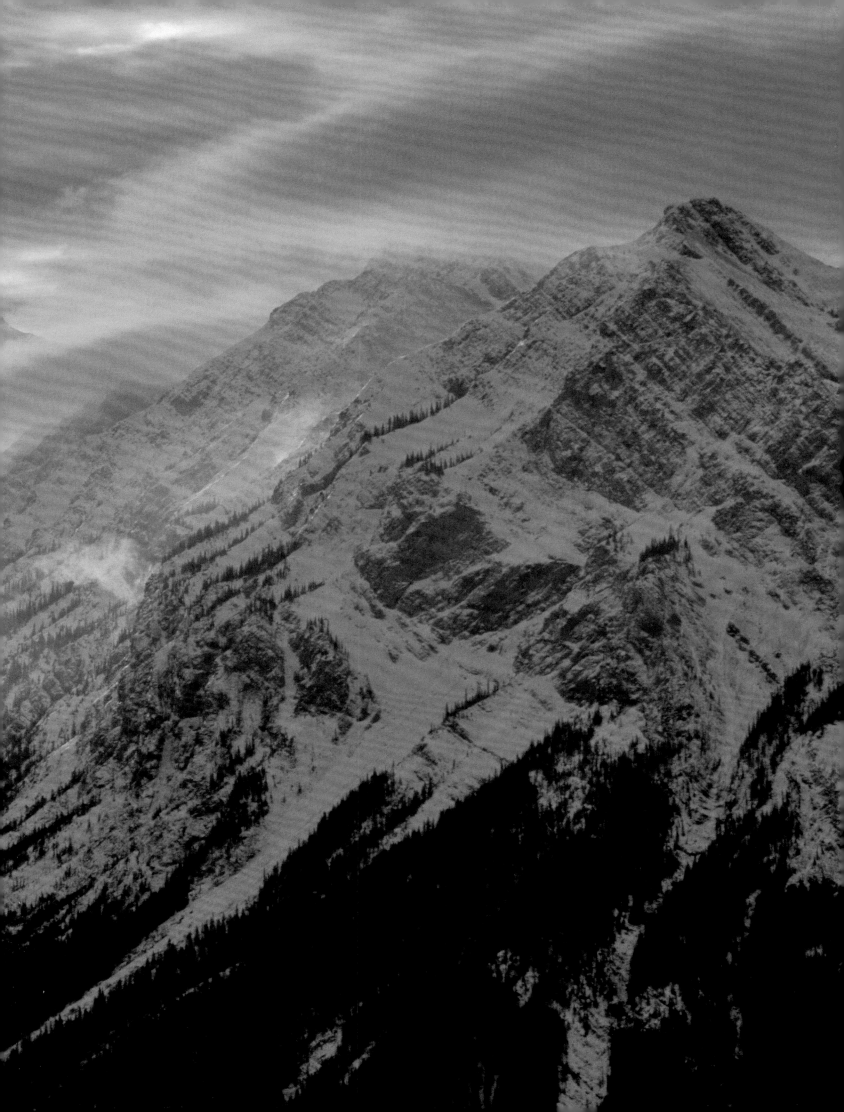

Afterword

Put a dozen photographers in the same place, at the same time, using the same equipment, and you'll get a dozen very different representations of the scene. We all see our external world through the filter of our past experiences and personality, and this personal bias is represented in the images we make.

My first memories of the Canadian Rockies came from childhood trips to see my grandparents, who lived on a farm west of Rocky Mountain House. On weekends, my grandfather would drive the family west along Highway 11 to meet the Icefields Parkway in Banff National Park. In the mid- to late '60s, the road was still graveled and rough, and it was a big adventure to get our well-deserved ice cream at a little store which is now known as The Crossing Resort.

Along the way, we would stop to fish, pick wildflowers, feed the roadside black bears plums and apples (which activity is now forbidden, fortunately), and look for the fabled Sasquatch (Bigfoot) that my grandfather reported to us that he had seen at least a dozen times.

These early experiences inspired my lifelong love of the mountains. I dreamed of being "Grizzly Adams," living with my pet bear in log cabin by a mountain lake.

Later, my love of the mountains turned into a profession when I became a research biologist for the University of Alberta. I lived and worked in Kananaskis Country for 10 summers, studying the social behaviour of Columbian ground squirrels. I have many fond memories of my time in the mountain meadows with these interesting little creatures. My first excursion into photography was making portraits of my squirrel buddies. From that beginning, nature photography — and especially photography of the Canadian Rockies — became an obsession of mine.

Presented in this book are my views of the Canadian Rockies, created over many years. People often wonder if my images represent an "altered reality" created through special camera techniques or through photo manipulation on the computer. My answer is no. These photos represent a reality seen with my eyes, and captured with my camera. Most of the images in this book are printed to represent accurately the photos that came from the camera.

However, cameras do "see" differently than the human eye: film and digital sensors record the tonal values across a scene in a compressed manner, showing less detail in shadows and in highlights than the human eye can discern. And film and digital sensors have their own coloured interpretation of the world. When I use special camera techniques or computer manipulation, it is not to alter reality, but to bring the photo closer to the way my eyes see the scene.

Another factor that colours the look of the photos is my love of early mornings. I am a morning person through and through: I love the ethereal light and the calm of early morning. Midday is too bright, loud and busy for my tastes, and therefore you will see few images made by me during the course of the day, when everyone else is active. My photos may look different from what the average visitor sees, simply because I am out and about at times when others are still sleeping.

For me, the Canadian Rockies is not a "been there, done that" kind of destination. Even if I visit the same scene over and over, it will never look exactly the same. One of the lures of photography is that there is no such thing as the "perfect" shot of a given place.

The mountains have a way of reminding me of my own mortality, which in turn flavours my taste for living. Staring at the computer screen in my office, I don't have the same sense of vitality that I do when I am peering down, from a high alpine meadow, into a plunging valley in the Rockies. When I am in the mountains, I am awed, humbled, and thrilled, in a way I never feel in the city. I hope these images will inspire you to seek out the mountains in search of the same feeling.

Darwin Wiggett